French Country
COTTAGE

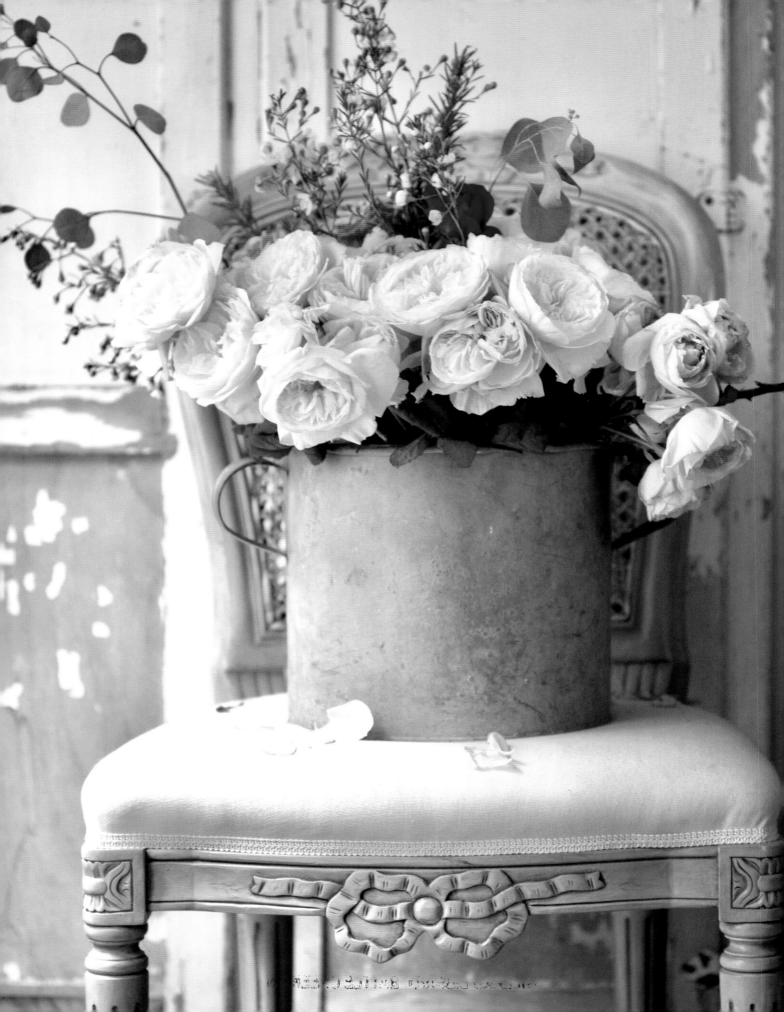

French Country
COTTAGE

COURTNEY ALLISON

GIBBS SMITH
TO ENRICH AND INSPIRE HUMANKIND

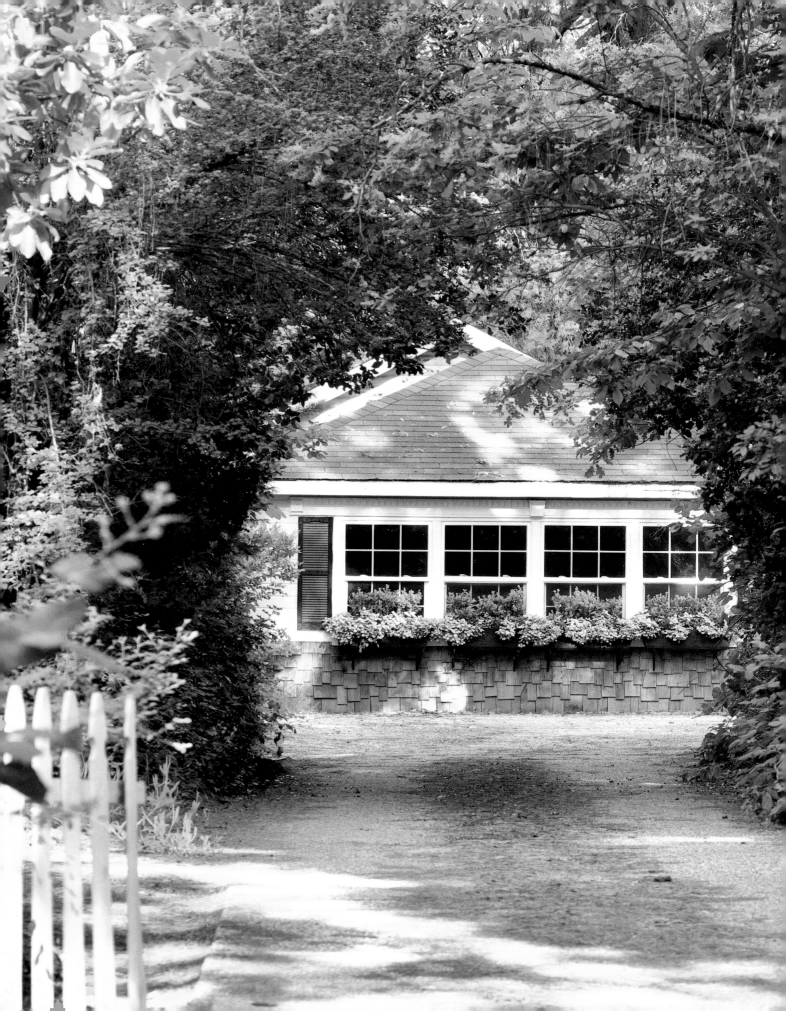

For Grammy, one of my closest friends.
Thank you for always loving and believing in me
and the little house that could.

CONTENTS

A GIRL BEHIND A CURTAIN

I once wrote a blog post about the girl behind the curtain. Like the powerful Wizard of Oz—who was full of confidence and made magic happen but behind that curtain facade was merely an ordinary man afraid to share his realness with the world—I share rooms, vignettes, simple DIY projects, and an occasional personal post on my blog *French Country Cottage*, though I haven't always felt ready to share more about what was behind that curtain: a sometimes complicated, always dream-filled girl with her head in the clouds, who found inspiration everywhere and who saw things a little differently a lot of the time.

I believe my love for all things sprinkled with a bit of whimsy and romance, and embracing that romantic style, started as far back as when I was a young girl in my childhood neighborhood. I grew up on a tree-lined street in Northern California that had houses set on spacious pieces of land filled with walnut orchards, overgrown shrubs, and an abundance of crickets chirping in the pond up the road. It was a slice of the countryside, though it was just a short walk to a busy East Bay downtown.

In that neighborhood I first discovered my love of flowers, of home, and of the romance and fascination that a house and other things with history held. Down the road from our home was a historic mansion set in the middle of a large lawn behind tall iron gates. It made an impression upon me from a young age, and I remember wondering what was inside and what kind of stories it could tell. It wasn't regal or perfect; it was crumbling a bit, but it inspired a love for original above new, and I fell in love with things that had history or a story.

Always a creative type growing up, I was a daydreamer who longed for adventure, and after high school, I loaded my car with a couple of boxes and decided to explore a bit in search of a place where I belonged.

I found myself pausing for work as I drove through a small town in Montana, and that first trip on the icy roads to my new job also led me to the man who would become my husband. The sweetest boy I had ever met, he took me bareback horse riding, and while watching those Montana sunsets, we fell in love. We bought a home and started a family, and after our first son was born, our travels took us to a farmhouse on 120 acres in the Midwest, where our second son and daughter were born. I loved the farm life there, with a big red barn and animals—a horse, chickens, and turkeys. It was idyllic, but I found myself missing family more than ever. We moved back to California, where not long after, we found this old cottage on acreage. And it was in this cottage that I would also find much of that fairytale life I had imagined.

I have always been passionate about decorating and making a house a home, and I feel fortunate that I grew up in a house where imagination and reinvention played a huge part in our lives. My parents are both creative types in different ways, and I might be a literal mishmash of them. I remember watching my dad, a contractor and real estate agent, sketch floor plans and jot notes with his chunky yellow construction pencil while he dreamed up ways to change our home. He was always renovating something, always seeing a space for what it might become rather than what it was.

My mother was creative with design in her own way, bringing home a zebra-print sofa with hot pink pillows, and regularly moving the furniture and redecorating. I honestly never knew what the house would look like when I got home from school each day—which, I have to admit, was kind of exciting. I was always eager to see how those pieces and the room would feel with everything shifted into a different light.

My grandparents were much the same. They moved to a small historic town when I was five years old and together designed and built a home, with my grandfather doing much of the work himself. It was another example for me of how listening to and curating that creative vision can bring what you imagine to life.

Looking back now, I can see that some memories of my childhood home and growing up might have been the spark for my grown-up style. Some of the reimagining of spaces. The constant change in decor. The visions for what something could look like with a little bit of love rather than what was right in front of me. I think each of those things play a part in my style and how I look at rooms and homes today and are why I knew that this house was something that could be much more than it seemed at first glance.

WHERE FRENCH COUNTRY COTTAGE BEGAN

It began in a 1940s cottage in California. It wasn't the pretty storybook house that you might imagine a country cottage to be. It wasn't charming—it wasn't even livable when we first saw it. To be honest, the real estate agent told us to bulldoze it and build new on the acreage—that was where the value was. But in spite of it having been vandalized and forgotten for over sixty years, there was something about the house itself that we were strangely drawn to the very first time we pulled into the driveway. There was a feeling that this was perfect for our family and had the potential to be that charming cottage we longed for. From first glance, I envisioned my kids running through the yard, evenings by the fireplace, and a place where countless dreams and memories could be made.

I saw Home.

Of course, I also saw the work—and it was not for the faint of heart. It was a bit overwhelming, to be honest. There were broken windows in every room, ceilings that were nothing but open rafters looking into the attic, and a bathroom lacking even the basics for usability. There was much to do to even be able to move in, and then to renovate it to make it inviting. And our budget wasn't mighty, which gave us a bit of pause. But in my heart, the energy of this house and property felt right. And so we took a chance.

We replaced windows and siding, refinished hardwoods, and took out light bulbs hanging by wires and put crystal chandeliers in their place. Bit by bit, we saw that vision coming to life. It didn't happen overnight; it happened over years while we lived in the middle of the project and while listening to and learning how we lived in the house, which showed us what directions to go. There were crazy discoveries, hours of pounding nails with my dad, and many nights of pizza because the kitchen wasn't functional—along with frustrations, tears, and many laughs, some out of sheer exhaustion. Those first renovation years are filled with some of the memories we laugh most about now, and those early years in the house were when so many sparks and ideas began to form and take shape

And in the middle of those renovations and reimaginings, all the while, our children ran through the yard, and birthday parties, family reunions, and graduation celebrations took place under the shade of those old trees. Jack-o'-lanterns were carved, twinkling Christmas trees went up, and spring plantings in the gardens brought an abundance of flowers in summer. There were lazy days in the hammock and evenings by the fire pit; first days of school, first loves and first tears; high school graduations and celebrations of big moments and everyday moments. And in some of the harder times, this house was a tangible something I could focus on that helped me to find my way.

Life happened in this cottage. Our family bloomed here. This home is where I found a bit more of myself and the confidence to follow my dreams. And it is where my French Country Cottage dream started to bloom as well.

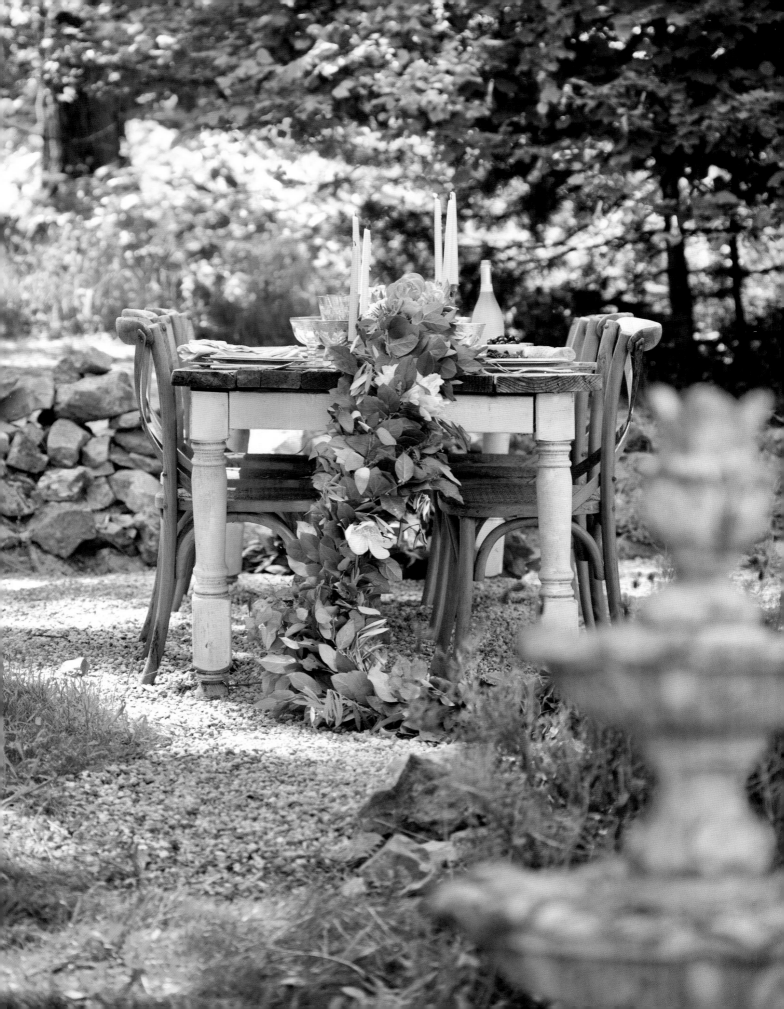

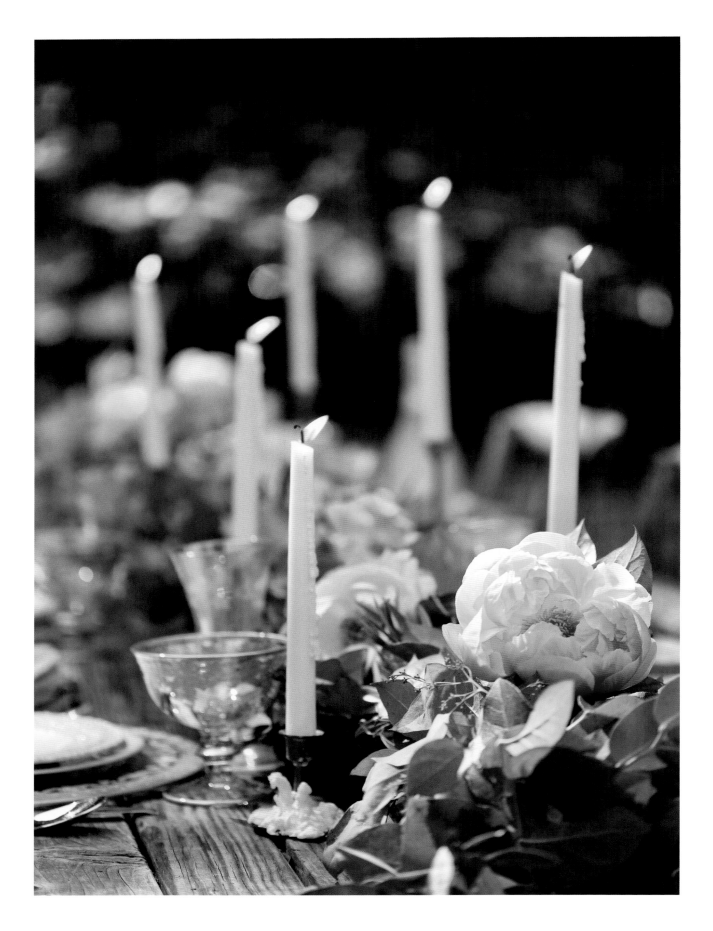

STYLE IN BLOOM

I once heard that elegance and couture need simple and casual to balance them. I think that absolutely sums up what I love in design. That quintessential mix and mingle of the exquisite and straightforward simplicity is everything for me.

With each new project in this house, I discovered something new about what I loved. As the paint covered the walls and I dragged flea market finds and old chandeliers home, I noticed how much I was drawn to the soft, romantic charm that began appearing. And I also noticed how, as we started each renovation, I struggled with replacing the old original: I treasured the "realness" and the story that came with the patina and character of the house above making everything new. Even if something was imperfect, it was the imperfections that spoke the strongest to me. Things like the kitchen drawers that dropped a bit when we pulled them out too far, the quirky layout of the hallway, and the pine plank walls dotted with knot holes that came to life with several coats of white paint. And I knew that somewhere in between up-to-date and modern and that 1940s vintage, there was a balance that was perfect.

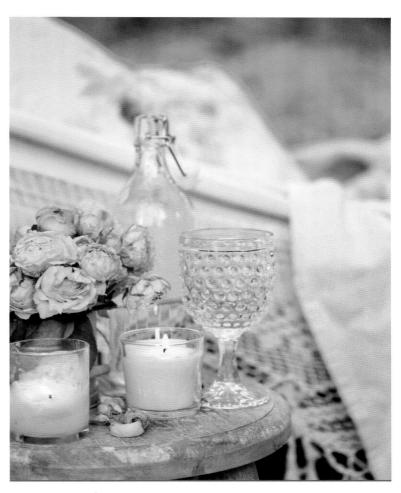

French Country Cottage style is fueled by inspiration, by notions of a dreamy provincial life, and by an abundance of flowers and romance. With the warmth of French country mingling with the classic, relaxed feeling of cottage style, it combines rustic elements such as weathered woods and slightly tattered fabrics with the refined elegance that comes from crystals and gilding, and together they create a composition that isn't too precious to be enjoyed, that feels welcoming and inviting.

Filled with soft, muted colors, layers of paint, worn patinas, natural textures, and a sprinkle of romance, it is a style that cherishes original, history, and memories. Pieces such as my grandfather's red and green workshop stool (page 26) that I use in the cottage kitchen, or the set of vintage floral dishes that were my great-grandmother's are pieces that bring back memories while they are given new life and enjoyed again.

My style isn't about perfection—quite the opposite, really. It is about seeing the beauty and charm in the imperfections. The chip in the tea cup, the wobbly bench made from repurposed boards that will never sit flat, and the beauty of blushing roses (that I admittedly let linger a bit longer than I should) dropping their petals on an aged marble countertop.

It is a style that appreciates "well worn" and sees it as "well loved." It celebrates simplicity and at the same time craves and indulges elegance. It is a welcoming way of living that invites you to embrace an inspired lifestyle and live a life that is beautifully decorated.

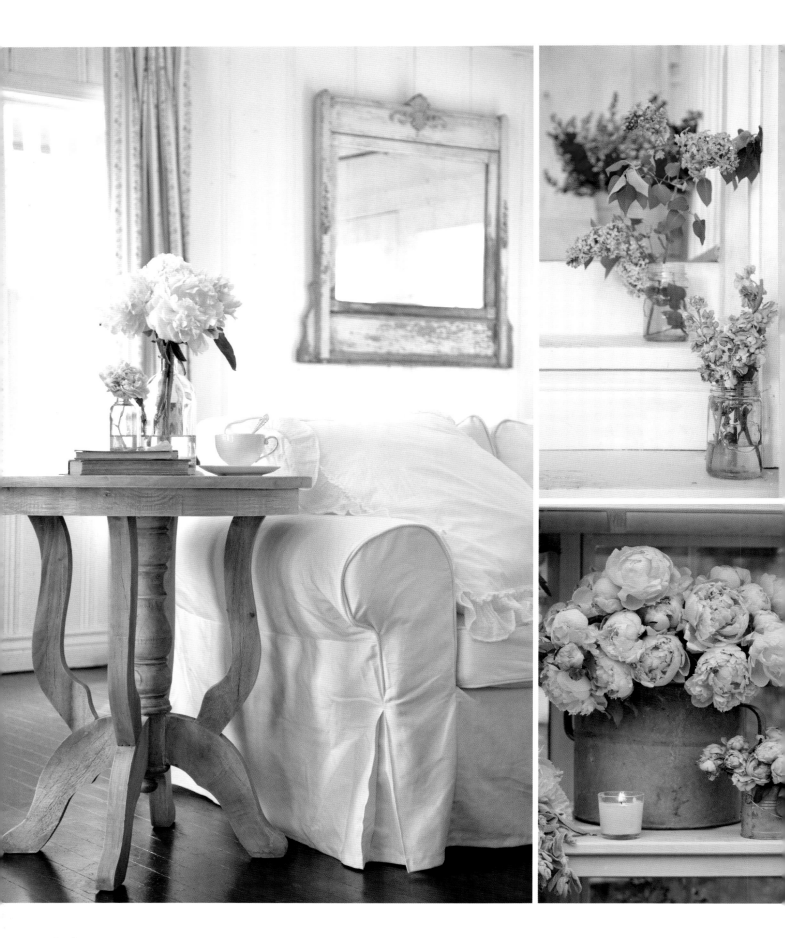

INSPIRATION

I am often asked what inspires me. And the answer simply is the world around me every day.

Details inspire me to take a closer look. The ruffled petals by the hundreds in a peony. The grain in a piece of wood that creates a pattern. The intricate carvings on a French armoire. I am constantly drawn to pieces with details. I find the most perfect balance is somewhere in between an abundance of details and just enough simplicity to make sense.

Patina inspires me with a sense of nostalgia and history—imagined history many times, since I don't usually know the story behind the object. I like to dream up scenarios about some things and the stories they could tell. Hand-rubbed finishes, painted layers chipping away, gilding on the daintiest of tables. There is a definite romance in the patina that comes from years of living.

Flowers of every shape and size are a huge inspiration and love of mine. From the time I discovered a hidden rose garden behind our house, I have had a never-ending love affair with flowers. Aside from their intoxicating scent and intricate layers, flowers bring beauty, and even as they become a bit wilted and their petals begin to fall, they shine even so, and I am inspired by them all over again in a different way. Whether they are simple bunches of wildflowers picked on a walk, a few roses or a few dozen roses

from the supermarket, or dreamy buckets of blooms for a styled inspiration photo shoot, fresh flowers and greens—potted and cut—are always in the rooms of our home and are a constant inspiration for my photography.

Simple things, everyday things that might otherwise go unnoticed inspire. Candles with beautiful dribbles onto brass sticks that are covered in layers of wax from evenings past. The palest of pale colors and linens with patterns that have faded; delicate embroidery and monograms on anything; and the way that a crystal chandelier catches the morning sunshine and sends it dancing through the room.

My family and children inspire me by showing me different ways of looking at things, *and nature inspires me*—the color of leaves on the ground in autumn, the birds singing outside my window in spring, the scent of fresh peonies in my bedroom, and the sun setting over the ocean.

Inspiration is that flip-flop in your stomach and the surge of excitement you feel when something moves you, that makes you want to pause and simply soak it all up and capture that feeling so you can feel it all over again.

I remember when I picked up my first "big girl" camera and started to capture what was inspiring me: it was my children playing in the yard; my boys laughing while running around, and my daughter peeking from behind trees and then twirling in her tutu on the lawn. They were moments that made my heart soar and that I wanted to save the feeling of. Soon after, I started snapping photos of "moments" that spoke to me everywhere: freshly picked blush peonies tied with ribbon on a settee; a table setting with flickering candles under the stars; a turquoise bicycle on the beach with ranunculus.

Some would say that some of those things weren't always real—and I would agree in some ways. Some of them are created moments that I was inspired by and snapped a photo of. But I would also say that for me, those are the places where French Country Cottage began and thrives. In that dream world, the one with whimsy and poetry, where inspiration, quite simply, is the inspiration.

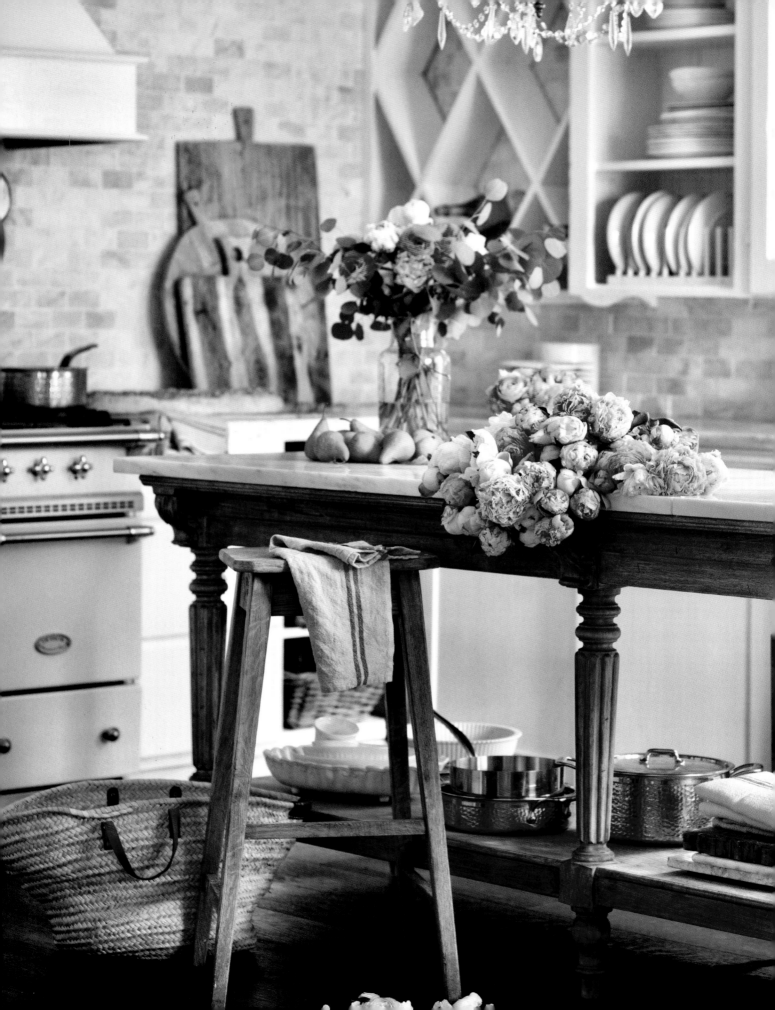

FRENCH COUNTRY COTTAGE STYLE

tyle is something that changes over time. It starts in one place and meanders on down the path of inspiration and vision while being sprinkled with passions—and it becomes more refined and more reflective of you. Finding your own style and what truly speaks to you isn't a simple snap of your fingers that says this is who you are. It is layers of many things. It is experiences, treasures, trinkets from travel, bits you are inspired by, memories and favorite pieces you enjoy every-day in your home. They each reveal a bit about you and what you are passionate about, and all together create a bigger pic-ture that tells more of your story.

JUST A COTTAGE

One of the things that I struggled with when we bought our cottage was that it was just that—a cottage. It was built as a vacation house and, as such, had an informal floor plan, and I longed for more elegance and formal spaces rather than a more simple style.

With worn wood floors, rooms with awkward layouts and quirks, it was the farthest thing from elegant. I started out trying to embrace that more rustic style—and then a quick stop in a secondhand store one day led to the first piece that gave me the confidence to follow my more elegant, French-inspired design dreams in this cottage. It was a simple vintage chandelier with a brassy patina, lots of crystals, and candlestick holders yellowed with age. My heart pounded at the thought of hanging it in the kitchen. I imagined those crystals sending light through the room and how elegant it would be even in a more rustic space—and I turned around and bought a chandelier that I didn't even know worked.

The kitchen light when we moved in was a 1960s ceiling fan with a lovely beer bottle pull, and when that came down and that one simple vintage chandelier went up in the kitchen and the lights turned on the first time, my heart soared. My husband even nodded and thought it was perfect. That chandelier changed the kitchen game. It instantly elevated a simple room, giving it the feeling that it was much more important. And that was the piece that was the start of finding my style and the confidence to trust the vision. That chandelier led to a second, a third, and many more, and each time the effect was the same. As that old rustic cottage started to feel a bit more refined, I realized that the difference between an ordinary space and one that knocks your socks off might not be as big a change as I had originally thought it would be. It might not involve top-to-bottom renovations or fancy floors and formal spaces; it might be something simple like a fresh coat of paint and a little bit of jewelry in a room.

Over the years, my style has evolved as I've fallen head over heels in love with a fabric or a paint color or a craving for more or less in a room. But even as some of my taste has changed, I have stayed with the mix and mingle of refined and rustic, and with the elements that I love. And when I do try a new idea, color, or style, I know that taking a style chance might be a flop or it might be a game changer. So my first rule is to throw out all the rules and follow what you love. And my second is that if you walk into a room and it makes you happy, it is absolute perfection.

A vintage-inspired island in the kitchen is ideal for preparing food, and trimming flowers to place around the house.

Elements of the Style

I believe in the power of patina, old chandeliers, and fresh
flowers—and that each of them belongs in every room.

PALETTE

The French Country Cottage palette is made up of textures you might find in nature, along with sun-bleached, faded colors, soft florals, and that delightful silvery color of weathered wood. The subtle softness of an old linen washed a hundred times is perfection, as are the pale blushes, shades of white and chippy patina that exposes layer upon layer of vintage goodness.

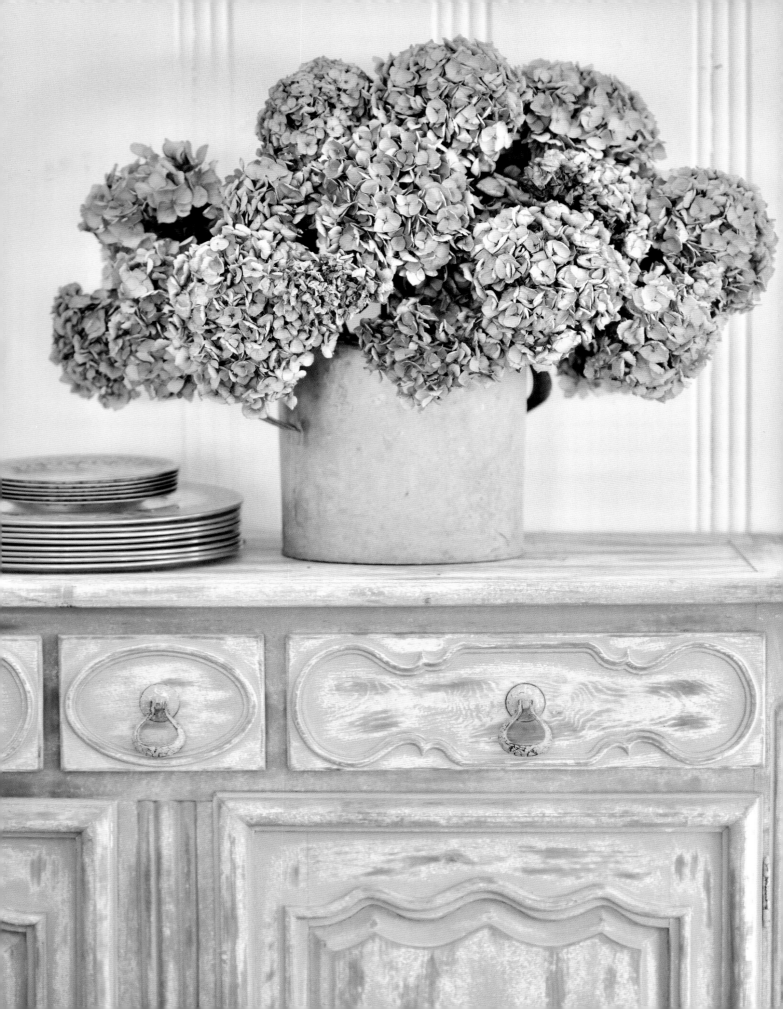

PATINA

The patina of antiques speaks to me so loudly. Knowing that a piece was part of a different time has a huge impact on my overall sense of style. The best treasures to me are the ones where the bare wood shows through old paint, or the foot is chipped just a bit. To me, they aren't a sign of something being worn and needing to be refinished but instead show that a piece was used and appreciated. The mingling bits and pieces of collected treasures and different patinas together tell the story in a room.

In my home, patina and texture make an appearance on everything from the furniture to the linens to the architecture. Sometimes it is simple, such as the knot holes and detailing on the wood plank walls and the hand-rubbed finish on the wood on the buffet. And sometimes it is more intricate, such as the delicate, hand-painted florals on the china cabinet in the bedroom.

Tiny details bring a large amount of charm. Delicate hand-painted designs, *mismatched* china, and old chipped paint are details that I love.

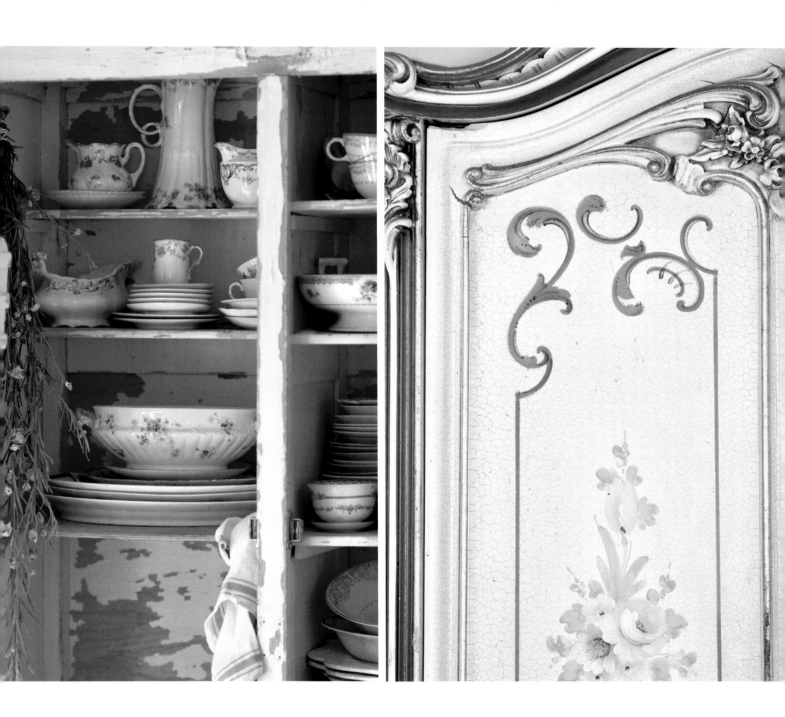

A juxtaposition of pretty vintage dishes with the distressed cupboard interior is a look that stimulates a response in me. I collect dishes that speak to my emotions rather than looking for brand names or perfect condition. The patterns, especially florals, are what I like.

ANTIQUES

Antiques and vintage play a big role in my style. Sometimes I'll find a piece that I am drawn to instantly: a sideboard at the flea market, or an oil painting at a tag sale. I am constantly inspired when I am browsing—and oftentimes, what catches my eye isn't what I would expect to fall for. There are the always-in-season pieces—vintage French chairs, mottled mirrors, old zinc buckets—which are grabbed up right away, of course; but an unexpected find might become a favorite.

Simple utility pieces—such as stools and chairs with broken caning, missing spindles and torn fabric seats seem to always find their way into my home. Even in a less-than-usable state, they are perfect for tucking into a corner. Another favorite are small Florentine nesting tables. I don't hesitate to grab another set or single table when I bump into them.

I once brought a set of five French dining chairs home—not for the dining room, but merely to use tucked into various areas. And a good reproduction will work as well. I like to buy chairs in pairs or more, if possible, for options on where to use them—though I admit that a single chair finds a way home just as quickly.

If I find something that speaks to me, I will bring it home even if I don't know where it will land. I am a firm *believer* that if you love something, you will *find* the perfect spot for it.

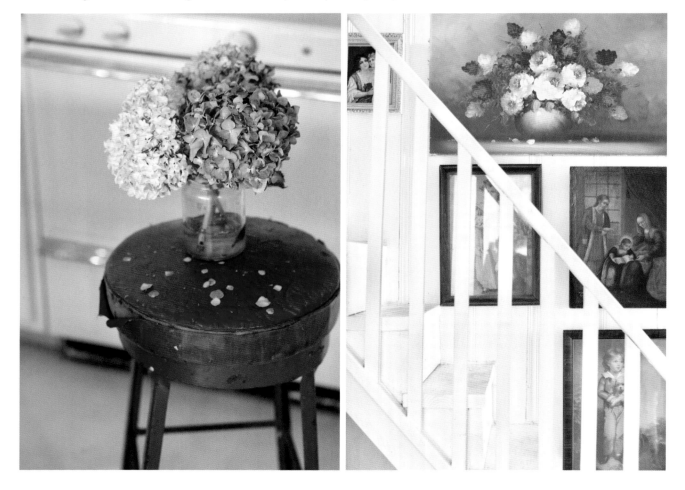

VINTAGE TABLEWARE

I am one of those people who have a hard time walking by vintage cups, plates and platters at a tag sale. Dishes with delicate details such as florals or embossed patterns and gilded rims always catch my eye. They often have imperfections—old stains on ironstone or a few chips or missing gilding, but if I love the pattern, those pieces will find a home with me. While I relish finding a large set, I pick up individual pieces just as quickly. I enjoy the mix and mingle of the patterns on the table and in the cupboard. My tip: collect pieces that you love as you find them. Before long, you will have a collection of beautiful mismatched and yet perfect-together pieces for everyday and specials occasions.

The epitome of romantic style, my great-grandmother's china has a delicate floral pattern of bouquets and swags on a simple cream background.

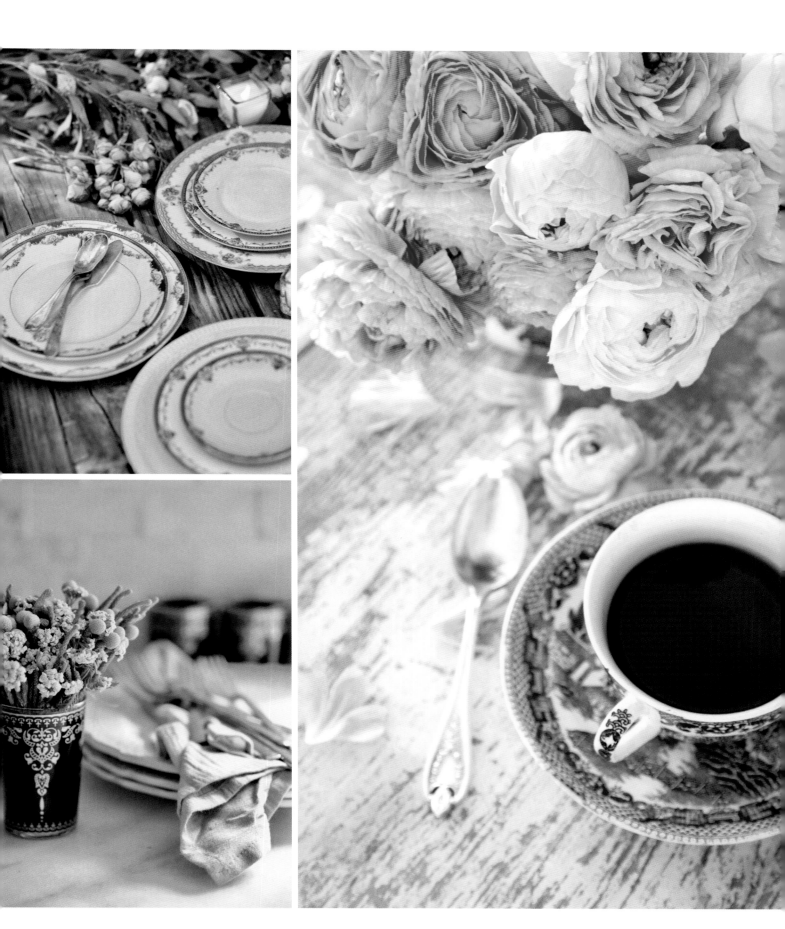

CHANDELIERS

Filling a room with light that bounces around like a little breeze quite simply makes it feel magical. I have no shame in admitting that I might have a room or two with more than one—and yes, even more than two—chandeliers in it. In my opinion, the more crystals, the better.

In our home and guest cottage, we have an abundance of chandeliers and sconces both vintage and new, that add character and elegance with their brassy frames, cut glass, and strings of pretty little crystals.

While I am not so great at practicing restraint when it comes to crystal-covered lights and feminine touches, I am always mindful of a fine line between just enough and too much with a chandelier. From size to style to light count, bigger isn't always the answer. Sometimes a smaller chandelier is all a space needs. Or if big is what you love, finding one with a glass body that seems to float is the answer to filling a space with beauty and light without overpowering it.

The most important thing to remember: if it makes you happy, it is perfect for you.

I must have chandeliers. *Dripping* in crystals and reflecting rays of sunshine. In every room. Even in insignificant and overlooked spaces such as hallways and closets, I like to give that room a chandelier and see it *come to life* in a new way.

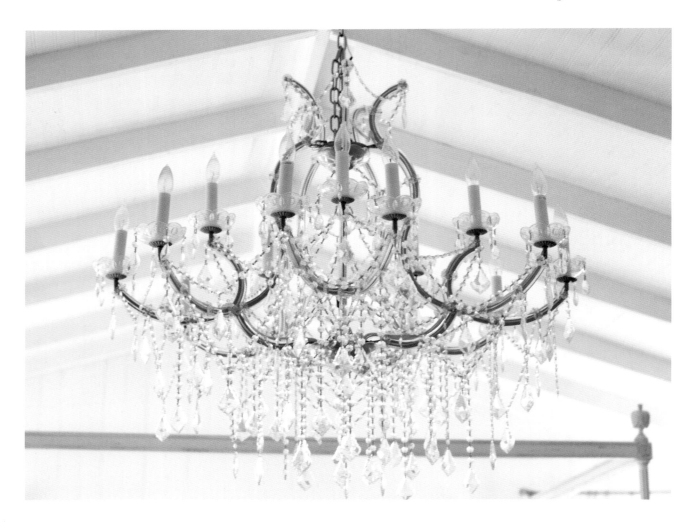

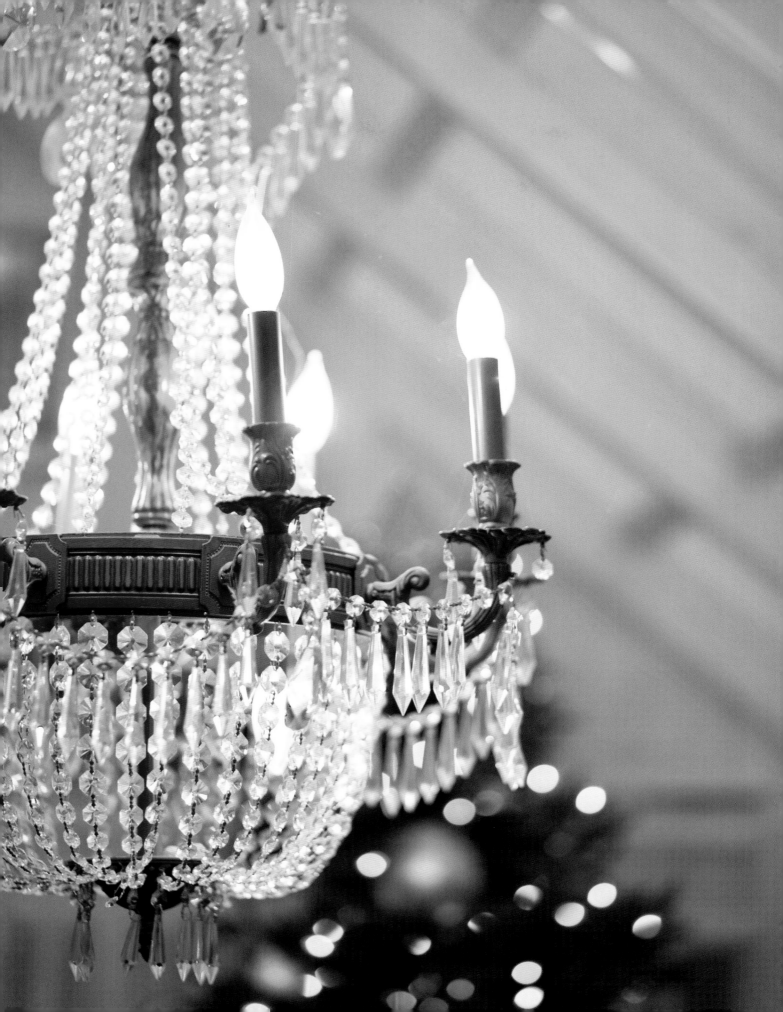

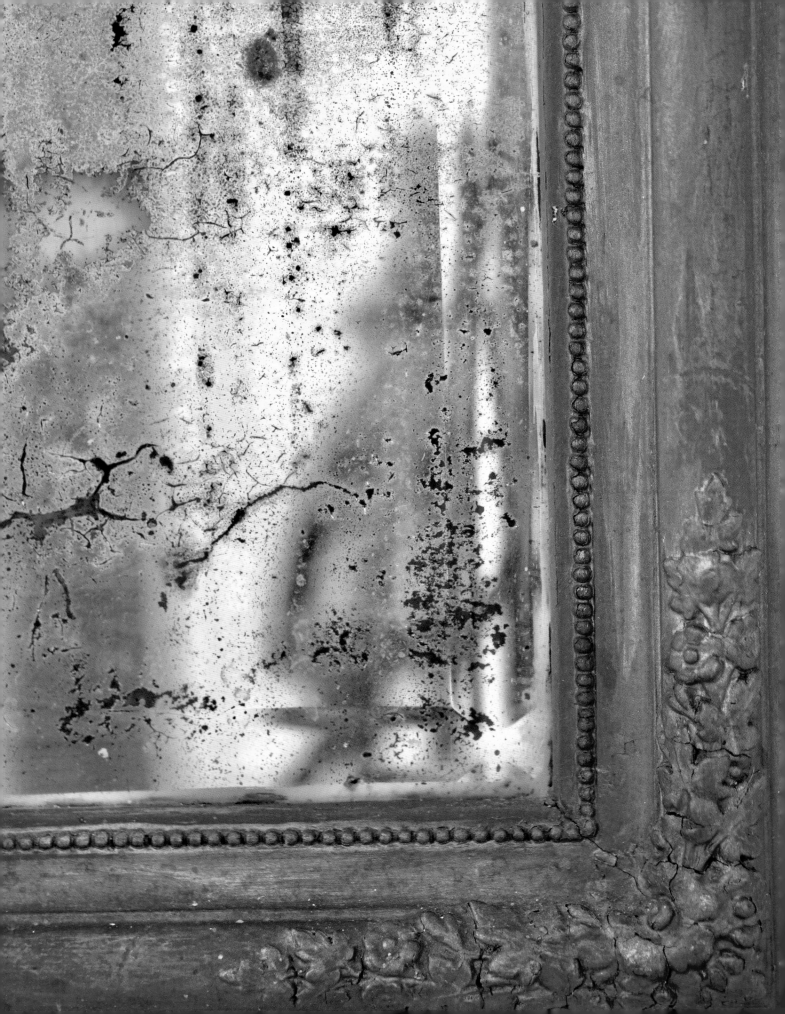

MIRRORS

I once gathered up a dozen or so mirrors and old frames of various sizes and created a wall of empty frames and mirrors in the hallway. It was simple, and there were more frames than mirrors, but the arrangement brought a bit of reflected light to that long, dark corridor, and with something on the wall, a small, unimportant in-between space instantly felt interesting.

My favorite mirrors are ones that are well worn and no longer reflect as well as they once did; those brassy, gilded, framed mirrors with the mottled looking glass that shows more black areas than silver make my knees weak every single time.

A favorite antique find was a charming pair of nearly identical Louis Philippe mirrors that I discovered in an antique store in San Diego. They are the same size and have the most delicious, delicate floral carvings that are almost identical. Though their looking glass is far from perfect and one of them shows more of the wall behind it than reflecting any light coming in, its imperfect glass only adds to the charm.

OLD METALS

Copper cookware is quintessentially French. I love my copper pots and pans, dents and all. I love old and new—and love finding ways to incorporate the pieces into my decor. Old copper molds and bowls are charming on the shelf but also to use in the kitchen on the counter to hold odds and ends.

For architectural interest: I used to think that the old door knobs to the bathrooms were a distraction. They had paint on the bases and a few dents from hitting the wall over the years; but these were low priority on the list of things to replace, and over time, I grew to love them—dings and all. Those knobs that dotted the crisp white doors and cupboards brought a certain old-world character; it was their flaws that made them interesting.

Brass candlesticks are some of my absolute favorites on a table. Mixed pieces that are various heights, sizes and styles somehow come together to create a cohesive look on the table.

Always on the flea market list are old silver pieces. And while I love shiny finishes, I've also found a love for letting them tarnish to that dark, blackened look. With pale pink roses, the mix is undeniably charming.

Vintage silver left to tarnish, warm coppers, and brassy old gold hardware are delightful and *enchanting.*

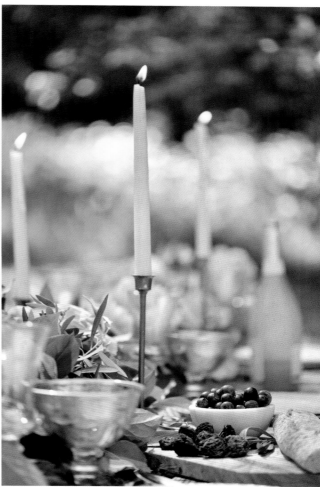

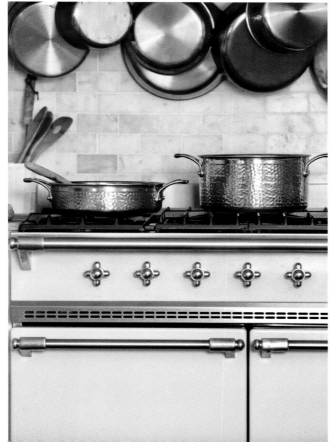

With silver flatware, I will buy mixed individual pieces as quickly as I will buy a set. I fall for pieces that have intricate details. The collected look of mixed patterns adds a little bit more intrigue to a table setting.

OLD BOOKS

Books are one of those things that I have on repeat and use everywhere for stylings. I have bought paper bags full of old books from church sales, thrift stores and tag sales. Less important are the age, title or subject on some, as sometimes it is merely the look and feel of those pieces of history.

I once carted home a collection of old building code books from a yard sale in the Midwest—all twenty-seven of them. They had the most delicious pale green pages and old leather covers; though I knew the amount of them alone was going to be hard to get into my suitcase, I couldn't leave them behind. Aside from the shoulder ache that remains even now, when I think about carrying them in my carry-on bag—those books are an enjoyable reminder of the sale and that summer.

I have filled several bookcases in the house (and the cottage, which is shown beginning on page 117) chock-full of old books. For unity, I will sometimes wrap the ones with more colorful covers in plain paper and write the title in pencil or turn them backwards for a cleaner look, letting the ruffled pages be the focus.

Ruffled pages, missing covers, and *exposed* spines have textures that appeal to me.

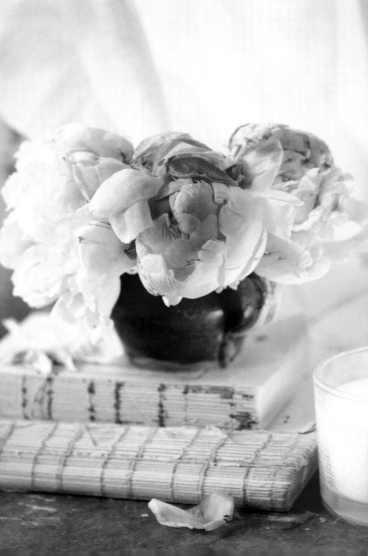

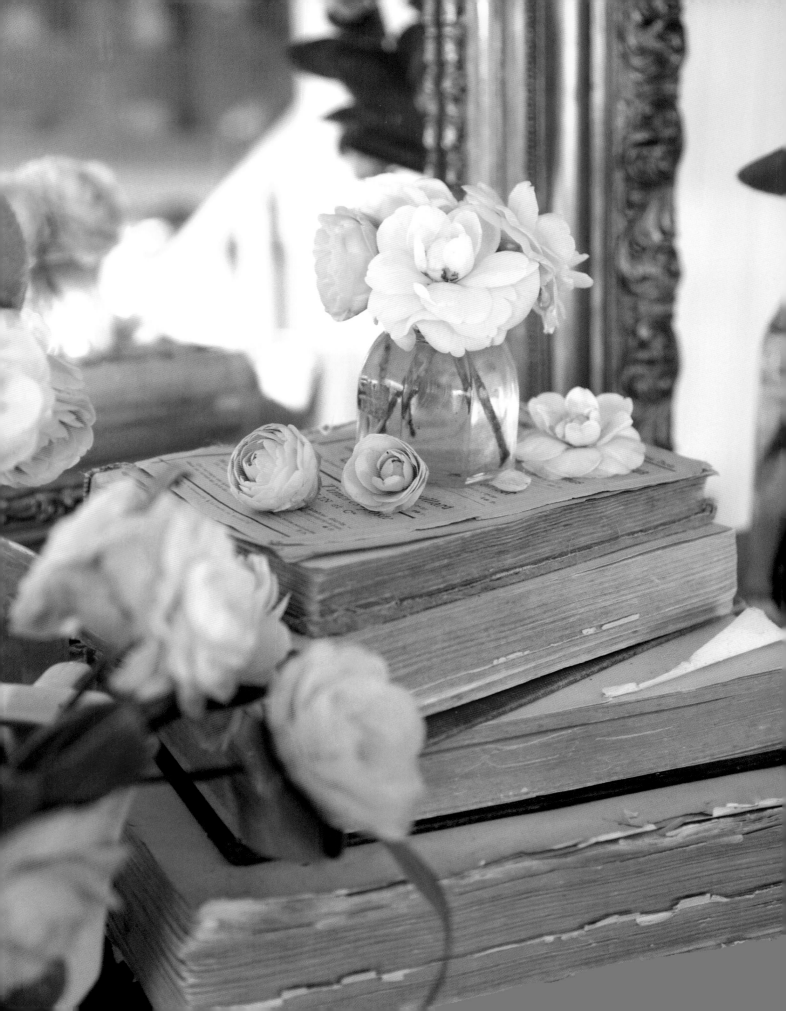

TEXTURES

From chunky blankets and stacks of willow baskets washed in a perfect shade of gray to that subtle texture of linen on pillows and upholstery, texture plays a big part in the way my style comes together and creates a look.

Texture brings a certain warmth and a comfortable feeling to any space. It adds details without being overwhelming in color or adding a too-busy, cluttered feeling. And in a room where you layer neutrals and soft colors, something like a simple woven basket can be a delightful addition.

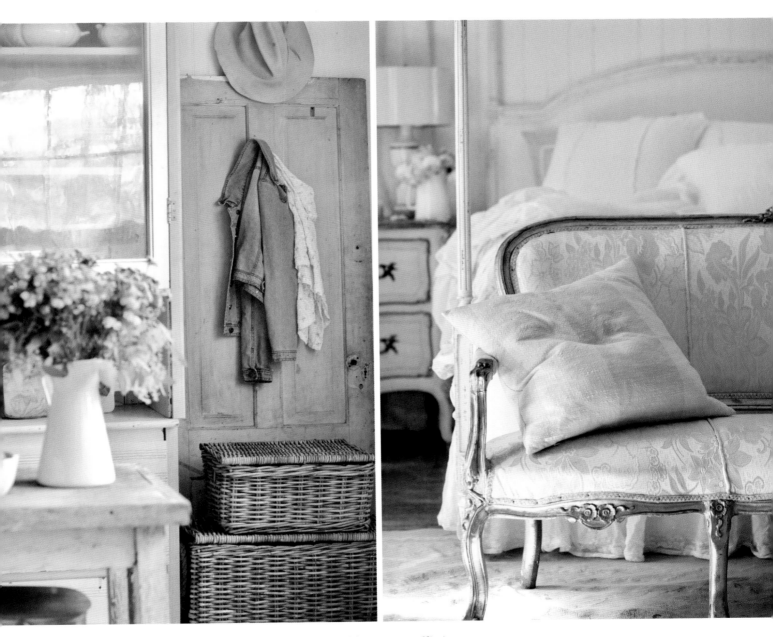

Nubby, chunky, soft, woven, you name it—I have an affinity for things with texture.

LINENS

I am a huge linen-loving girl. I have an armoire in my guest bedroom full of folded linens, a closet in the hall with quilts and blankets, and baskets with extras just waiting to be layered on the beds. I also have fabrics I have collected over the years that have the color, pattern, or style that I love and that wait for the perfect project to be used. I like a mix of simple, plain linens dotted with old romantic faded florals and French tickings. My favorites are those with shades of white, oatmeals, old washed grays and faded florals, and simple patterns in the softest of colors.

On the table, I keep linens simple. Blush Irish linen is one of my favorites, with just a hemstitch edging and clean lines. Old 1940s bark cloth curtains and floral sheets and duvets are always in favor and on hand for seasonal decor changes.

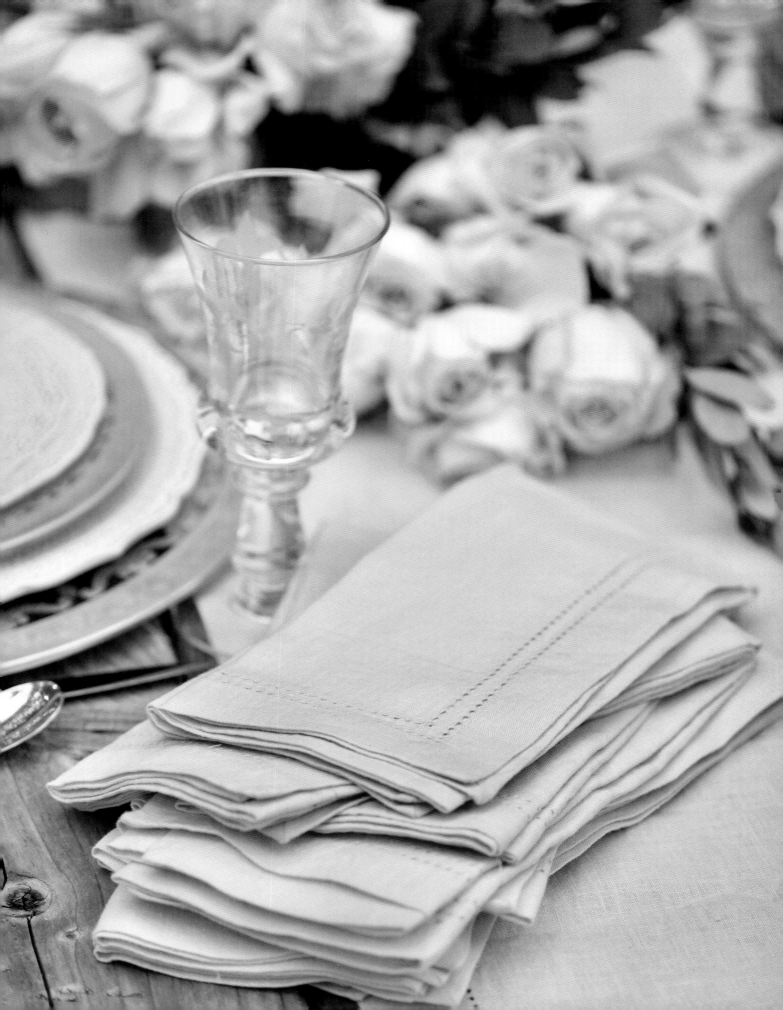

FRESH FLOWERS

I remember the day that I discovered that there was a secret flower garden tucked away behind my childhood home. It was up the ivy steps, just past the playhouse, and a small sprint up another dirt bank. Hidden behind a row of large ligustrum trees was a path that wound through the bushes that opened up to a rose garden at the edge of the property. I remember thinking it was a most magical discovery, and I would follow the peppery scent of the roses when they bloomed and enjoy that quiet spot often. The romance of their beauty, their scent, and even the petals that fell and carpeted the ground beneath them spoke so strongly to me, and there was something about that garden that inspired a passion for flowers and the desire to make them a part of everyday living.

Flowers can change the feeling of a room completely in an instant. They speak volumes in their petals and pretty shades and they add something to a room that nothing else can. To me, a room is not truly finished without a bouquet of flowers—or even a small jar with a single bloom. They are a must in my French Country Cottage style.

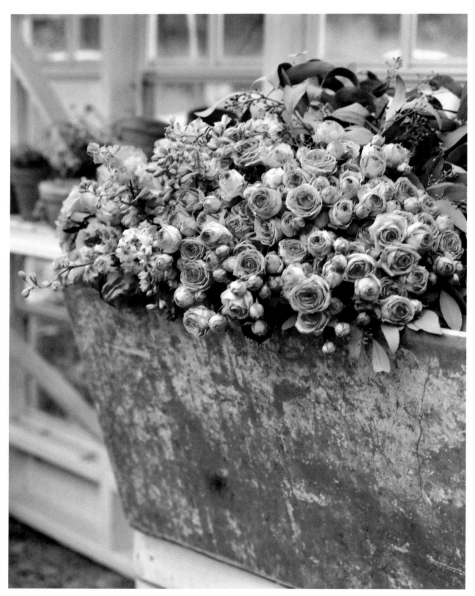

My favorites are ones you might find in an old cottage garden. Peonies with layers upon layers of ruffles, garden roses with their intoxicating scent, and delicate blooms such as ranunculus, lilacs, stock, hydrangea and larkspur all find a place in my home, among many others.

Whether clipping blooms in the garden to bring indoors, grabbing favorites at the flower market or grocery store, or picking a few wildflowers while on a walk, those flowers in my home are a daily indulgence.

I am not particular about fancy vessels—a simple glass jar, chunky zinc bucket, silver creamer, Limoges china, or farmhouse pitcher will all do.

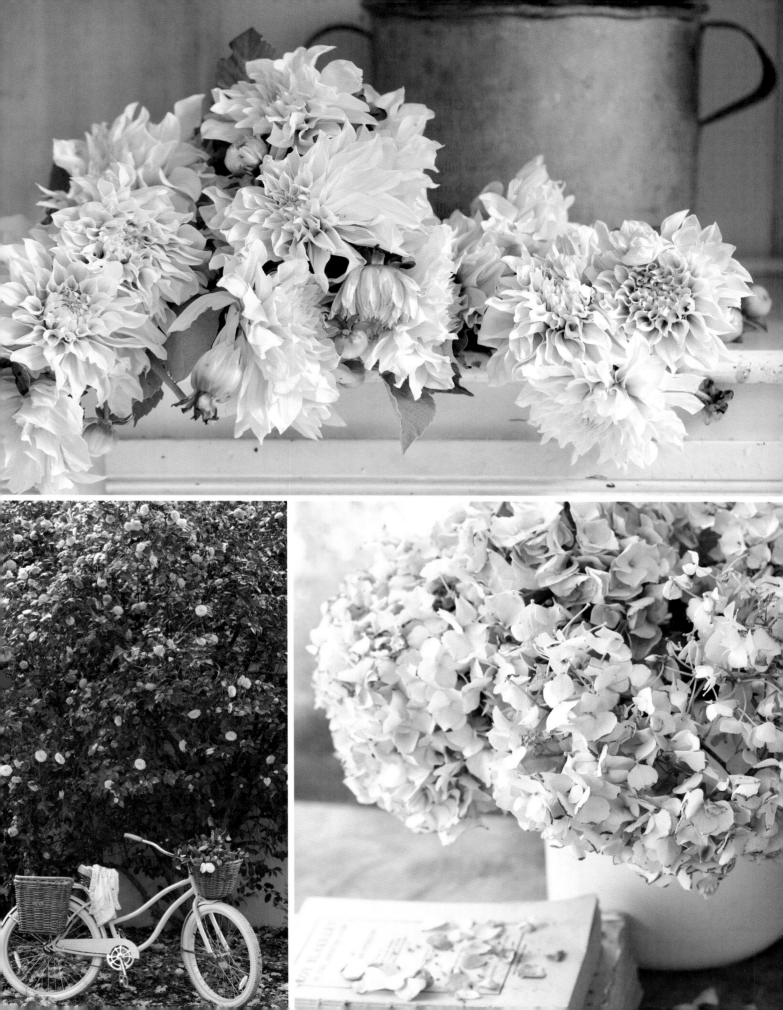

A LOVE OF ROMANTIC VINTAGE

One of the most quintessential aspects of French Country Cottage style is an undeniable touch of romance and vintage charm. It is a style full of collected pieces that tell a story. It isn't a style that is carefully designed; it is a style fueled by passions, inspirations, what you love. With each trinket, piece of china, etc., there is a bit of romance. Maybe the memory of the thrill of the hunt, the moment you found it, or the dreamed-up idea of the history it has. Those pieces that speak to you are the ones that speak the most about you and what you are passionate about.

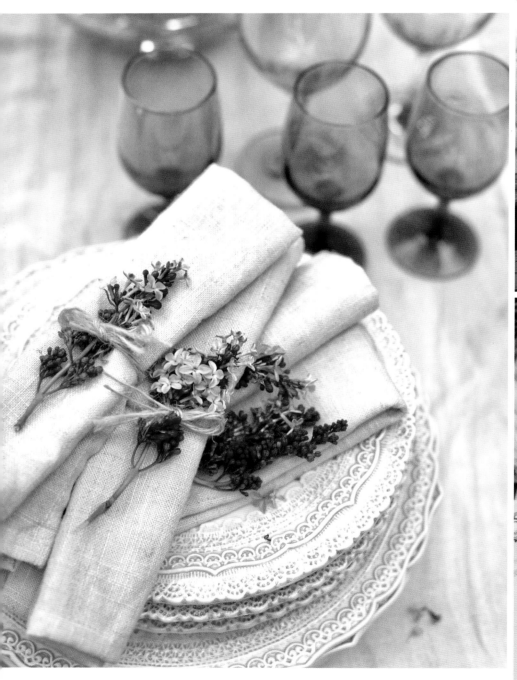

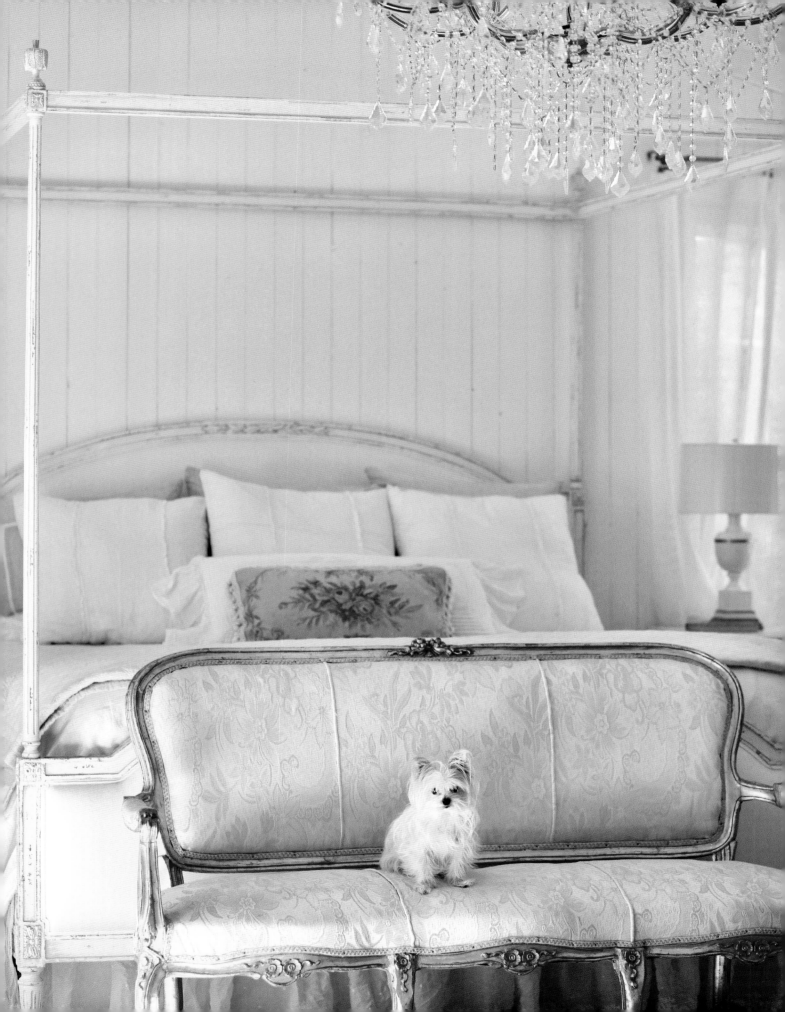

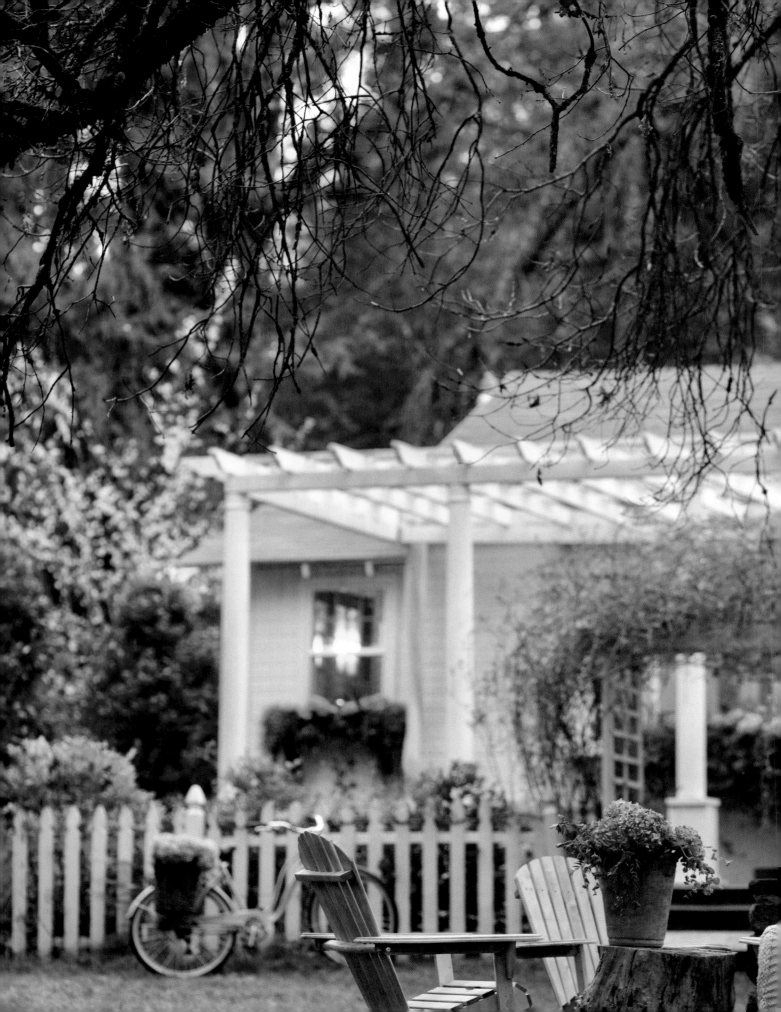

MY HOME

From the very first week we lived in the house, we learned interesting and curious things about it. And through the years and the renovations, it has been a house filled with discoveries, many that were somewhat like kismet and others that made us scratch our heads and wonder—from things hidden inside the walls, to the slightly off-level floors and ceilings in some rooms, to old wiring and plumbing that didn't make sense, to missing insulation, to that time we discovered that the top of the wall boards and crown molding were not actually completely sealed (there was the tiniest of gaps between them, which we realized when we had an unexpected houseguest one of those first evenings in our home; a bat flew from the attic into the living room through one of those tiny gaps. And along with it, it brought a late-night impromptu project to seal every ceiling in the house).

When we were first working on renovations, my dad would come every couple of weeks and we would tackle a project or two. Being a contractor and builder, he knew how to fix the things we weren't sure about, and we enjoyed quite a few laughs as we dreamed up renovation ideas, right along with the mishaps and different things we discovered as we worked. And with what was quite literally a comedy of errors at times—there was also so much that we learned without even realizing it. Like that bees don't like to be disturbed, and they don't like construction—ever. That measuring three times is better than just twice, and that sometimes a simple fix is far better than an overly thought-out plan. There was the time one of the main water lines leaked—after-hours on a weekend while my husband was out of town. Thankfully, our oldest, who was just about ten at the time, knew exactly how to fix the pipe because he had watched my dad work on plumbing the week before, and so we tackled it together and it worked. And another time, when trying to miter corners of the angled crown molding in the cottage unsuccessfully, our middle guy, who is gifted in construction, jumped in and cut the pieces right the first time and put them up. He was instantly hired to finish that project—and hired for a few others besides. There were the wonky, not-quite-level floors, the doors that didn't like to stay closed, and the little nooks and crannies we discovered as we worked that became charming spots in the house. And in those imperfections are many memories that are part of the journey of this house and how far it has come since we found it.

Part of the beauty of the long renovation process, which took much more time than we ever imagined when we signed on the dotted line, was that it allowed time for the house to talk to us. By living in the space, we could better understand the flow of the rooms and what worked and what didn't. And we noticed things like the path of the sunshine in the morning and where we seemed to spend most of our family time. This helped create a more refined vision for the house and how we wanted to live in it and what we wanted to keep and what we wanted to change to make it work better.

Our cottage on an early spring evening under a sherbet-colored sunset sky. My dad built window boxes and chunky corbels out of old fence boards for nearly every window on the house and cottage. Filled with perennials and fresh annual blooms each year, they add a perfect touch of cottage charm.

The Living Room

The living room is second only to the kitchen when it comes to gathering spaces. Our living room, with wood plank walls, hardwood floor, and an open, beamed ceiling has evolved from a dark and dreary space with small windows to a room filled with natural sunlight pouring in through several sets of French doors.

Over the years, the decor and furniture in this room have been on shuffle. When the kids were younger, for a more comfy and lived-in, relaxed look, I brought in inexpensive slipcovered sofas for plopping on. They were key in keeping my sanity when the boys had friends over, as well as for cleaning up any country dirt tracked in from outside. I paired the sofas with flea market finds, including an old bench made of fence boards that served as a makeshift coffee table for several years, and tucked in some of my favorites— gold tables—beside them.

With just this one room serving as living room and family room, it has always been a bit of a balancing act between what was easy and comfortable and what also created that more elegant style that I craved so much. And just as the kids have grown up, our home and the pieces in it were ever changing and growing to a different look as well. Those wobbly flea market benches and slip-covered sofas have done the shuffle just like so much of the rest of our home. And on occasion, those pieces have given way to more elegant French-style furnishings that created a refined atmosphere, even in the midst of the overall relaxed feeling the room has. But just like anything else in this house, the rooms change with the seasons, or sometimes, simply my mood, and those slip-covered sofas find their way here again and the French sofas will make appearances in other spaces as those whims give way to change.

Without formal rooms set aside for living, family, and dining spaces in the house, the large living room becomes all of those things and is truly an *everyday* space. It is where conversations happen while dining and while *relaxing* by the fire.

In the living room, the antique gilded French mirror adds a bit of drama to an otherwise quiet corner.

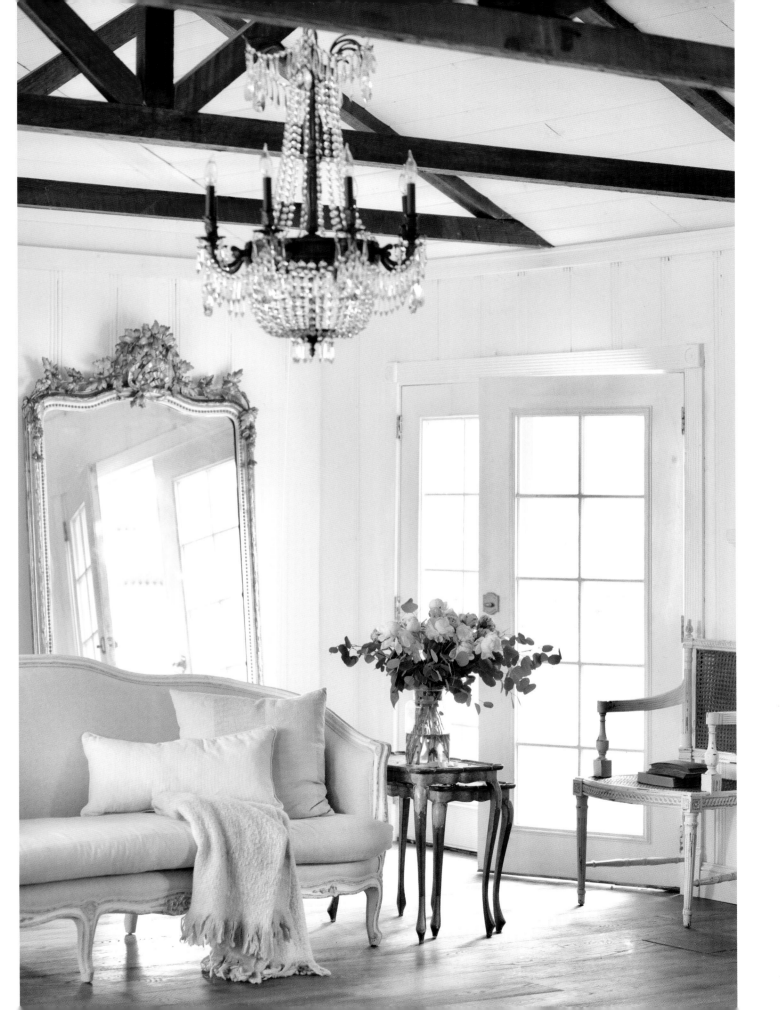

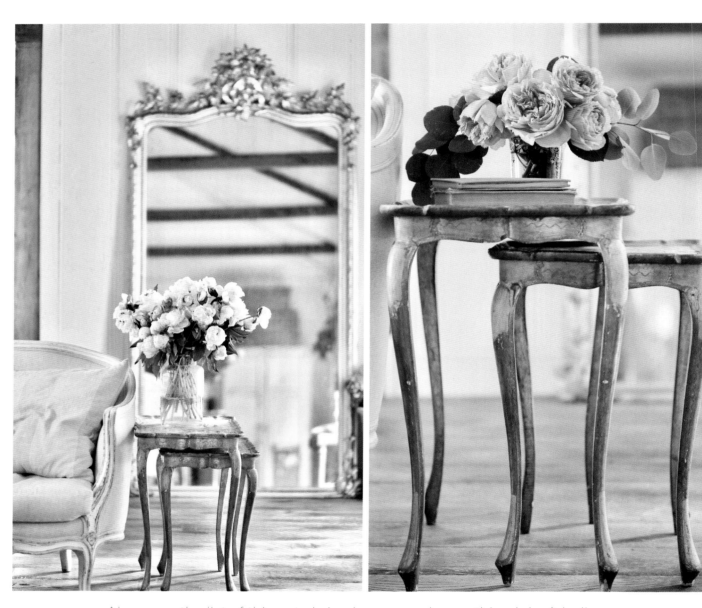

Always on the list of things to bring home—and something I don't believe you can have too many of—dainty vintage Florentine tables, perfect for stacking up or for tucking singly here and there. Old zinc buckets make perfect flowers vases.

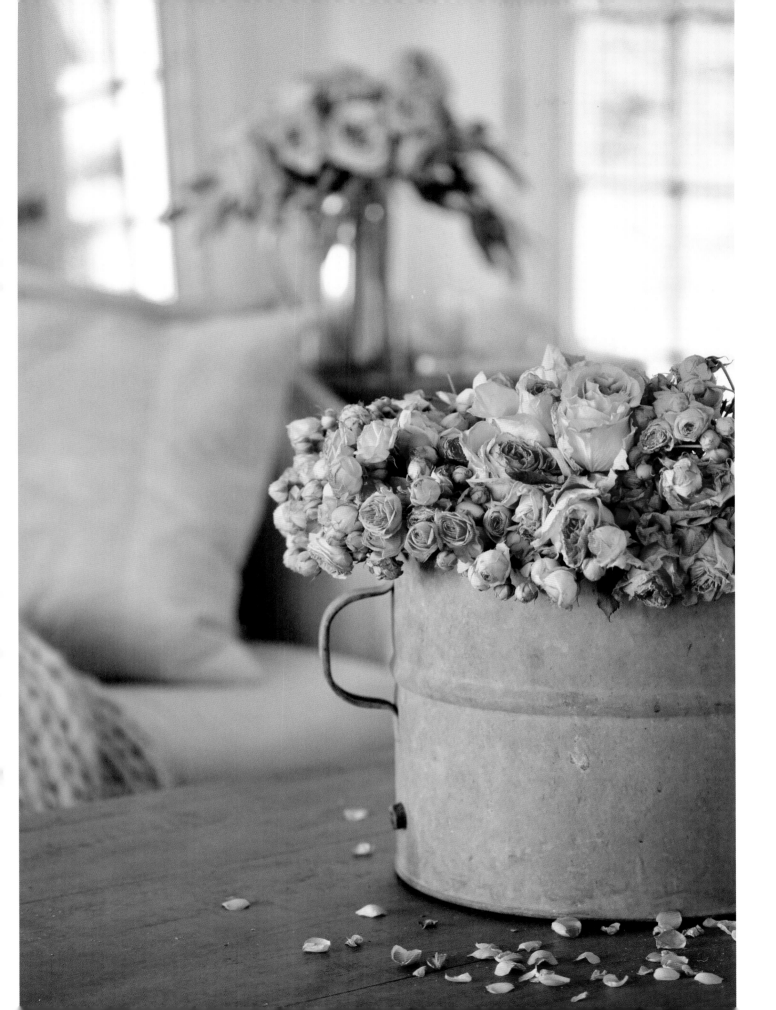

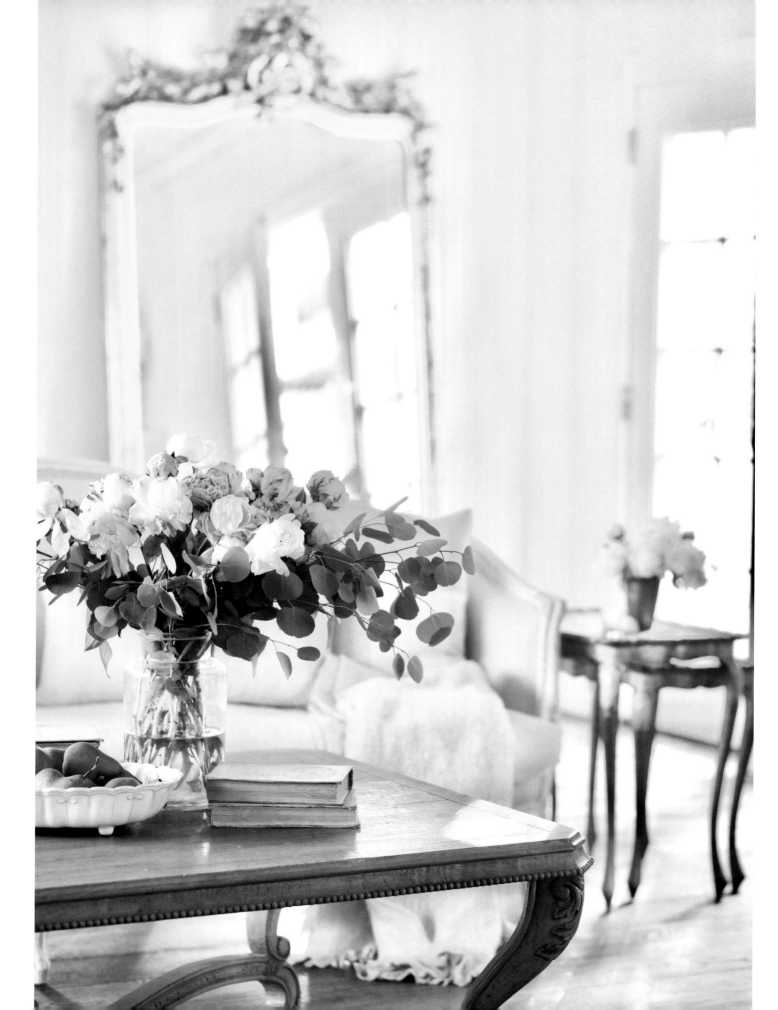

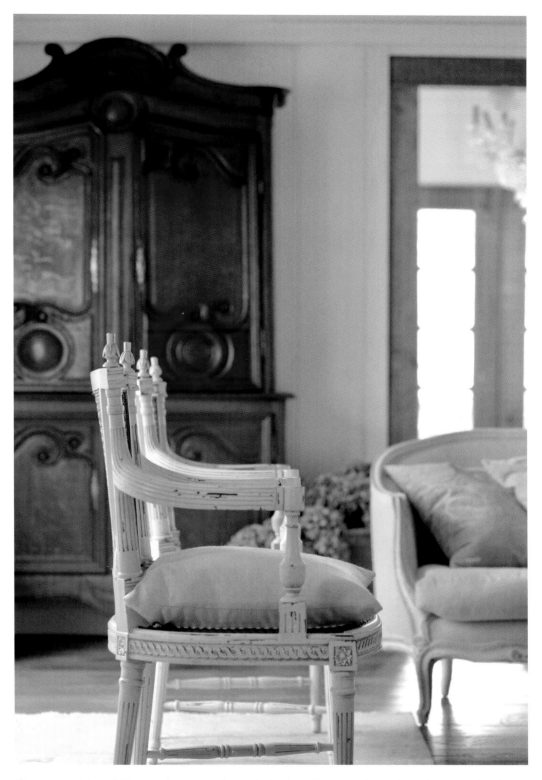

On one side of the entry area is a gilded antique mirror leaning against the wall. Intricate and ornate, this mirror is the epitome of what I love. Its elegant gilded frame and carvings juxtaposed with less-than-perfect glass is a most incredible pairing.

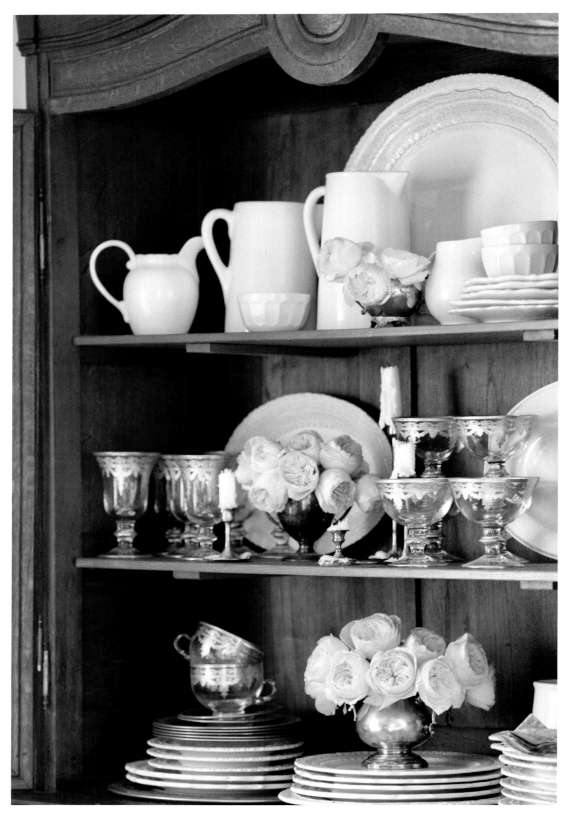

The piece that speaks most to my French country side in this room is this antique buffet deux corps. It is a tall and stately piece with the most beautiful hand-rubbed patina, and it serves as much needed storage for vintage china, stemware, and a collection of tureens. When I want a different view, I will reverse the doors and leave them open. They are merely set on old pins, which makes a change easy to do.

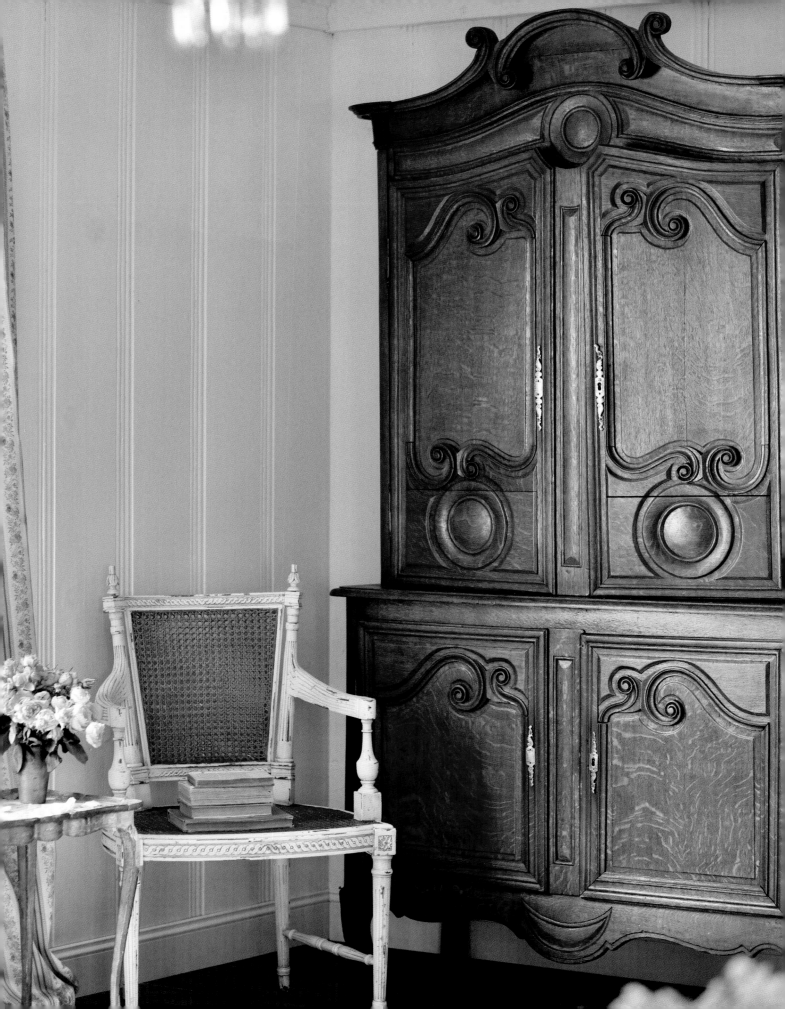

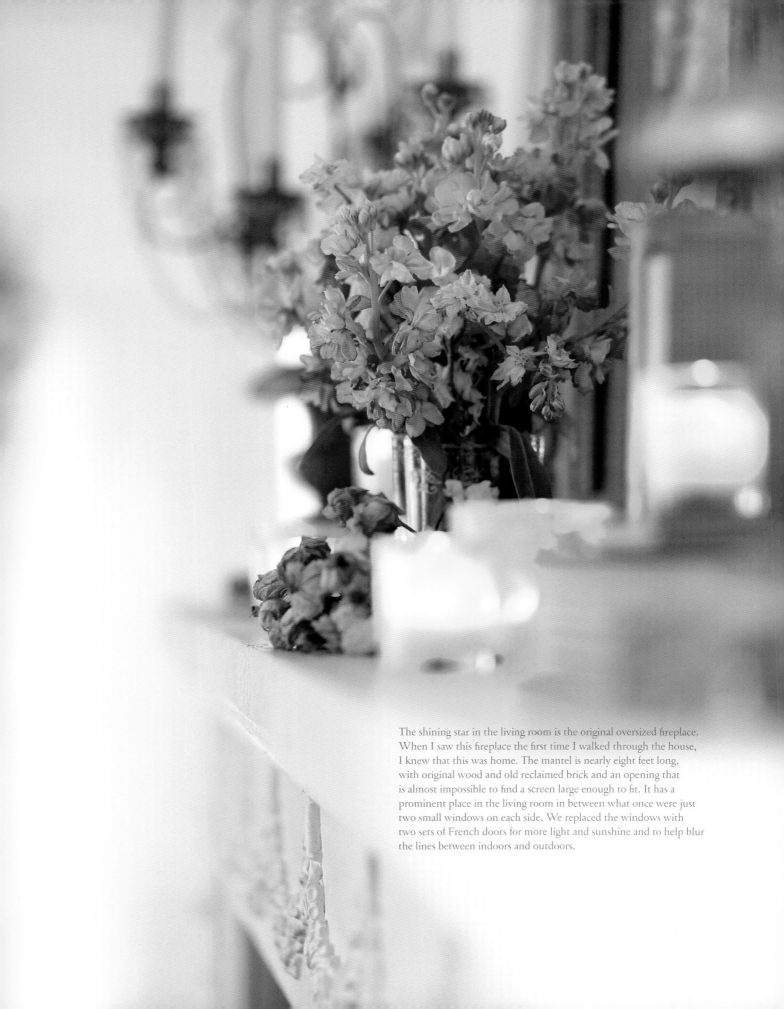

The shining star in the living room is the original oversized fireplace. When I saw this fireplace the first time I walked through the house, I knew that this was home. The mantel is nearly eight feet long, with original wood and old reclaimed brick and an opening that is almost impossible to find a screen large enough to fit. It has a prominent place in the living room in between what once were just two small windows on each side. We replaced the windows with two sets of French doors for more light and sunshine and to help blur the lines between indoors and outdoors.

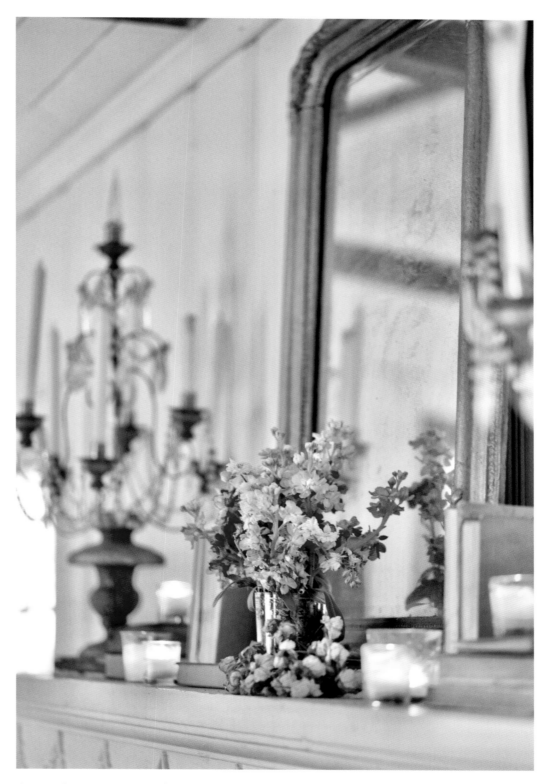

An antique mirror, old books, candles, and a small bouquet of ever-changing blooms dress the mantel.

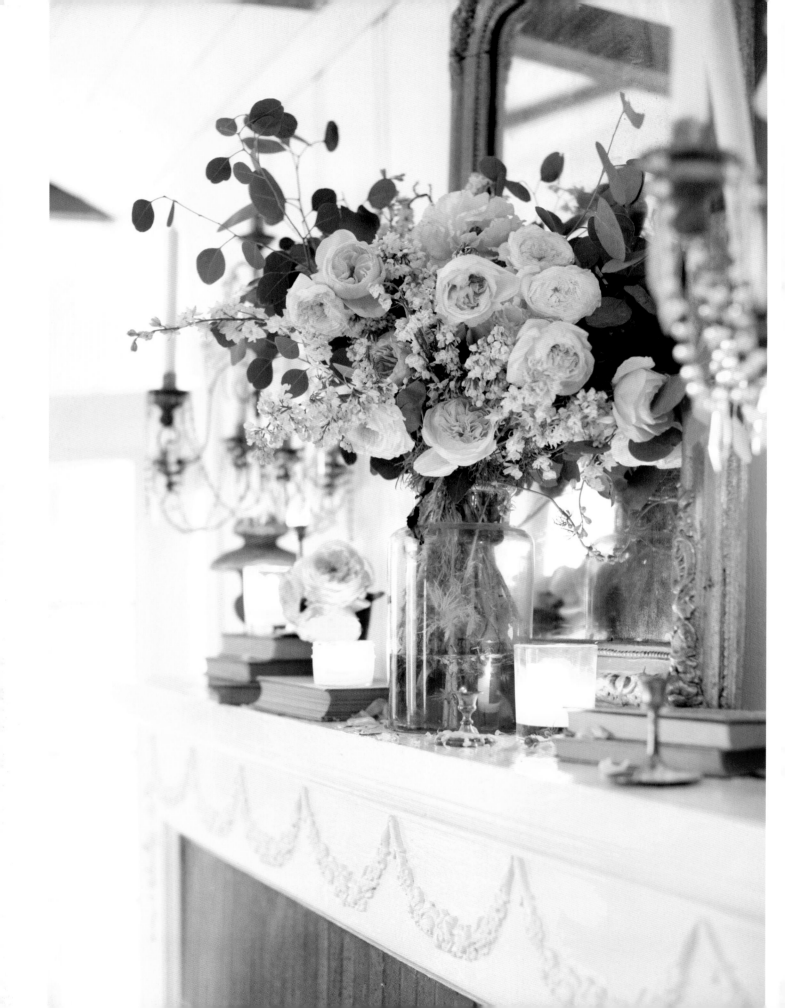

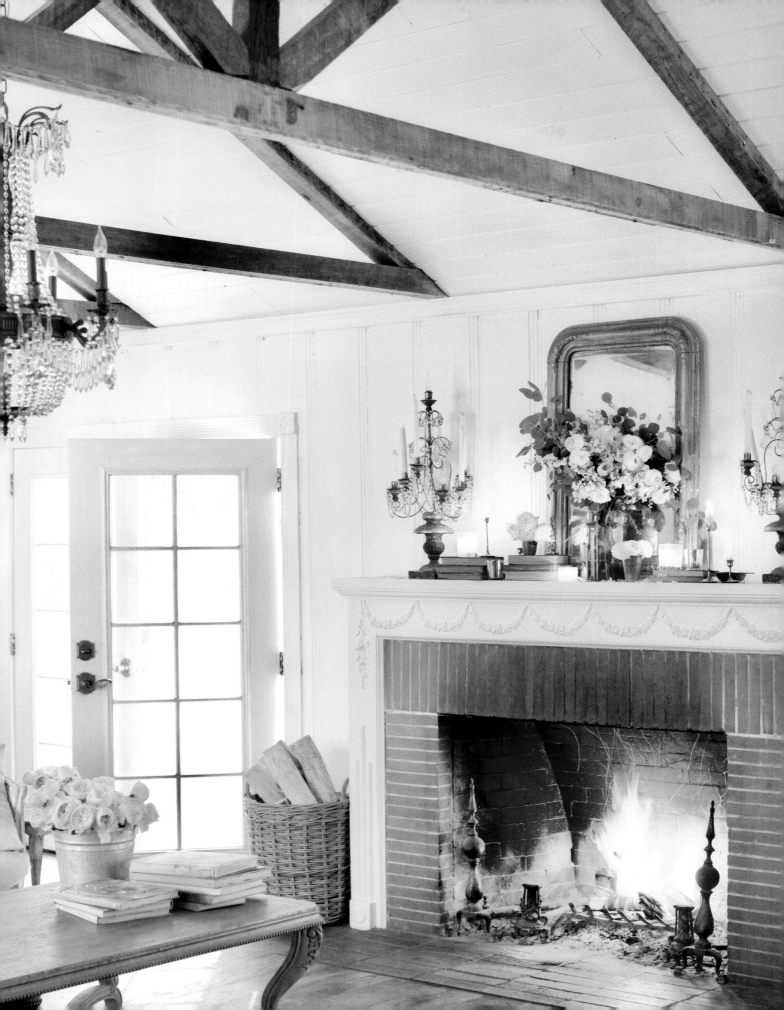

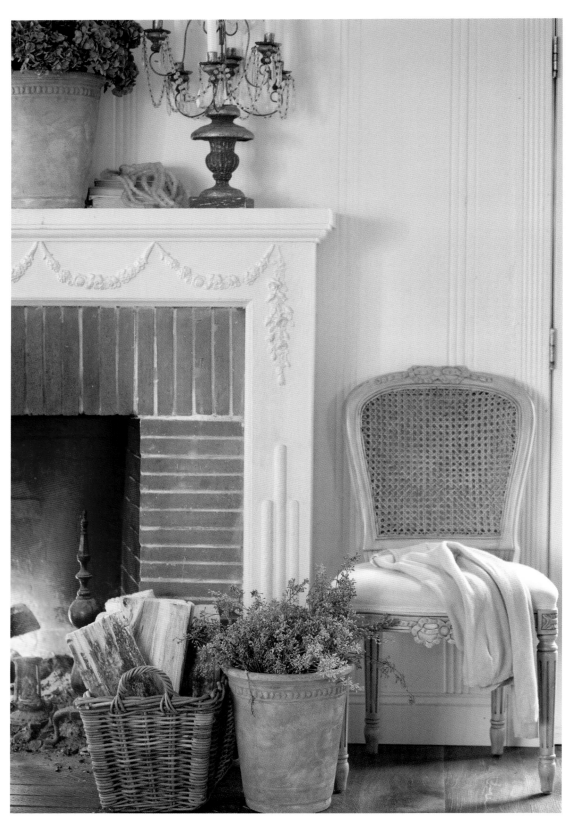

I have a love affair with chairs and have been known to bring home several if not a half dozen of the same ones when I have found them. They are known to travel from room to room, and I like to tuck them in here and there to complete a vignette, such as in the little spot by the fireplace, where a favorite caned-back chair fits perfectly. Candles and a warm glow from the fireplace create ambiance for a quiet evening in.

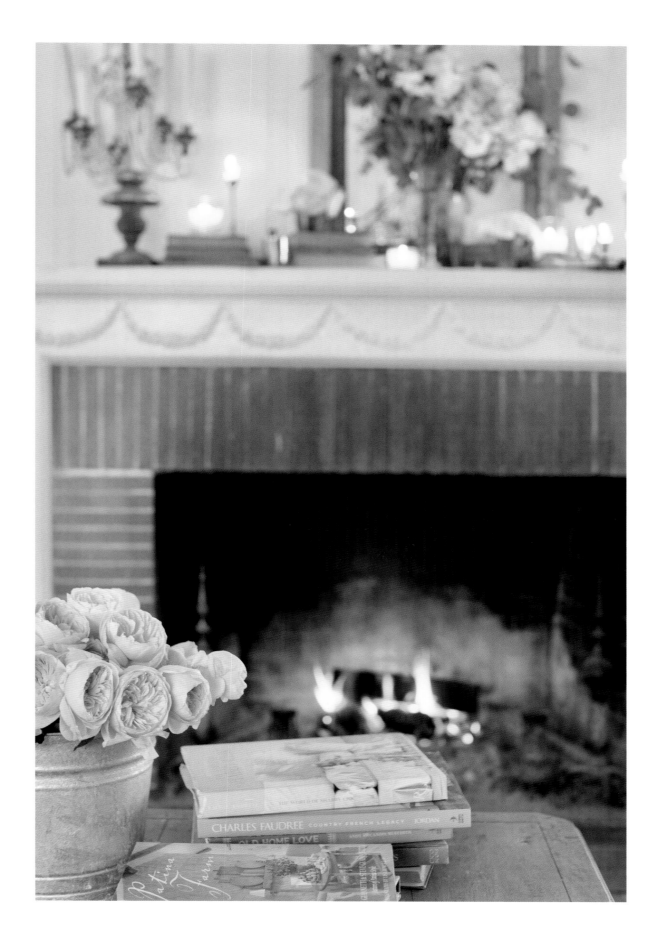

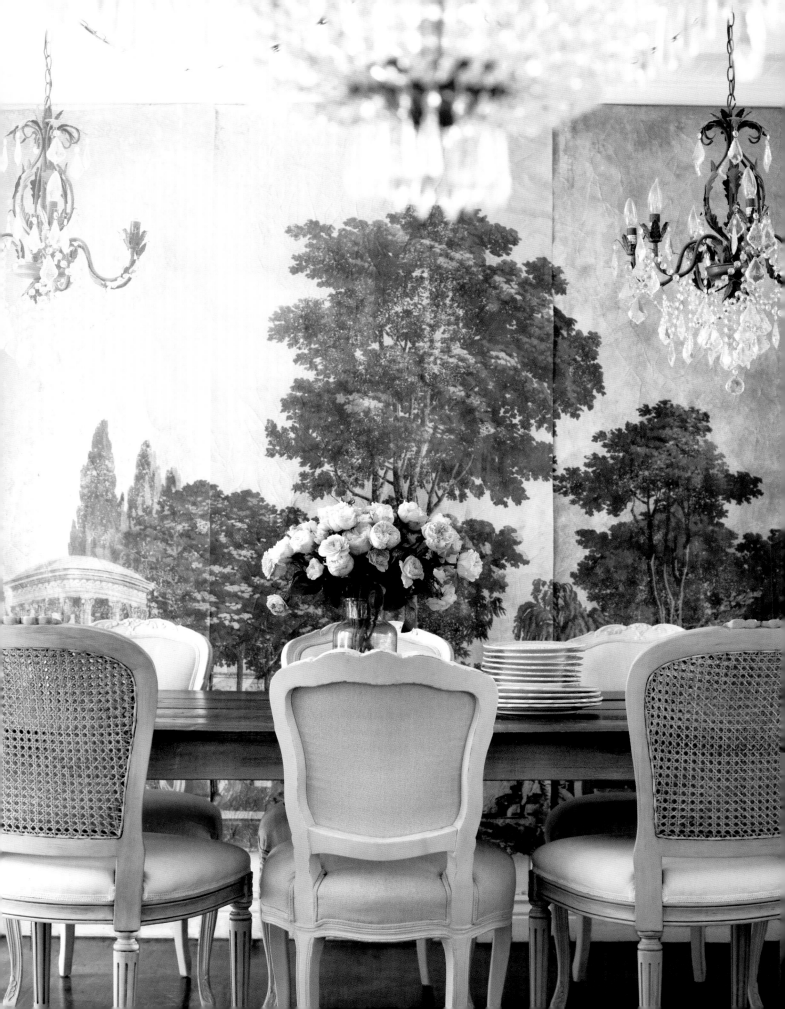

The Dining Room

At one end of the living room is a simple area that serves as a dining space. Since this home was designed as a vacation cottage, there were no formal living spaces with names like dining room, living room, or family room. That informality was something that bothered and frustrated me about the layout of the house for quite awhile, but it also challenged me to play with various pieces and arrangements in the room to see what worked. Originally there was just one single light bulb hanging from a wire in the ceiling in this large room, but with the addition of chandeliers at one end, a dining room of sorts was born.

The walls in the living room and dining area are the original grooved and detailed knotty-pine wood planks. I can remember the first time I stepped into this room, how dark and dreary and cold it felt. The walls were almost an orange-stained color and were so heavy in look and feeling, and combined with the small windows and lack of lighting, the room felt much like a small cabin in the woods rather than a cottage. Being someone who loves rooms filled with sunshine and light, I knew that while I loved the wood and the interesting details they added to the room, they would be coated with creamy white. Painting those wood walls was one of the first projects we tackled in each room of the house. The creamy white paint brought out so much of the detail and interest, and with their grooves, old knot holes, and character, they add an incredible amount of charm to each room.

I absolutely adore the charm that wallpaper patterns brings to a room or a closet. But when there is wood on the walls, you don't necessarily want to cover it up. When craving a different look, I will hang French scenic canvas panels right over the chalkboard for a more muted, elegant, and very French effect. I love how something as simple as a canvas print or layer of fabric or wallpaper can completely change the entire look of a space.

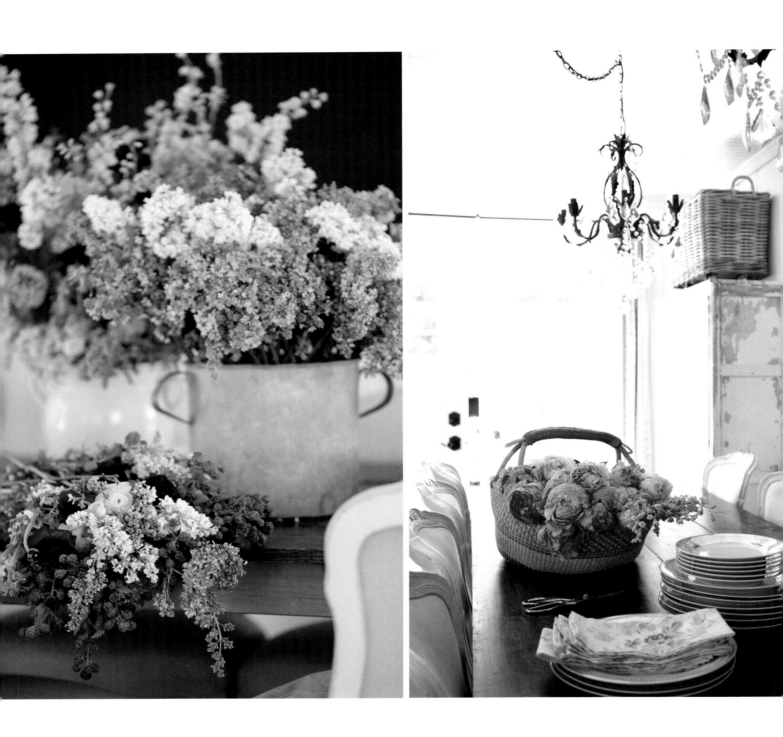

The oversized chalkboard on the dining room wall happened one weekend after a wild hair of inspiration. At a church tag sale, I saw an old schoolroom chalkboard that was in several pieces, and though I didn't bring it home, it sparked a vision for a chalkboard on the wall behind the dining table. My husband built the "chalkboard" out of plywood, which we secured to the wood walls, painted with chalkboard paint, and framed with older gold-painted wood trim. It has been on the wall for years and has served as a doodle spot, wine-tasting menu area, a birthday and graduation celebration message area, and many times just by itself as an interesting backdrop for the room. Baskets and buckets of flowers are always perfect for the dining room, to add a touch of romantic charm.

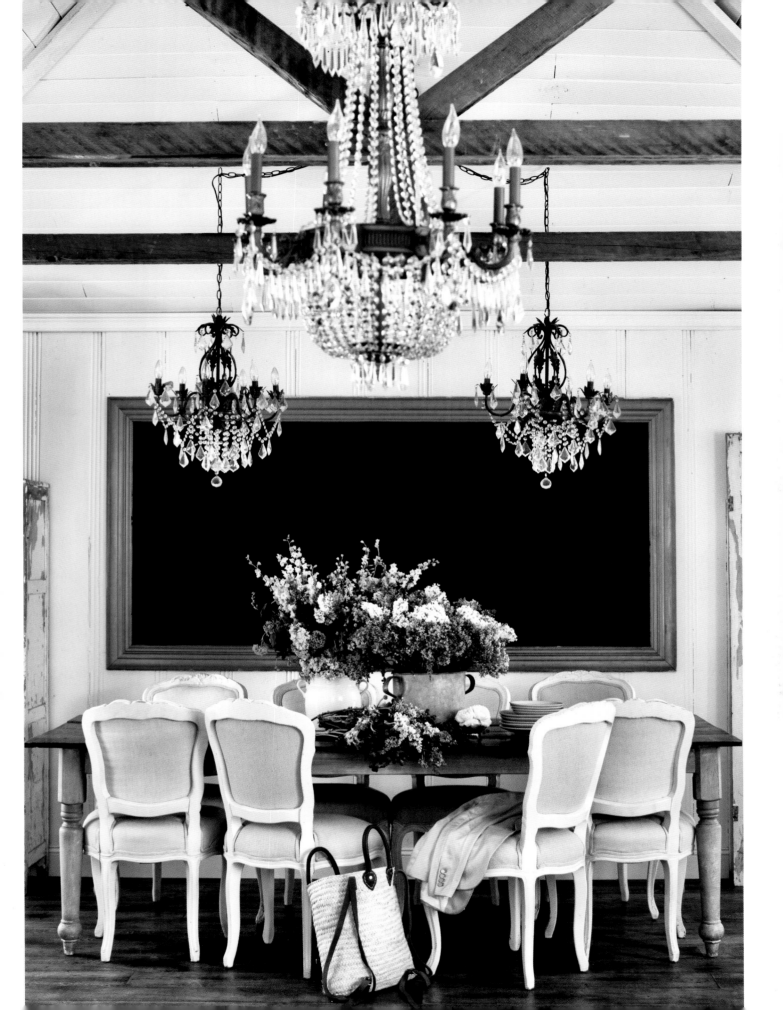

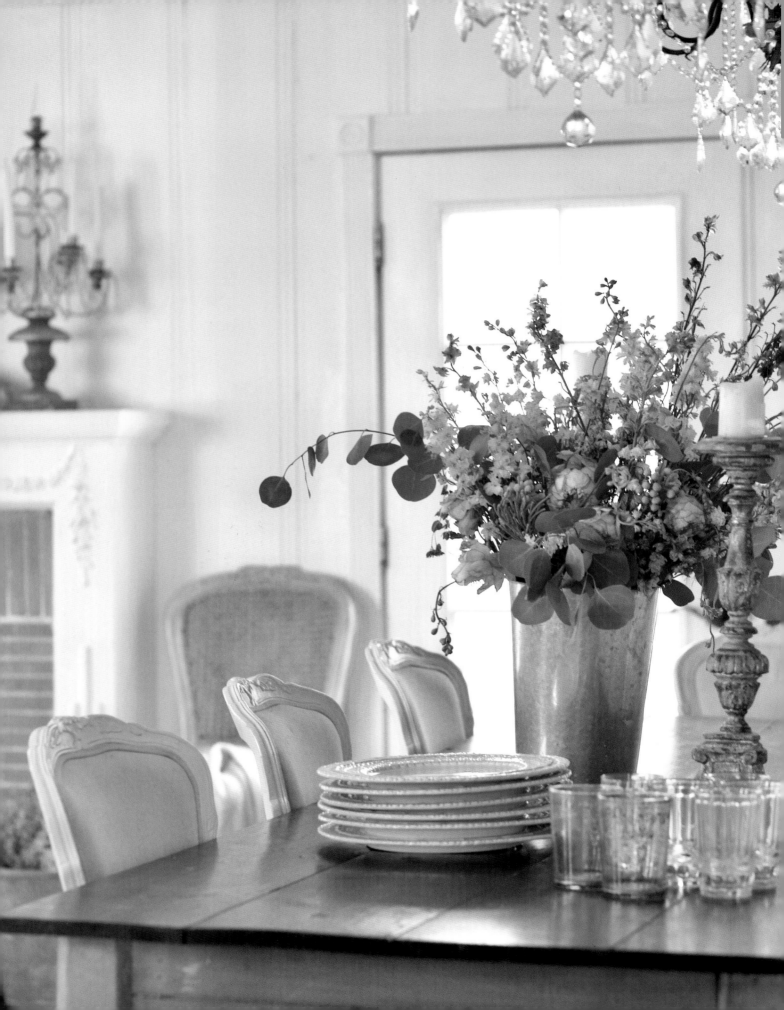

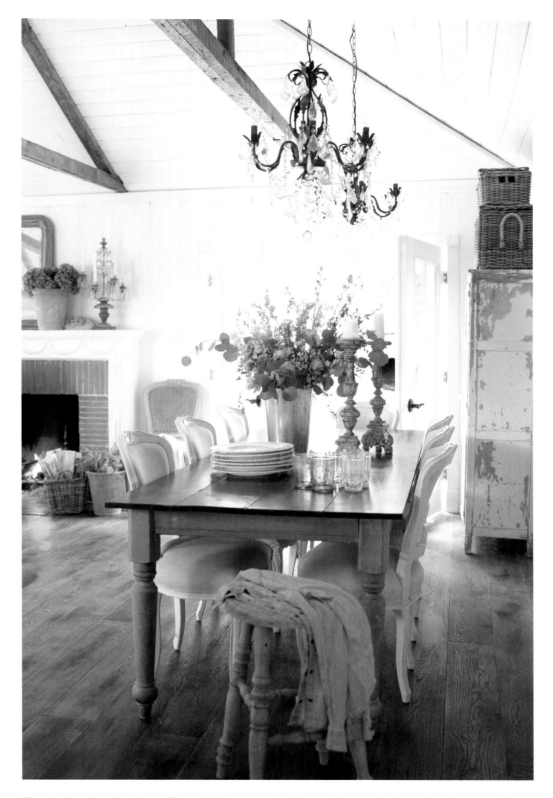

The nine-foot-long farmhouse dining table has a story involving two boys, a pile of wood, and a request. My boys loved working on projects on the house and were always there to lend a hand with pounding nails and renovations, and they were both avid wood workers in high school. I had mentioned that I was looking for a long farmhouse table to fit the dining room area, and so the boys took the smaller version of our table apart and reused the legs to build this longer farmhouse table. It is something that we use every day and that is one of those pieces that tells a story in the room.

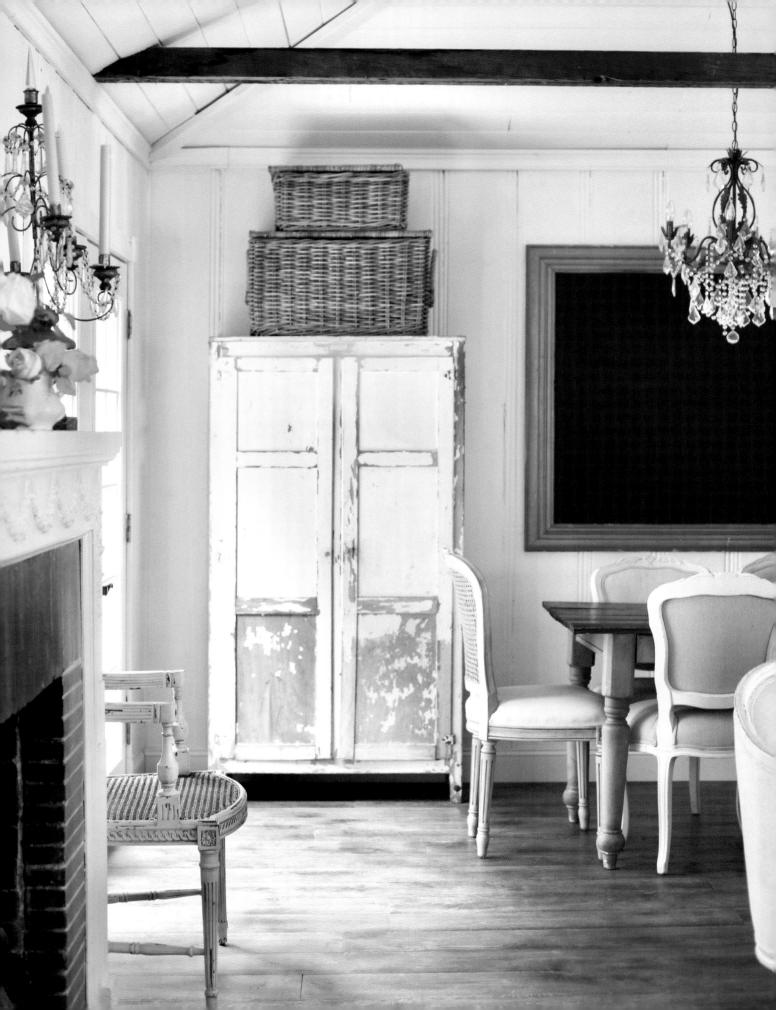

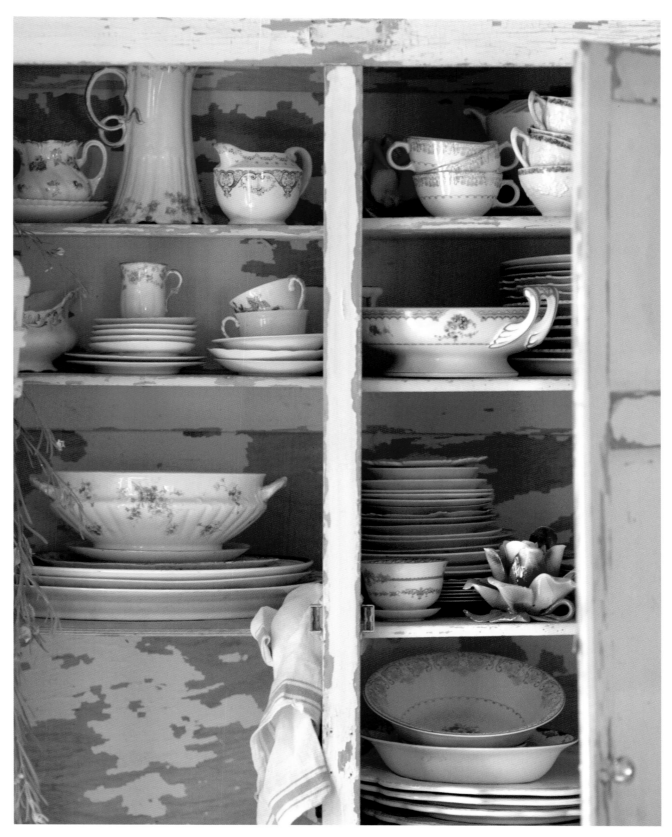

At the other end of the dining area, a more-chippy-than-not cupboard tucks nicely into the corner. The open doors reveal a sunny yellow interior with stacks of vintage china and table setting elements. When I discovered it, the cabinet was losing its painted layers, after having been stored outdoors, so I brought it home, flaked off what was not staying, and sealed the remaining paint to keep it intact. The result is a charming farmhouse look.

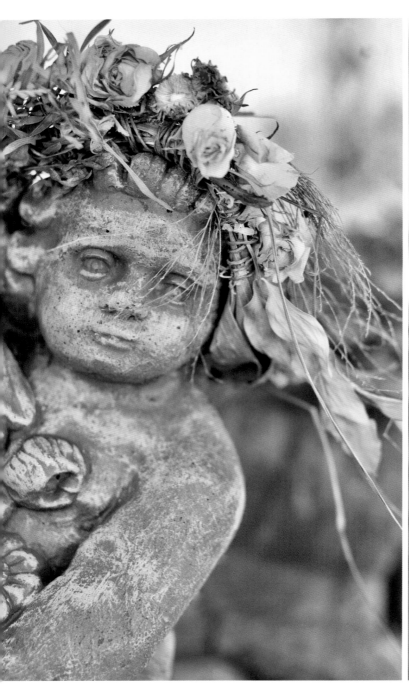

With worn paint and simple lines, this chunky buffet is a spot for a bit of whimsy. An old crumbly cherub statue, stacks of books, and favorite candlesticks create a simple vignette at one end of the dining area. I like to dry flowers and use them on the sideboard simply plopped in place. For a romantic addition to the statue, I made a flower crown by hot-gluing leaves and flower buds to a wire.

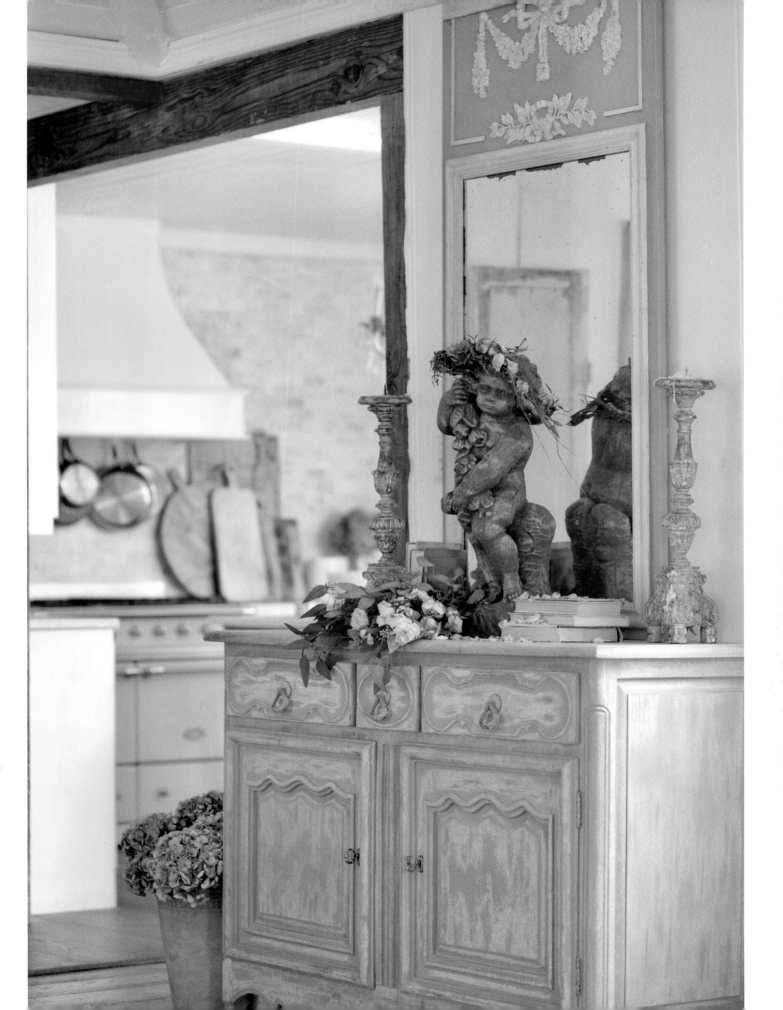

The Kitchen

When we first stepped into this house, the very first thing I fell in love with was the kitchen.

The original painted cupboards reached all the way up to the ceiling and spanned from one end of the kitchen to the other, creating quite a bit of vintage drama in an otherwise very basic space. They had been built right into the walls and were loaded with simple yet charming details. I fell for the subtle curves at the base of the cabinets and the centered sink with the shelf above that was a perfect spot for placing collections of pitchers or a bit of greenery during the holidays. Most of all, I loved that the cupboards were tall and original—even though their size, in comparison to today's appliances, has meant that they have proven to be a little more challenging to work around.

While much has changed in this room, much has stayed the same. Over the years, we have shifted the floor plan from a galley kitchen in order to create a hallway and expand the bathroom. We removed some newer cupboards that were added at one point and reconfigured the work space and changed the layout to fit better. But that original bank of tall, painted cupboards has remained. Even though their soft pine boards are not perfectly smooth, those imperfectly perfect cupboards were one of the first things that made me realize how much I crave pieces that are original—the ones that are wearing years of age and patina—much more than shiny and brand new.

With drawers that like to fall when I open them too far, tall shelves I have to climb on a stool to reach, and a *quintessential* cottage-style charm, the kitchen reminds me daily that not everything needs to be *perfect* for it to be absolute *perfection*.

A wall of pine shelves opposite the original kitchen creates an open-cupboard pantry area. With plenty of space for displaying collected ironstone, gilded glasses, cookbooks, and spices, it also creates a place for utilitarian pieces such as a coffee maker and copper mixer, since the original cupboards were too low to accommodate their height on the counters.

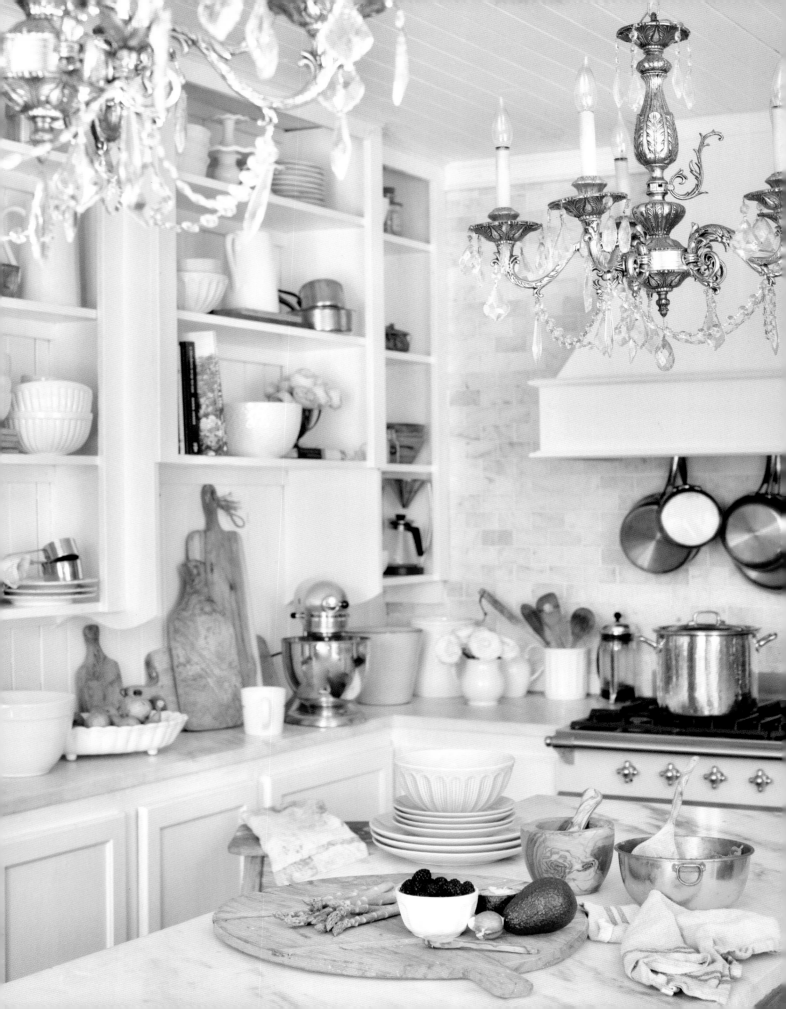

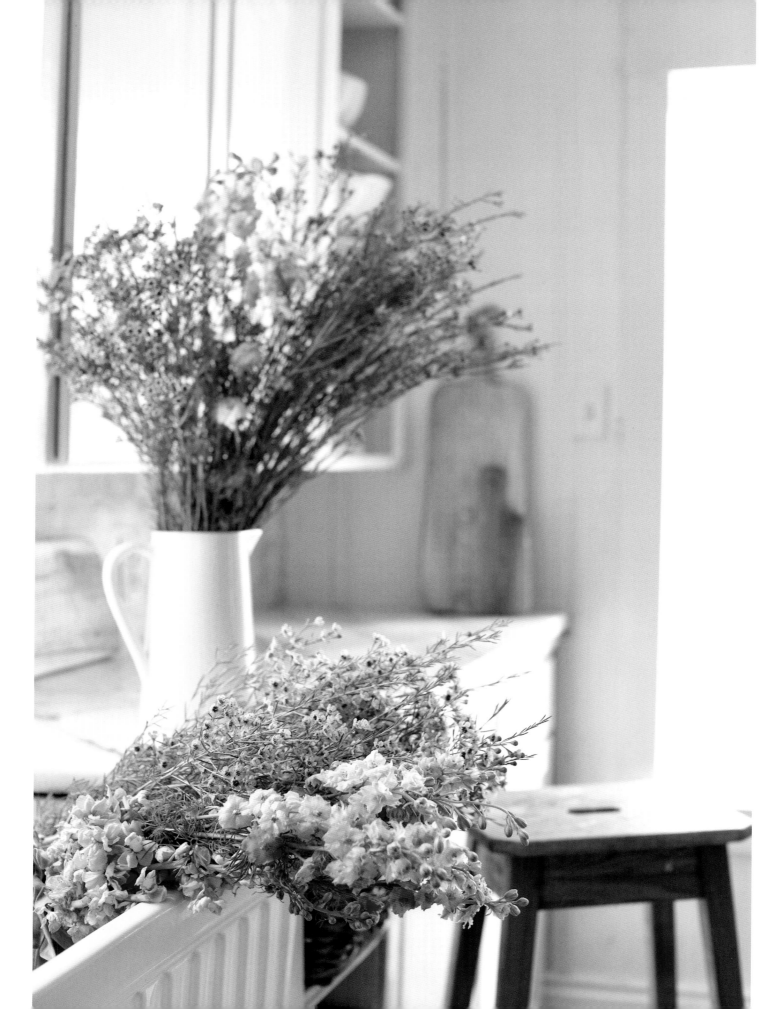

The open upper shelves in the original cupboard areas are the result of a broken door we noticed when we first moved in. When I pulled the door off the hinges to tinker with it, I paused and took note of the tall open shelves that the now bare area instantly created. Since these cupboards were built right into place, as the house was, the back of the cupboards is merely the knotty pine on the walls, which meant they were perfect for a new look. I removed the matching door at the other end of the kitchen for symmetry and finished the now-exposed interiors with a coat of white paint. These small areas are ideal for stacking our everyday white plates and bowls.

The deep farmhouse sink has a large single basin that is perfect for soaking flowers and washing extra-large dishes. Next to the sink on one side, three damaged drawers were removed and replaced with simple shelves for several baskets, to bring a soft, rustic texture to the white-painted expanse. The original grooved knotty-pine planks on the walls are coated in a barely different shade of white to complement the crisp white cupboards.

A narrow, nine-foot-long reproduction French drapery table was converted for the kitchen island. I fell in love with the table's detail and patina and envisioned a rustic French table used as an island. I had a chunky slab of marble cut for the top to create the work space. This slab, which was a large piece left over from our kitchen renovation, was not in perfect condition. It had a spot that was chipped and also a couple of old cuts and dings, but I knew that even with less-than-perfect lines, it was the piece that would add that vintage feeling I was looking for.

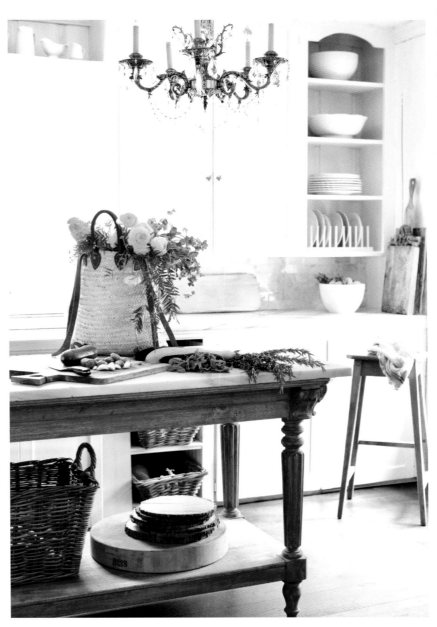

One of the things that I have learned while renovating this house is that where I once wanted only perfection in each element and each change, I noticed that the bits that spoke the loudest to me were the ones that were not polished and pretty or new. The marble-topped island is a perfect example. It is akin to a reclaimed piece of wood and it brings old character to a new piece.

The chandeliers above the island are vintage, nearly identical, and were found several years apart at two separate secondhand stores. They add light to work by as well as a touch of elegance.

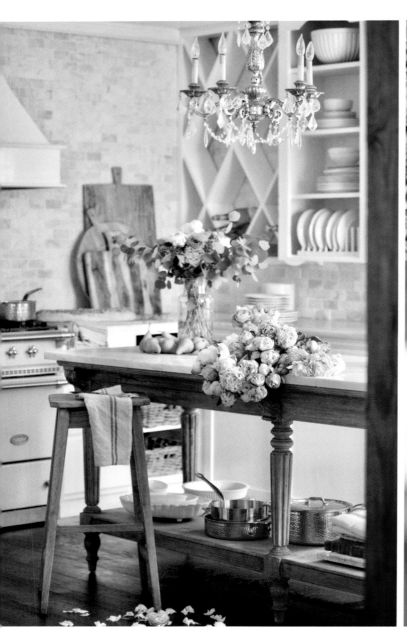

Perhaps the most noticeable part of the kitchen is my pale, duck-egg blue Lacanche range. She is a classy, elegant lady who doesn't shout to be noticed but is definitely the center of attention. Her polished brass knobs contrasting with the muted color makes my heart sing. The pale blue leans to gray and even almost white sometimes, as the light changes throughout the day.

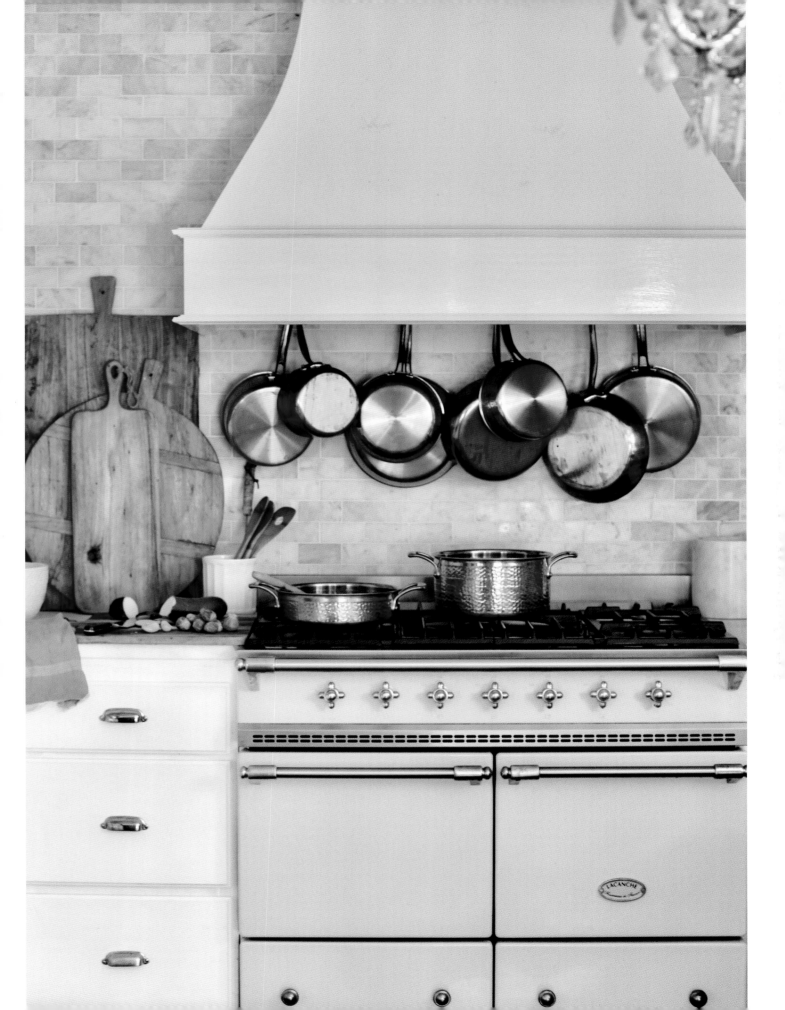

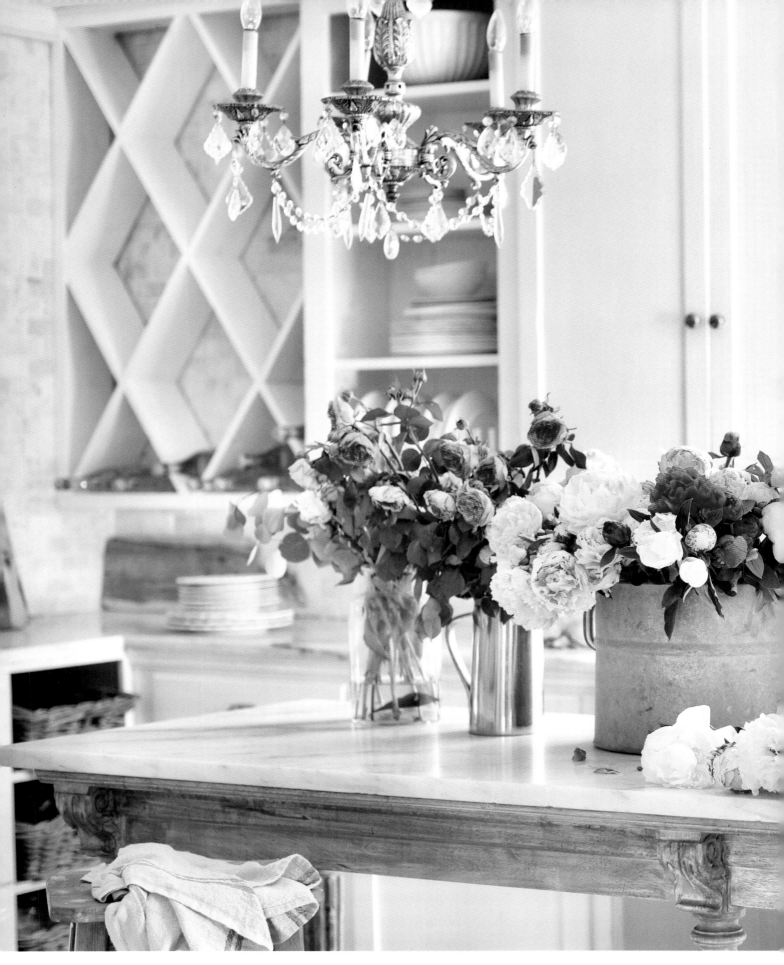

The island does much more than look pretty, of course. It also creates a work station for preparing food and on occasion resembles a flower market work table for clipping and arranging buckets of flowers. Above the island, the kitchen is lit by double chandeliers illuminating the room while adding vintage elegance. These are the original vintage $20 secondhand finds that first gave me the confidence to take this cottage and make it more my style.

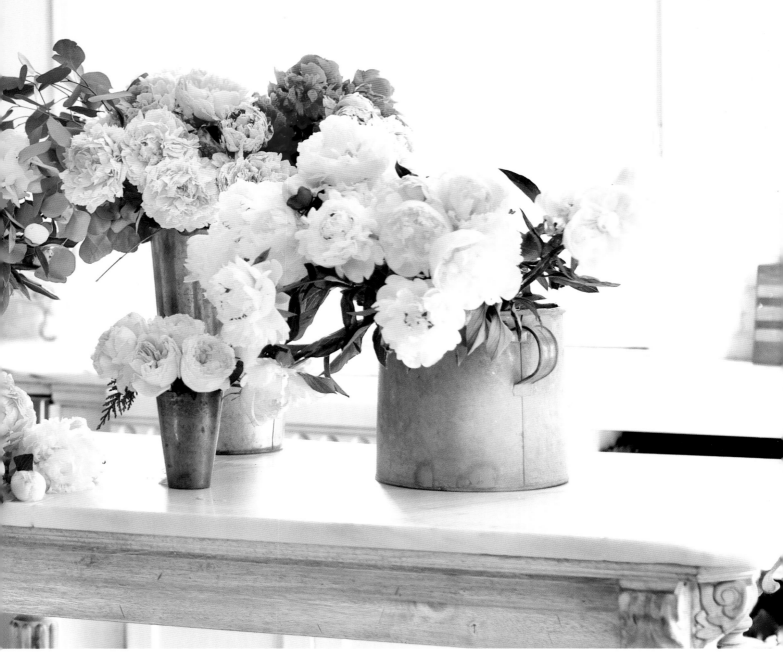

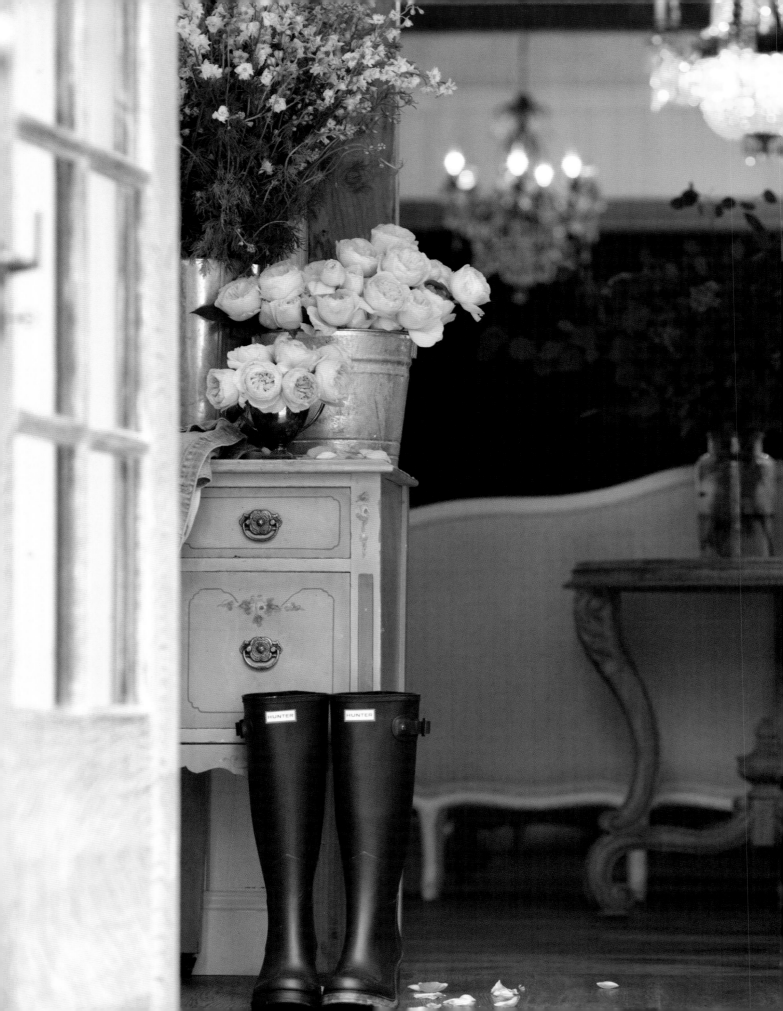

The Entry & In-Betweens

The in-betweens are hallways, landing spaces, or little rooms you walk through to get from one spot to the next. Though they are just in-between spaces, I don't feel that they should be overlooked. They are areas where family portraits or a collection of paintings and old mirrors can be enjoyed.

Just a simple, small in-between room that separates the outdoors from the living room, the entry looks much like a sunroom, with antique French doors and windows on each wall to let in the sunshine. It is a convenient place for taking off boots and bringing buckets in from the garden, and the entryway creates a bit of a pause in-between the outdoors and the living room. Our entry isn't grand in scale or details but creates a charming landing spot and welcomes you in. With reclaimed wood framing the opening, this room leads to the living room, where a round table holds flowers and books and the decor is always changing.

A vintage 1930s floral-painted desk serves as a spot for catching fresh flowers and gardening bits. I love the burst of sunshine it brings to this room.

Those long corridors and passageways that lead from one room to another are a *purposeful* element in a home. They also offer extra space to style and bring *delight* on the way.

A simple pause between the outdoors and the indoors, where boots and buckets of flowers often land. Sconces and an elegant chandelier add a bit of loveliness, and the windows allow an abundance of light to stream in.

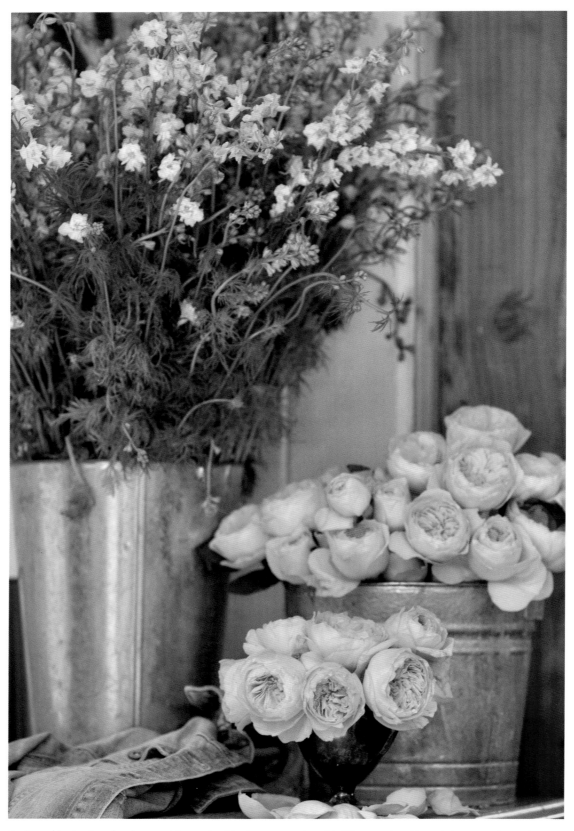

Buckets of fresh-clipped and seasonal flowers land in the entry on the table. The entry is a this-and-that spot where what greets you when you walk in is always changing. Just inside the open doorway, a round table with carvings and curvy details holds books, a bouquet, and other objects behind the sofa in the living room.

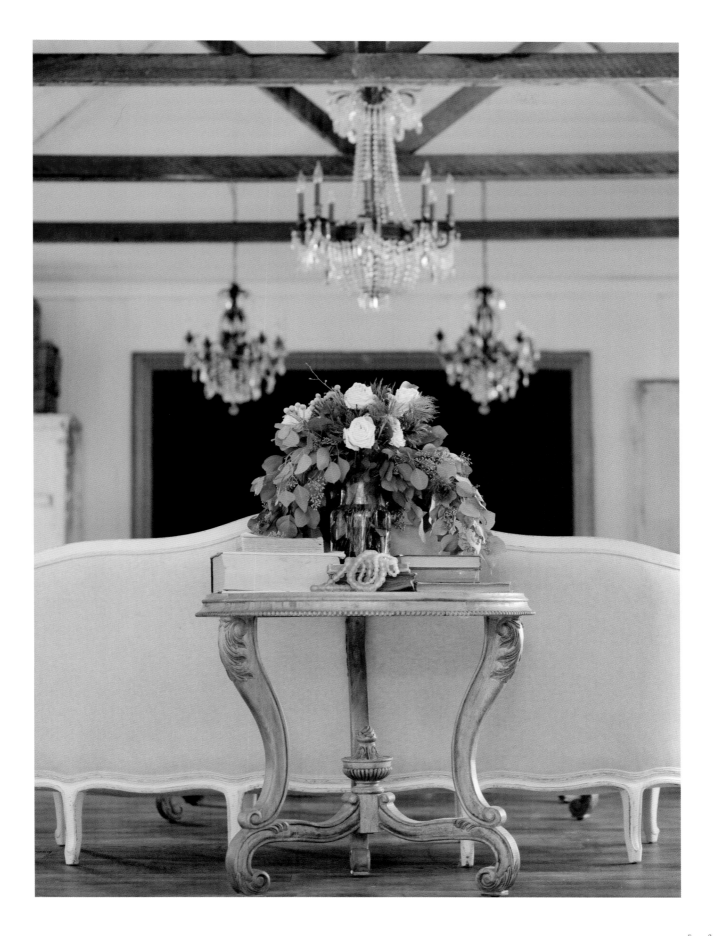

This hallway was one of the spaces we reimagined; it was once part of a "laundry" room that, in fact, had no laundry hookups. It became something different as it was renovated, and now the long, narrow hallway shuffles us from the common living areas to the back of the house and a landing spot before reaching the bedrooms.

Wanting a more formal look for the long wall, I broke up the expanse of vertical knotty-pine walls using a simple base wainscoting. Armed with a few panels of door skims, molding, and a nail gun, I added the three-foot-tall sections of blank board to the hallways and then created simple boxes on top for subtle interest—a higher-end classic touch that may seem out of place in a cottage but that I feel fits in nonetheless.

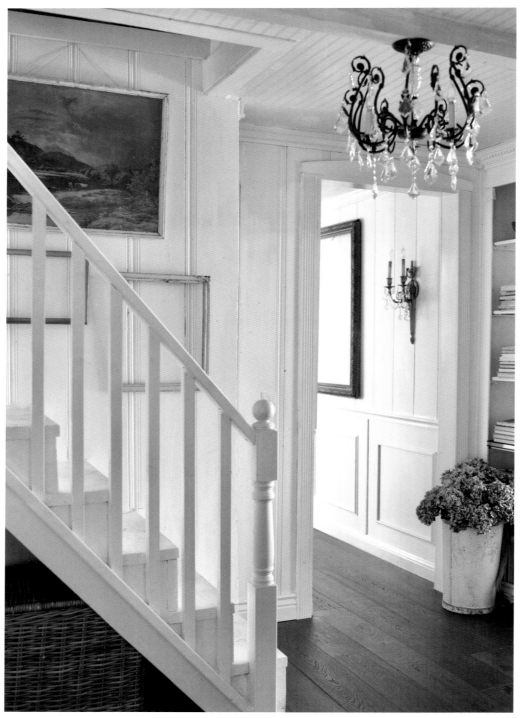

A reproduction Mora clock with a subtle blue-gray finish is nestled into one of the quirky spots where a corner backs up to a closet. Down the hall, a room in between the more formal areas and the bedrooms has stairs leading up to the attic, built-in bookshelves, and a storybook-type antique armoire. The laundry is tucked into a corner here, and just beyond are office, kids' bedrooms, bath, and the back of the house.

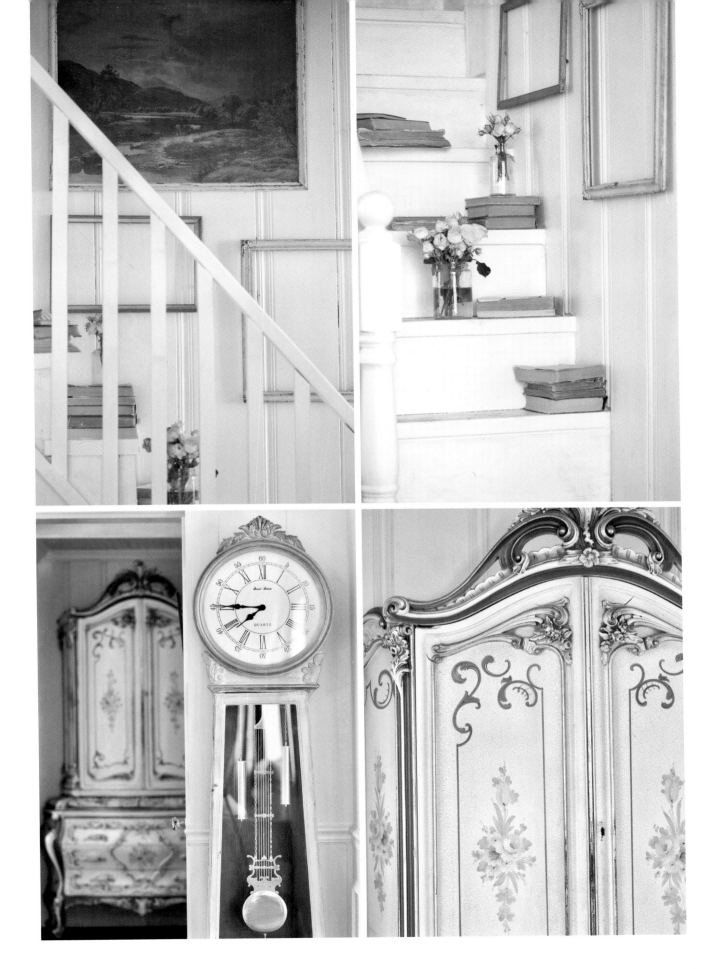

My Office

We have played musical rooms many times while living in this house. While renovating one room, we would set up a bedroom in another and then do a shuffle as each room was finished and we were ready to tackle another space. This small room at the very back of the house was once my daughter's room, and then for a short time, my older son's room. When he moved out, it became my office.

My office has original corner windows to let in an abundance of light, a simple French-style desk, and my grandmother's china cabinet filled with bits of inspiration. It is where I get to cater to my softer side color-wise more than in the shared rooms. Here swatches of fabrics, handwritten notes, snapshots, and bits of nature collected on walks find a spot to be and to inspire. The nearly seventy-year-old original hardwood floor has old paint splatters and dings and scratches, and I have come to love the very artsy ambiance it adds to this space. The no-holds-barred feeling of being able to create in this room without fear of damaging anything has made it a favorite.

My office is much more than a place to sit down and get a bit of work done at the computer. It is an *inspiration* spot. A *collection* spot. A place where this and that find a home until they find a home.

When this was my daughter's room, I wallpapered the ceiling with an embossed paper that reminded me of old tin panels. I also installed a dainty old cast-iron fireplace surround for a little bit of whimsy. I love to place mantels in a room even if they are just for decoration. They add an important architectural element and provide a focal point. The blush color on the walls got a fresh coat of white for a while and is now a barely blushing color again. It reminds me of the childhood bedroom that I loved creating for my daughter.

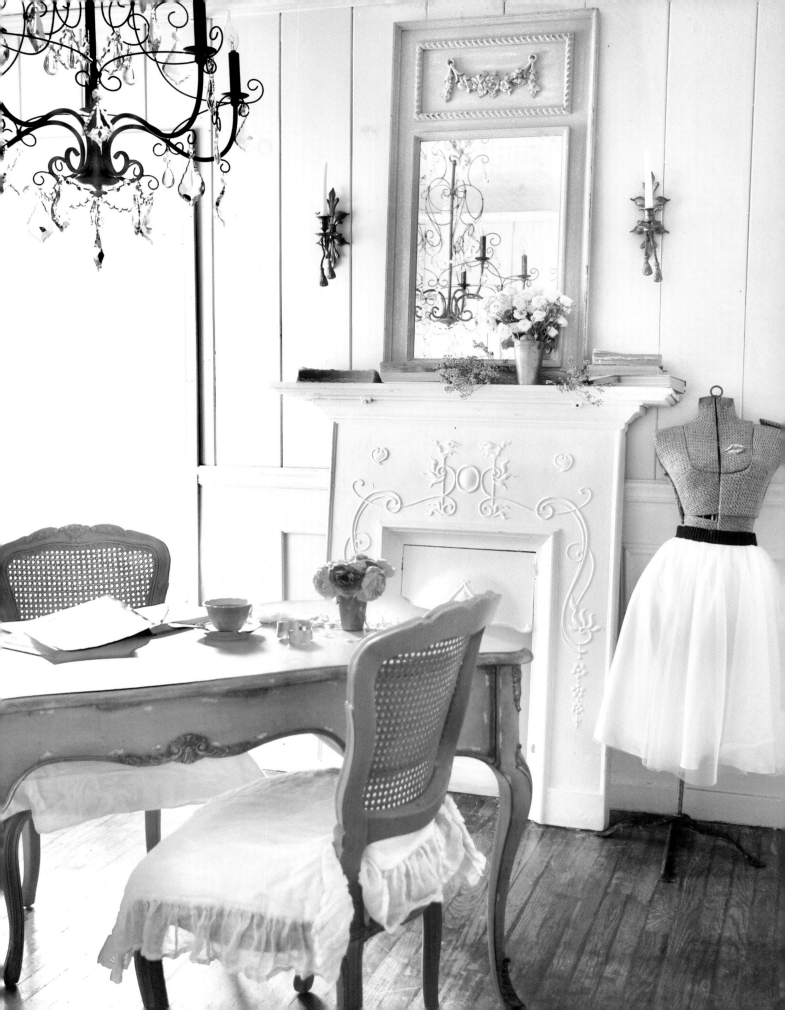

A vintage mannequin discovered in an old shed waits to be draped in the latest piece of inspiration fabric and ribbons, while a bit of simple string and favorite photographs decorate the wall while providing inspiration and smiles. Portraits of family and favorite snaps and memories on display are easy to change with just a clothespin and an idea.

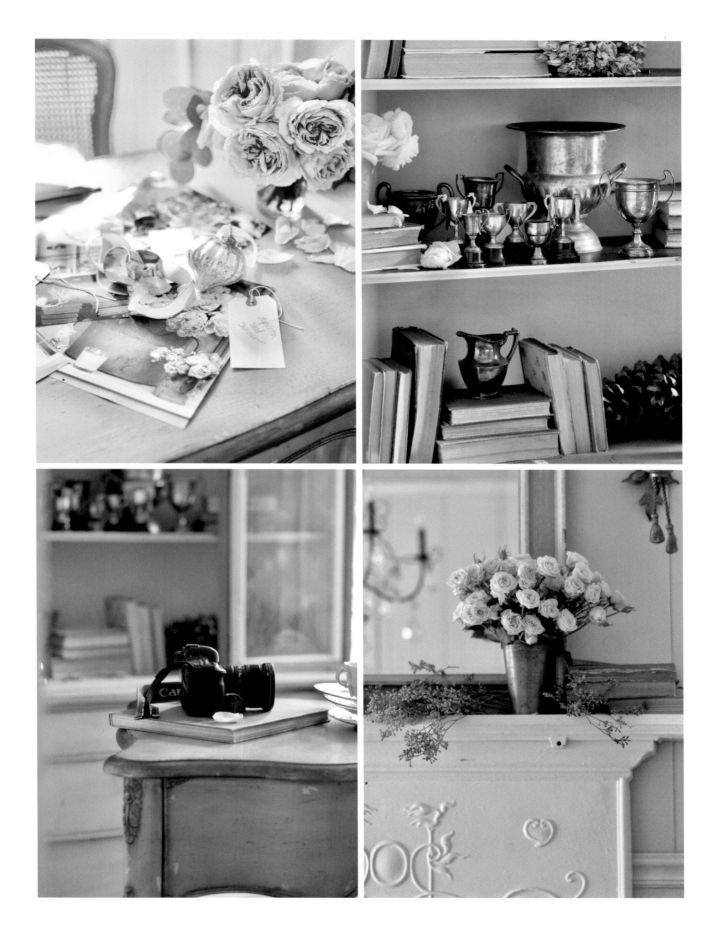

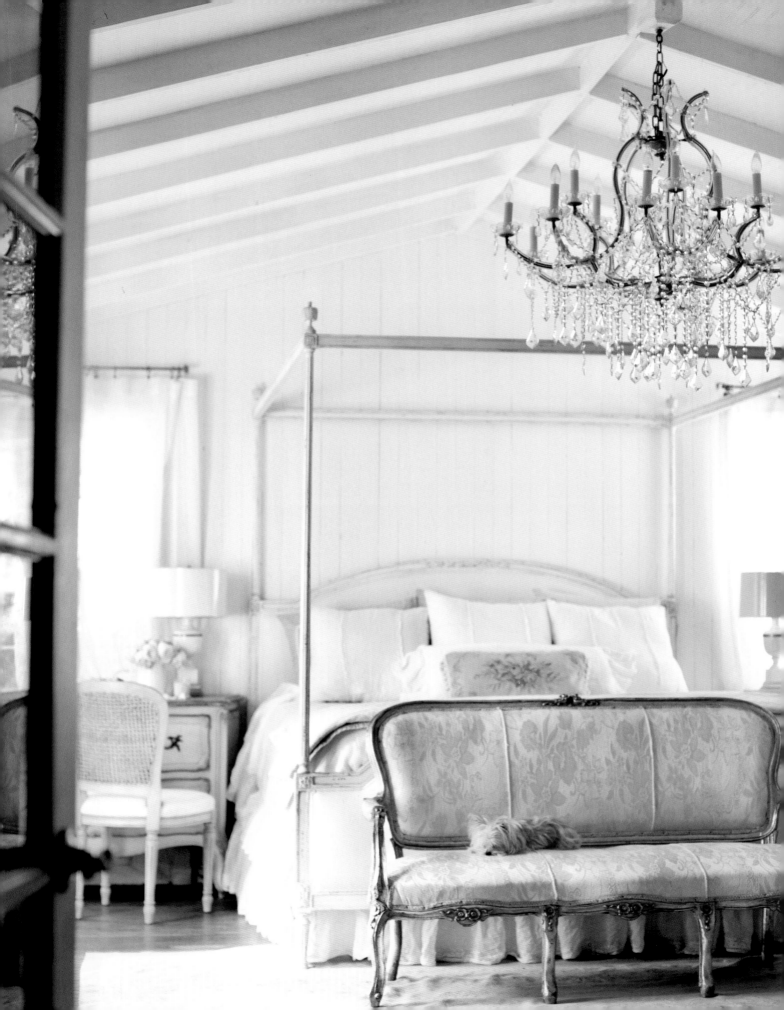

Our Bedroom

Layers of soft linens in whites and neutrals, gilded and painted antiques, and an admittedly over-the-top chandelier give our bedroom a romantic French Country Cottage atmosphere.

We built our bedroom as an addition to the original cottage about ten years ago. Adding on to a vintage home while keeping the original look has challenges, so we focused on a few of the original and easy to re-create elements to blend it seamlessly: corner windows, wood plank walls, and matte hardwood flooring.

Over the years, my style has shifted toward what is more serene and restful for the eye. Where I once loved layer upon layer of patterns and colors in a room, I now crave the peaceful, elegant feeling that comes from tone-on-tone neutrals. As such, the bedroom has changed to reflect a lighter feeling.

I fell in love with the simple lines of this reproduction Swedish country-style bed the first time I saw it. While the chippy paint and oyster-colored linen fabric set a neutral tone, the canopy frame indulges the side of me that loves elegance and reminds me of my first canopy bed at age five. I leave the frame uncovered—simply enjoying the dainty lines, beautiful carvings, and wood—which also makes the bed feel lighter and more grown-up.

The bedroom design started off very much French Country. I craved color and pattern at that time, and we started with yellow paint on the walls whose eventual shade was the result of no less than five remixes to dull the glaring neon tone that kept coming through. That buttery yellow became a perfect backdrop for one of my signature pieces: a bold red-and-white buffalo-check secondhand sofa that I reupholstered. That sofa has been moved from the foot of the bed, where it felt a bit too large for the dainty lines of the bed, near to the bedroom fireplace, and though it is probably the boldest color in the room, it is a favorite piece even now.

With corner windows and French doors, our bedroom is filled with warm sunshine and light. The canopy bed speaks to my childhood bedroom, and the crystal chandelier adds romance and drama without overwhelming. A vintage settee with chippy gold paint and covered in blush fabric is one of Sweet Pea's favorite napping spots.

Our bedroom is not just a place where we start our day and retreat to in the evening. It is a quiet *sanctuary* from the busyness of the house.

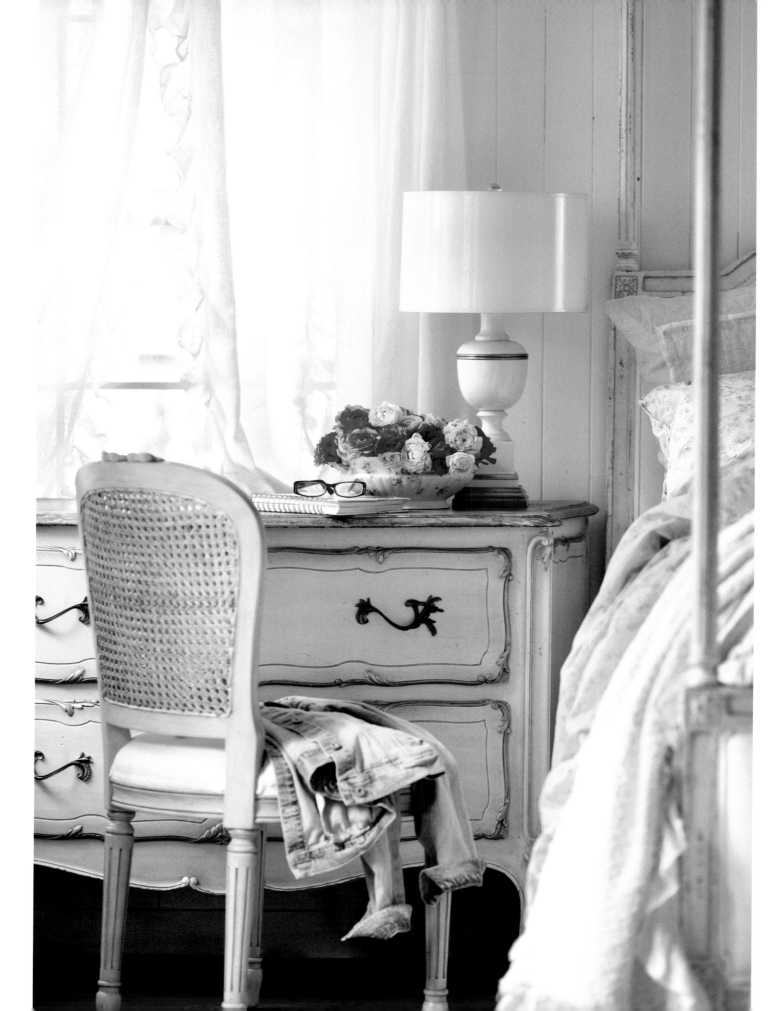

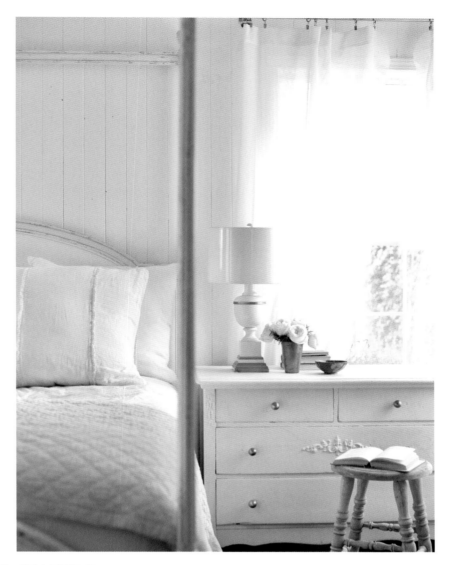

NIGHTSTAND FEATURE:

The nightstands in the bedroom are a good example of mix and mingle without a match. They are not the same style, era, or finish. One is more elegant and detailed with gilding, and the other more simple with details covered by a coat of paint. Even in their different looks and styles, they balance each other and work well together—much like a marriage.

Hers—A 1930s French commode serves as my nightstand. This was a happy accidental find. I had contacted a seller on Craigslist about the buffet deux corps in the living room and set up a time to take a look at it. When my husband and I arrived, she opened a garage door to reveal the inside chock-full of chairs, dressers, mirrors, and more, all French- and European-style antiques. When I spotted this French commode with faux-marble top, pale yellow paint, and gilded details, I knew it was perfect and we loaded it up, along with quite a few other pieces. Various flowers,

stacks of decorating books, and this and that seem to land here often.

His—My husband's nightstand is a simple antique chest of drawers. It has a muted color and subtle carvings, and this chest provides a large amount of storage for his various treasures. In contrast to my side of the bed, this chest is compact, with clean lines and, on the top, just a lamp, a stack of old but interesting books, and a clay dish the kids made for all his papers and pocket bits. I was lucky to find a man who couldn't care less about the style and girly aspects of the house.

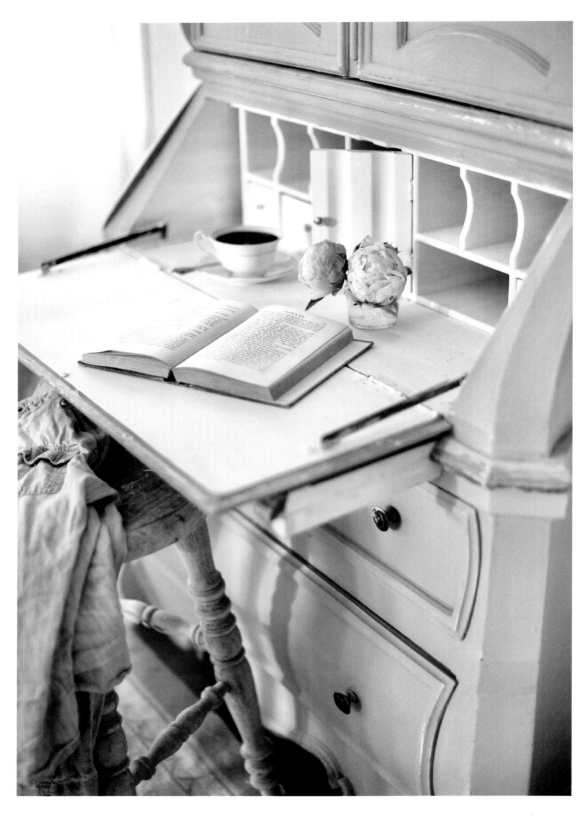

A Swedish-style drop-front desk with a warm blush interior creates a spot for sitting and jotting down notes. Everyday technology, which I don't like to see on display, is tucked away in the top and neatly hidden from view.

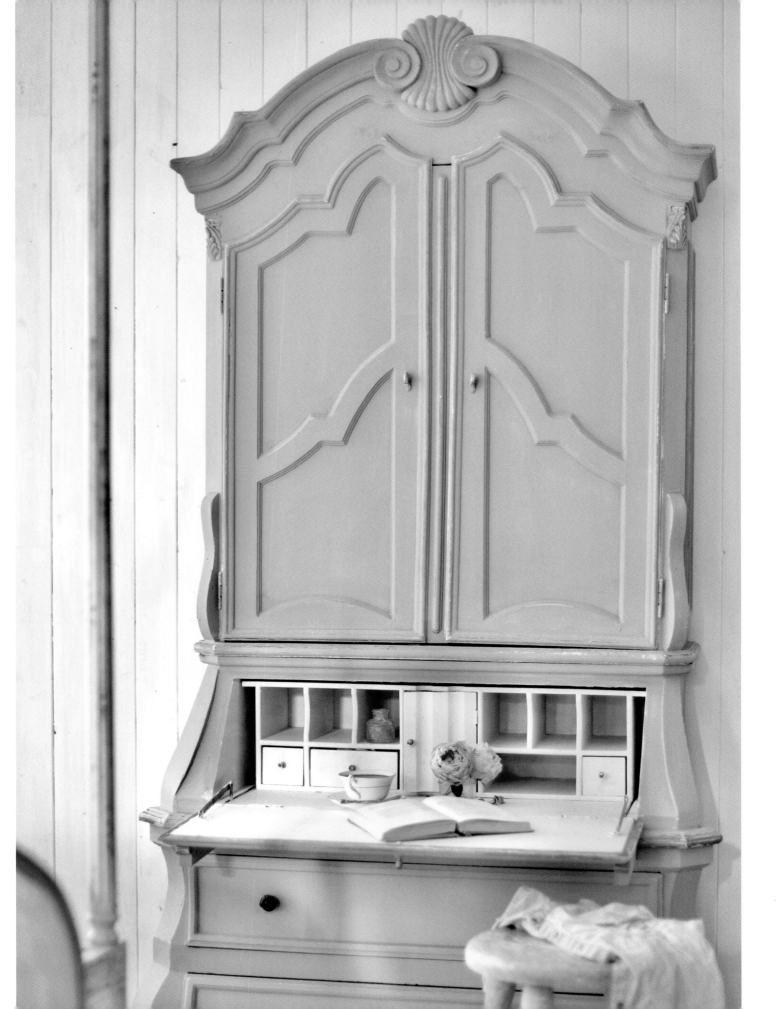

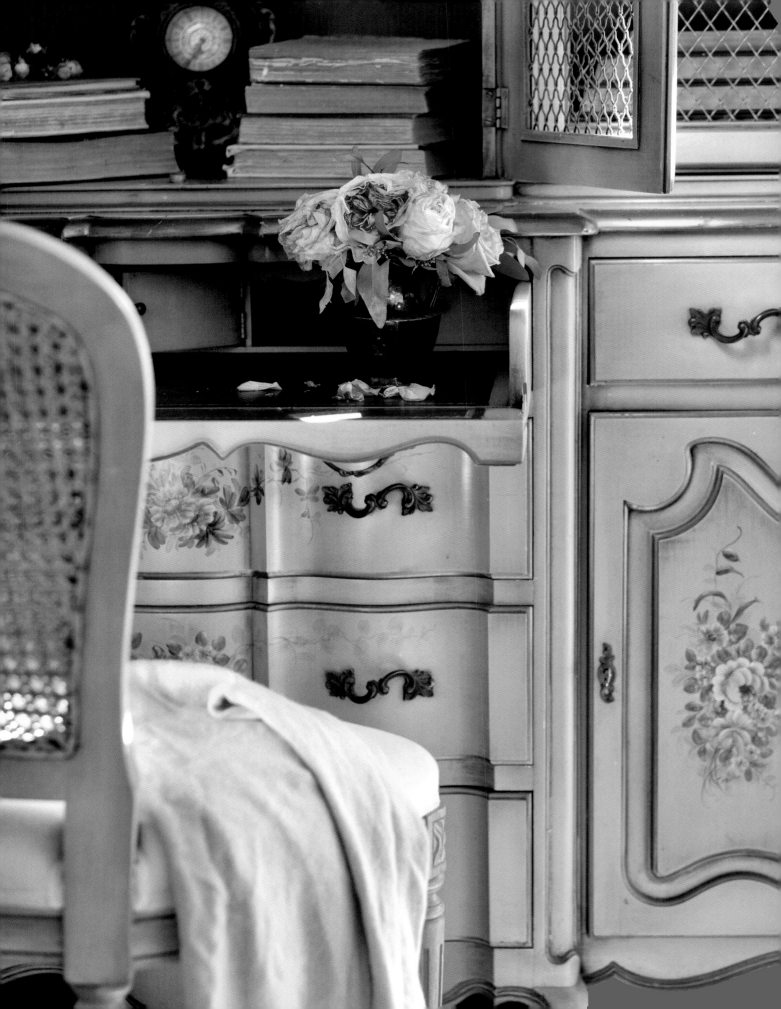

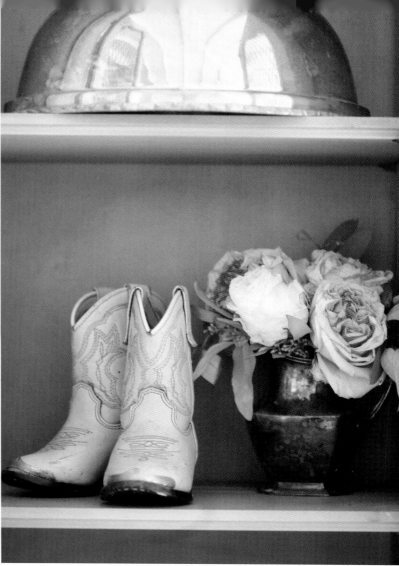

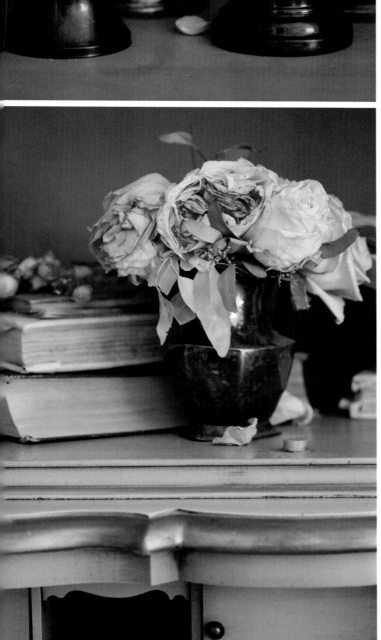

An antique hand-painted floral china cabinet found a home in the bedroom. Its florals, wire-front doors, and drop-down front have a French Country sensibility, while the shelves provide places for treasures: antique trophies and creamers, ruffle-paged old books, my daughter's first pair of cowboy boots. My favorite bedroom chair moves from my nightstand to desk as needed.

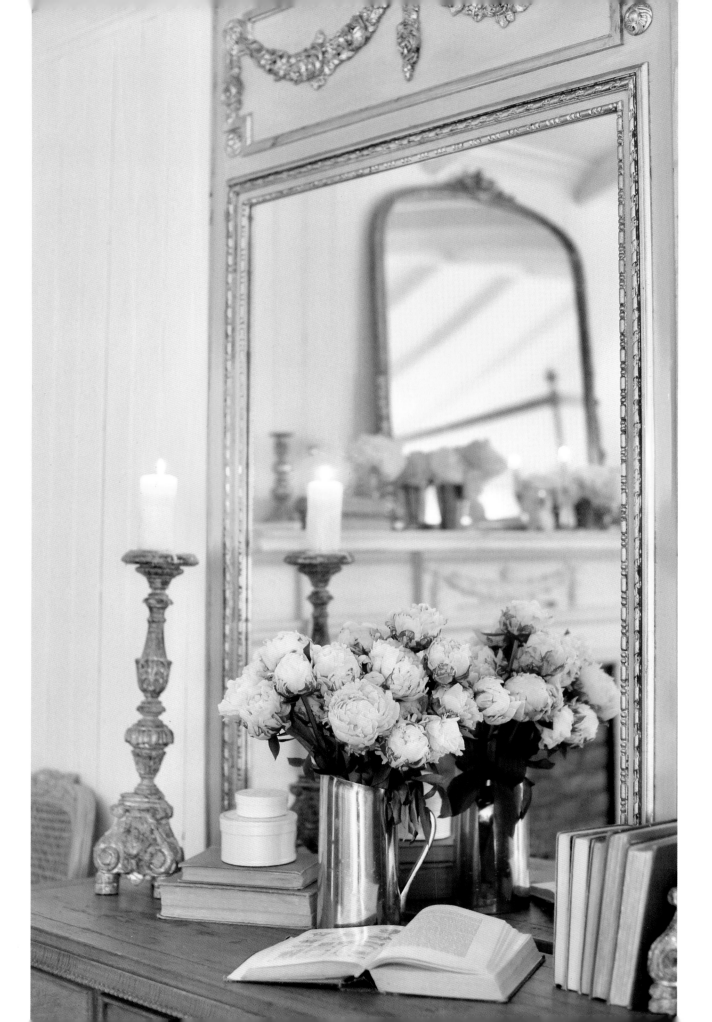

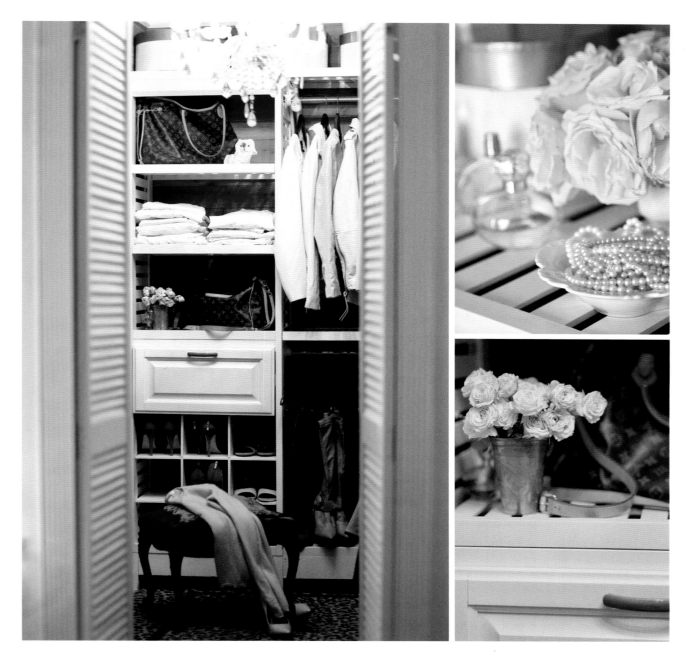

My closet is small on size but big on storage area, with shelves for holding everything from clothes to hatboxes and favorite accessories.

Across the room from the bed, a large vintage mantel serves as a focal point for the seating area, as well as a place for setting out seasonal decorations and sometimes simple candles to enhance an evening "fireside." An elegant reproduction trumeau mirror reflects the fireplace and the large crystal chandelier.

The Bathrooms

The master bathroom is just across from the closet, and while it was originally utilitarian and a bit short on charm, we reimagined this room and another small room to allow for a larger bathroom. In the process, we finished the ceiling, following framing lines, which gave it a spacious feeling. Chunky wood beams framed a new large opening, creating a wide-open view, and the bathroom is now more indulgent.

One thing that this cottage is certainly short on—as are many older homes—is closet space. Not having ample closets creates a reason to indulge in purchasing decadent pieces such as armoires and cupboards. In the bathroom, I moved a stately French armoire with glass doors against one wall for storing towels and everyday items. It has an original whitewashed finish and we added wood shelves in place of glass.

I wanted a tub for soaking and one that spoke to my vintage aesthetic. In the small alcove area behind the shower and next to the armoire, we tucked in a dainty claw-foot tub.

The vanity was a custom design that I dreamed up one day while we were tiling the shower. I have been known to start with one element and see how the room speaks to me and then find the direction. In this case, the bathroom started with the original, very old, cracked sink, which became two inexpensive pedestal sinks, and then over the years became this custom-designed vanity made from a reproduction French console table.

The cast-iron claw-foot tub is a reproduction in a smaller-than-usual Swedish-style size to fit in the nook behind the shower. Marble subway tile juxtaposed against the wood plank walls keeps with the original style of the house and creates a quiet backdrop for mottled gilded mirrors. Clear glass doors on the French armoire insist on keeping things stored in the prettiest of ways.

Overleaf: A large carved French-style mirror sits in the center of the vanity and reaches all the way to the sloped ceiling. This mirror was originally above the tub area—and I adored that over-the-top size and all the interest it created there. But while looking for the right size mirror for the vanity, I decided to move this mirror for a more dramatic, large reflection in the center of the sinks. While the understated gray color and chalky-type finish it wears is unassuming, its sheer size and detailed top command attention and add a little drama.

The master bathroom was originally a laundry room with a back door and with a very small, low-ceilinged bathroom attached to one side of it. When we renovated to allow for the new hallway, we carved out a place for a larger, more *indulgent* bathroom with a soaking tub and beamed ceiling.

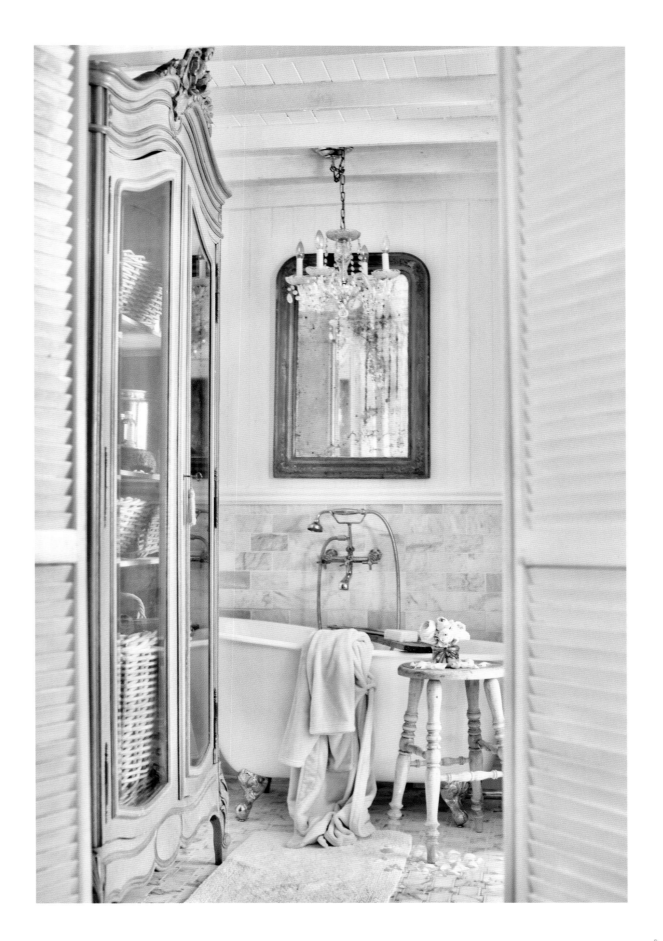

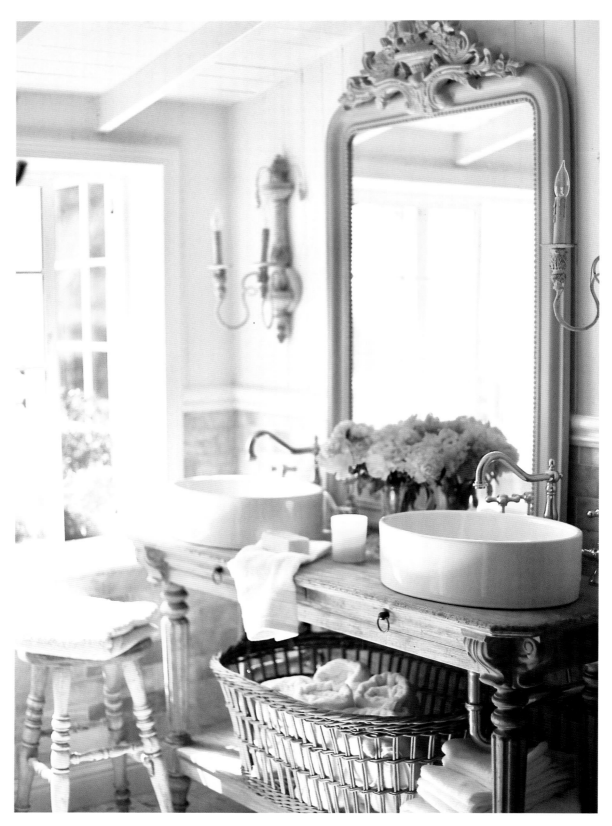

Being that this piece is a console table and not very deep, it is an ideal size for a small space like a bathroom. We added two simple vessel sinks on the top and vintage-look bridge faucets for a timeless feel. Plumbing is not something you generally want to call attention to—but if pipes are exposed, they should be pretty, in my opinion. Since the underneath of the vanity is open, we used brass finish supply lines and drain pipes for a prettier look.

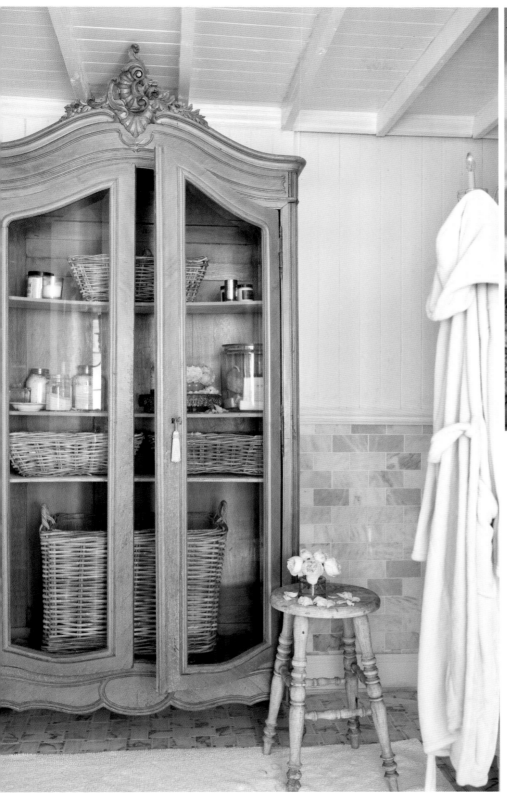

Clear glass doors on the French armoire insist on keeping things stored in the prettiest of ways. At the bottom of the armoire, a large area is perfect for tucking in a chunky rolling laundry basket.

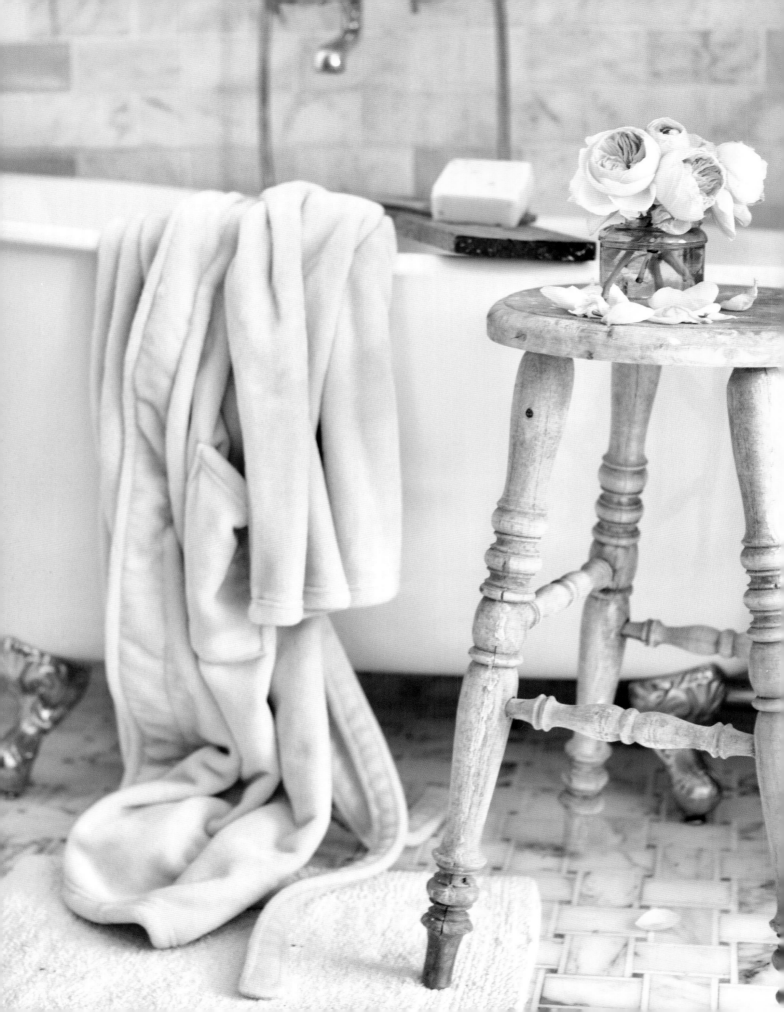

For holding things like fresh flowers or towels, one of my favorite bleached-wood stools is ready. Across the tub top, a weathered cedar fence board that I found in a leftover and scrap wood pile holds soap and a brush.

The old gilded mirror is one of my favorites. It doesn't reflect very much, since the silvering is long gone, but the frame and mottled glass are like poetry to me. A tiny antique crystal chandelier over the tub sheds a bit of quiet light.

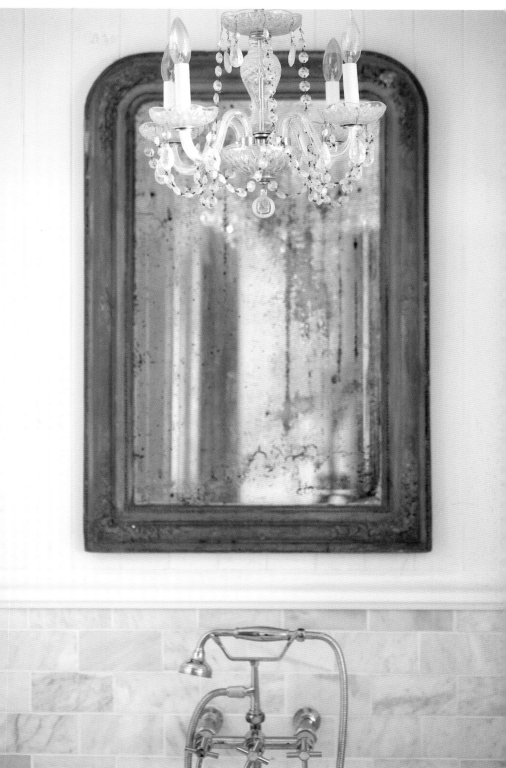

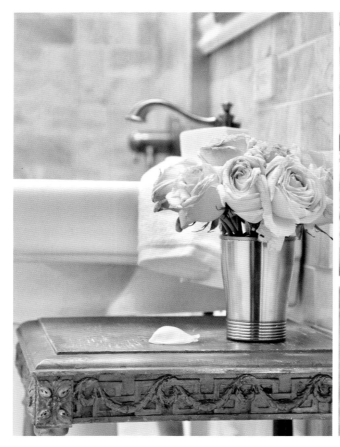
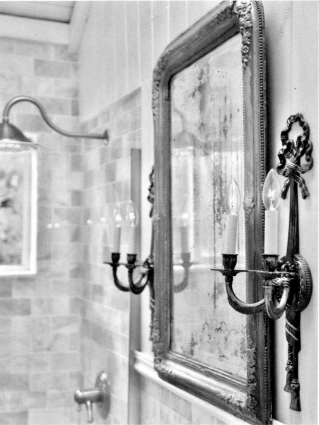

Down the hall by two of the other bedrooms, this bathroom was another space that started as one look and with a couple of small-scale renovations over the years has become another. It began as an unfinished room that was meant to be a bathroom at one time, but it was without a sink or even a finished ceiling and so wasn't a completely usable room. It seemed to have undergone the beginnings of a renovation, with a sloped 1960s "spa" bathtub that, though large on size, was full of cracks and never stayed warm in spite of being filled with the hottest of water. The glossy tile underfoot was slippery and a worry when getting the kids in and out of the shower. There was also an unfinished skylight area in the ceiling that left a wide-open view to the attic. We tackled the basics first, closing up the ceiling and adding an inexpensive pedestal sink so the bathroom was usable—especially since this space was the more finished of the two bathrooms that were available. And when we renovated, those things that were not our style or were of concern were replaced.

When we took the added wall tile down, we uncovered the original wood planks underneath the layers of tile and drywall, and that was the inspiration for reinventing this room. Marble tile and painted wood finished the walls and floor, and the skylight stayed because it brought much-needed light into an otherwise dark, north-facing room. Finishing the ceiling following the frame lines avoided a "skylight tunnel" and created airy feeling in this small space.

The marble subway-tiled shower is a bit oversized, making it feel that much more indulgent. Next to the shower is a stack of shelves for holding bathroom bits and a rolling laundry basket to catch towels and hold laundry clutter. A classic-style reproduction pedestal sink and ribbon-embellished sconces add a charm of yesteryear. Next to the sink, a dainty vintage gold table is a place for folded towels, washcloths, and a small bouquet.

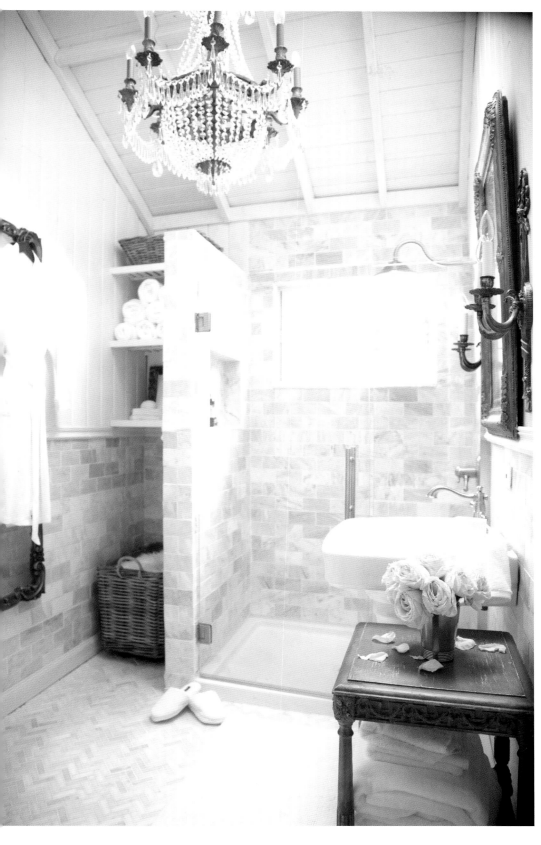

The shower is floor-to-ceiling marble subway tile, and the added glass door brings an airy, spa-like feeling.

The Attic

The attic is a dream room for me, one where childhood treasures and a sprinkling of magic come to life.

When we first moved into this house, amidst all the work that we had on the to-do list I was already dreaming about finishing the abundant amount of space that was above two of the back bedrooms. In a previous home, we had utilized a similar space as a playroom and it was one of my favorite things about that house. Though it was not the first project on the long renovation list, we eventually tackled the attic, and with just a few finishing touches, an upstairs room was created. Overlooking the old oak tree and fireplace in the front of our property, the attic is now a room that, instead of just holding boxes and storage bits, is filled with vintage pieces, projects, and a bit of storybook charm. I love to come upstairs and putter around with the boxes and crates full of Christmas ornaments, sort through folded linens for the perfect one, and rediscover the various treasures that are stored here.

A place for play and for *retreat*. A place for daydreaming with a cup of tea. Our attic is a little bit of a childhood *dream* spot in our home.

Simple pine plank floors and walls and the original ceiling coated with fresh paint create a getaway spot for daydreaming. Rotating decor includes piles of pillows, old books, and an antique settee. Old stools and tables, vintage chairs, hatboxes filled with ornaments, old photographs, and bits of childhood make the attic a grown-up playroom.

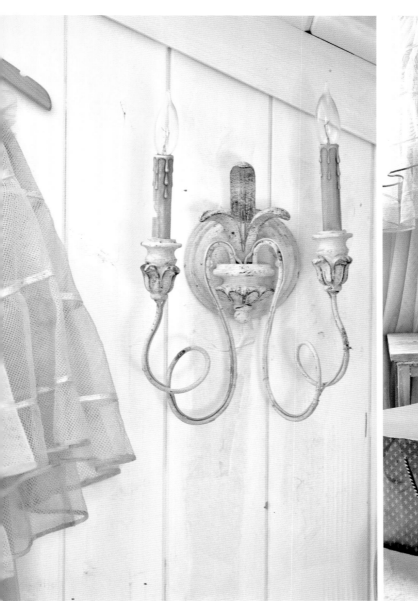

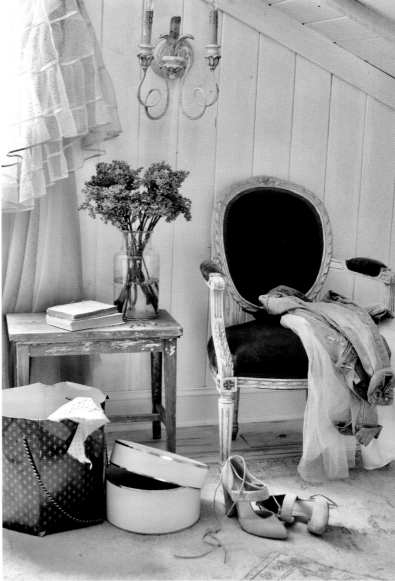

The attic is a quiet place filled with things that inspire me. A lovely antique chair covered in faded and worn teal velvet serves as a catchall spot, while an old bench holds books and a handful of pretty wild flowers. Simple sconces with curvy lines and details add elegance to the wood plank walls.

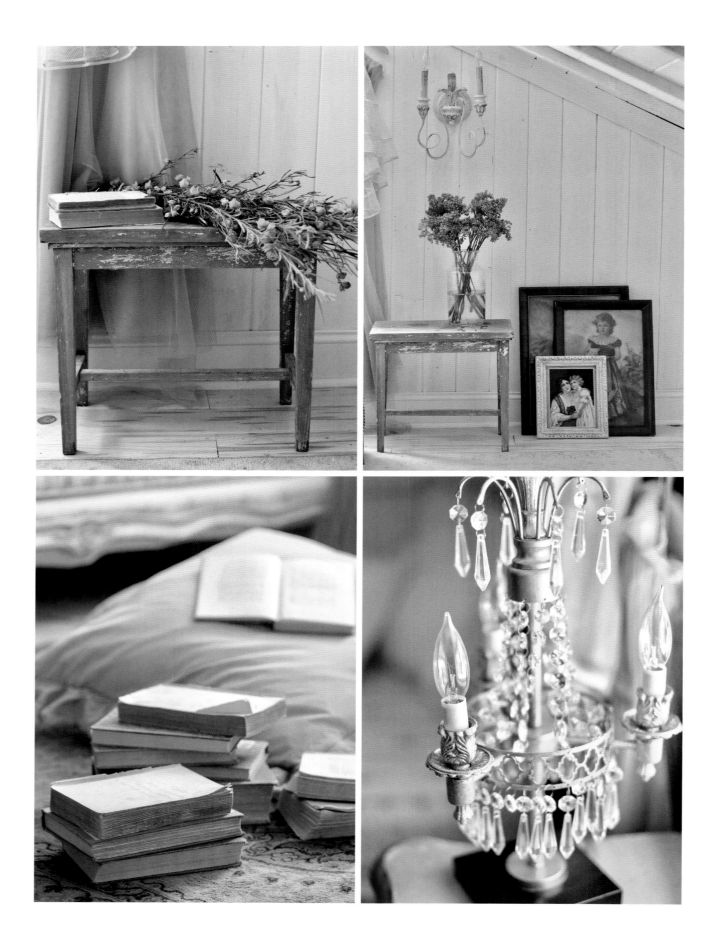

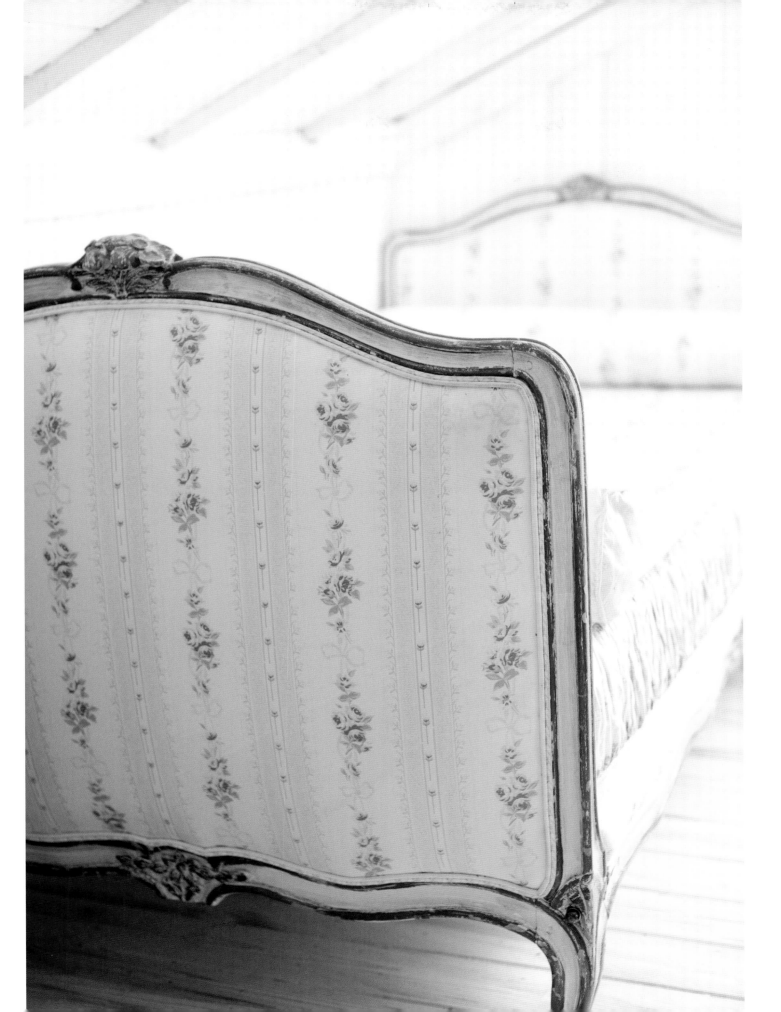

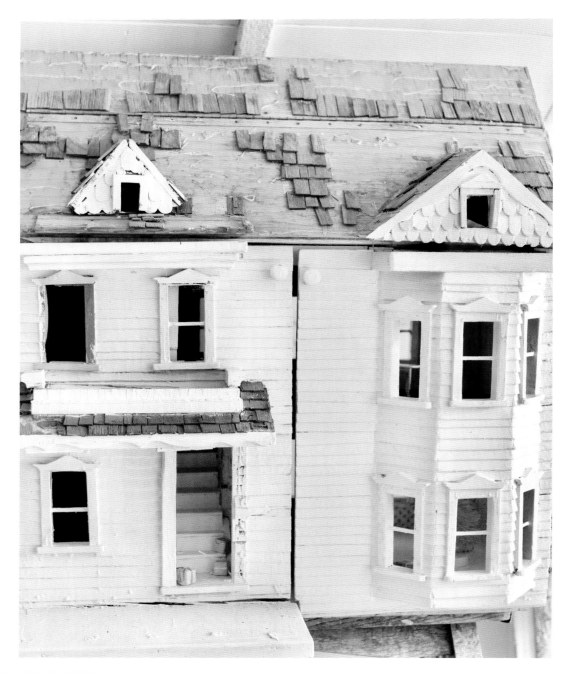

THE DOLLHOUSE

My dollhouse is an object full of wonder for me. Over the years, it has come along with me as I've moved, losing pieces of siding and trim here and there along with a whole lot of those cedar shake shingles. It is a fixer-upper in a big way but on a small scale, and in some ways, the dollhouse reminds me of our cottage and how it looked when we first found it. It wasn't pretty as a picture, but it had possibilities just waiting to be uncovered—and so, a new renovation project has started.

My dad built the dollhouse for me not long after my parents divorced. I can remember the hours I spent gluing fabric to the plywood walls for wallpaper or putting together little furniture we found for it. The world of my dollhouse and the small "family" that lived there was a place to retreat from the chaos of that time and find a bit of myself. It is a bit worse for wear all these years later, but as I am renovating it bit by bit, I am finding that even as some things change, others will stay the same because they have become part of the story.

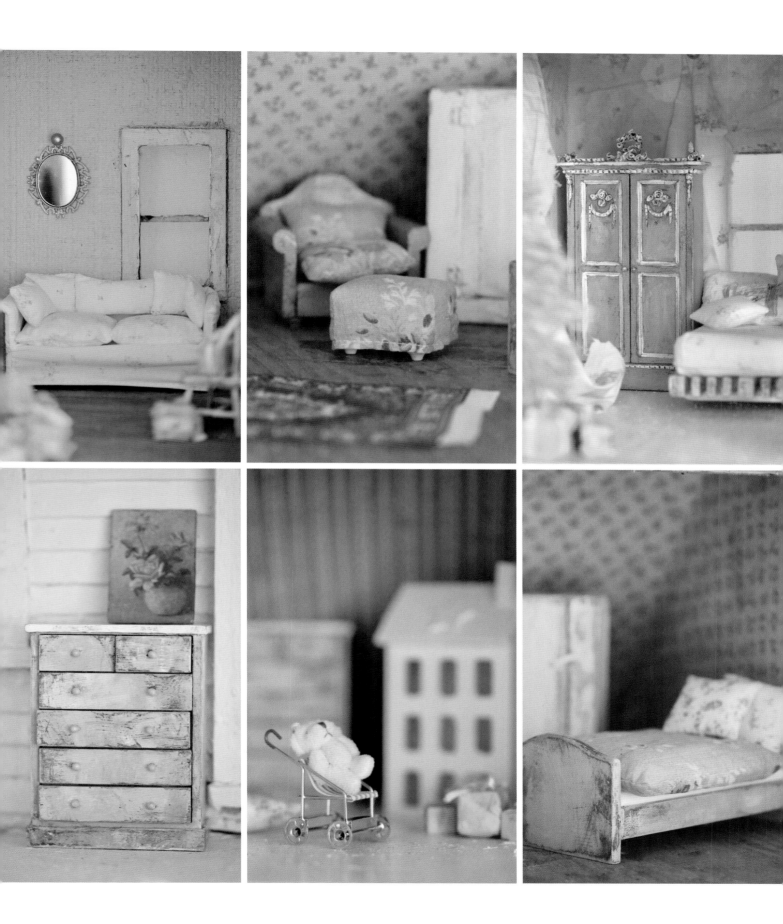

CHAPTER 3

THE LITTLE COTTAGE

Carriage house. Guesthouse. Studio. The little cottage wears many hats that change often. It is a small house dotted with stacks of vintage books, collected antiques, and charming old pieces that tell a bit of a different story. It isn't a house down the lane that we travel to—it is a smaller house on our property, where both of my boys moved when they first moved out of the "house." It has been the perfect spot for sleepovers and guests and is where, for years, there were drums and guitars playing in the background as the band gathered to practice inside those walls.

When we first looked at this property, the little cottage was somewhat like a bonus space. It was a very rustic two-part house of sorts, with steps and a small door in between. It is built partially into the rolling hillside, with concrete floors and an abundance of windows—and on the outside, it was covered with very old half-log siding. We weren't quite sure just how this 1,000-square-foot space looked when it was first built; there were no floor plan records for our property on file—which meant that we had to take cues from what we found in the space and the changes that we could see had happened and imagine what it once might have looked like.

It seemed that over the years the little cottage had evolved from a small home to a smaller home with a workshop/garage. And in that large main room, we knew there was more to the open space than met the eye. A serendipitous find in the basement of the main house pointed us in the direction of bringing that tiny space back to what we imagined the original had been: we discovered a bank of antique glass-front cupboards sitting on a shelf in the basement that were a Cinderella glass-slipper-perfect fit on the wall where we thought a "kitchen" might have once been. And so, we reimagined the space with those original cupboards in place as the starting point.

A single French door on the cottage wears a pale blue color and is framed by a simple pergola. It is a lovely spot for climbing white bougainvillea, roses, and ivy.

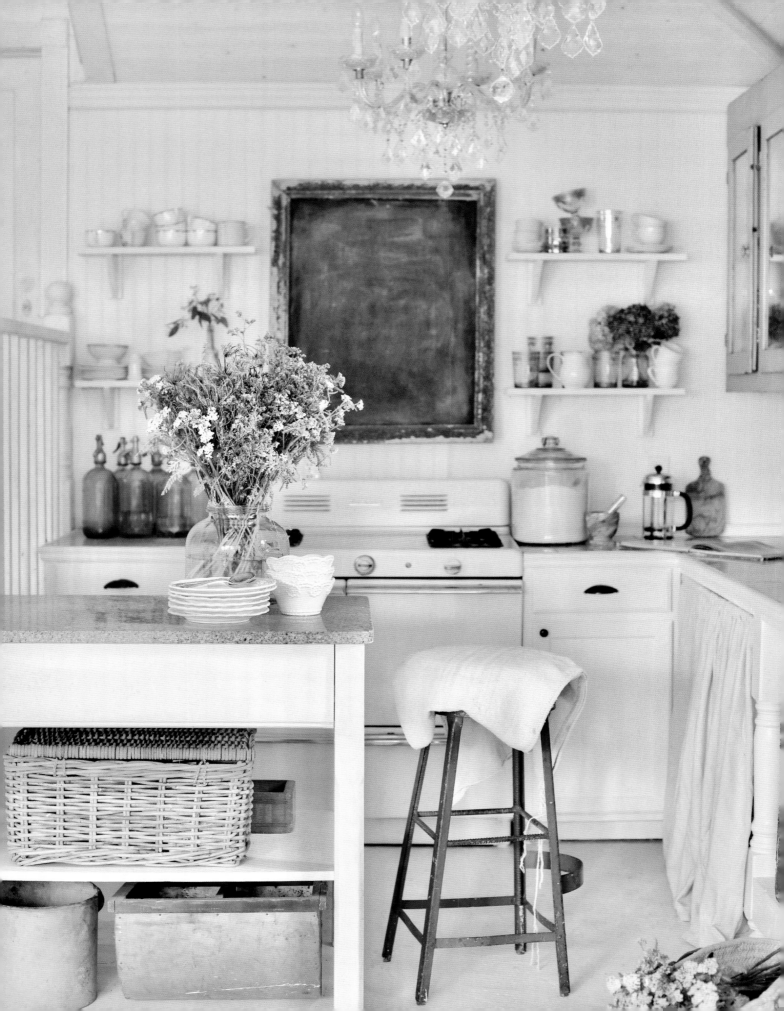

The main half of the little cottage serves as a living space, with kitchen, dining room, and living room and a bathroom in one corner. It is more rustic in feeling than our main house, more cottage style or masculine in some ways—though with a turn of the books and change of accessories and flowers, it leans toward feminine and romantic in a snap.

With that rustic base to work with, we chose to embrace the original charm and quirks. Instead of replacing many of the old, worn elements, we simply cleaned them up and made them part of the design to let history and nostalgia shine. We painted the concrete floors with a creamy white porch and floor paint—embracing cracks and imperfections instead of covering them up with planks or something more refined. And the original open beams and boards on the ceiling were coated in fresh white paint and left exposed, for a barn-like feeling. Nothing in the cottage feels too precious to be enjoyed. It is a place where less-than-perfect old nails and rustic touches are celebrated rather than covered up.

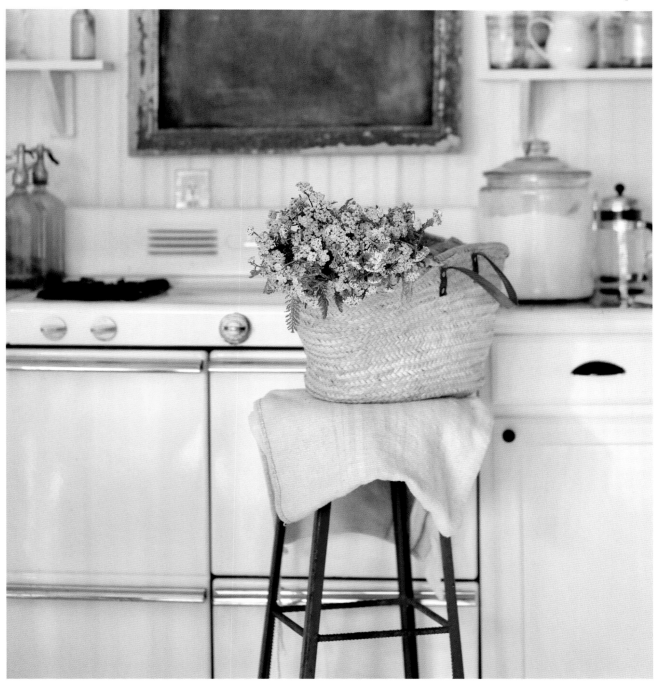

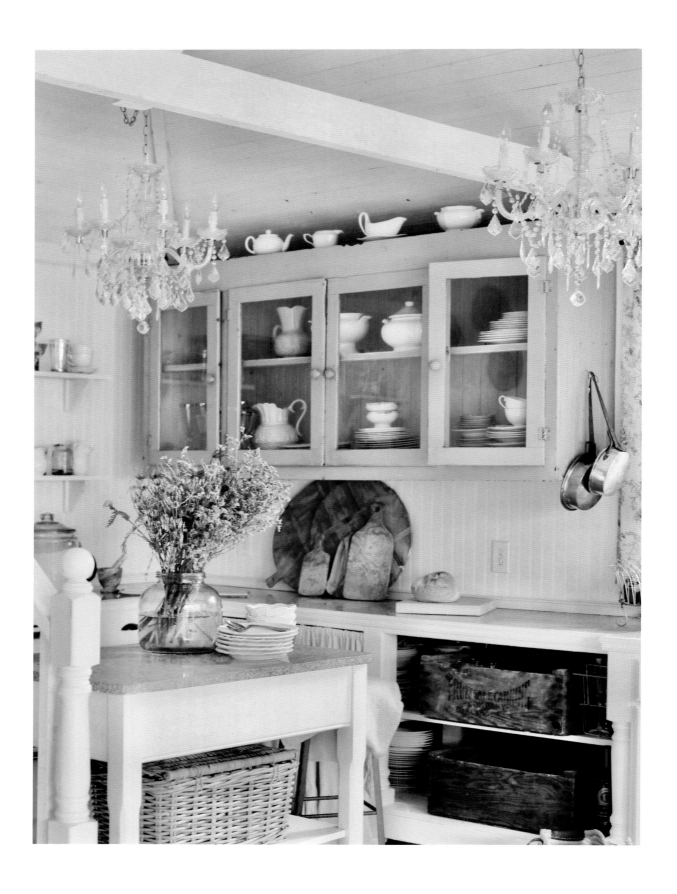

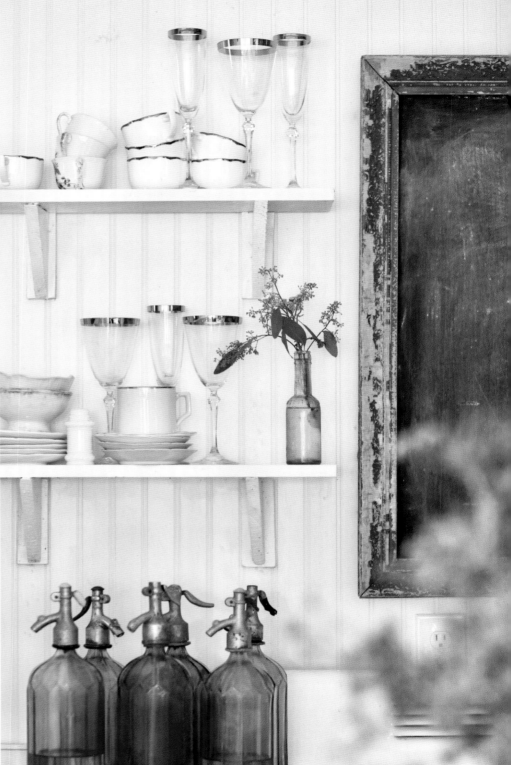

A mix of vintage and new. The original old yellow cupboards were discovered in the basement of the main house, while the base shelves were hand built in an open style to match the rustic feeling of the cottage. Vintage seltzer bottles gathered on the counter add a soft pop of color. Collected small plates, bowls, tea cups, and gold-rimmed wine glasses fill the open shelves. They are all simple elements you can find at flea markets, and thrift stores, and many have a chip, stain, or etching, which to me, enhances their vintage beauty. I like to stack and gather them in various arrangements to add a subtle color and interest, even in small spaces.

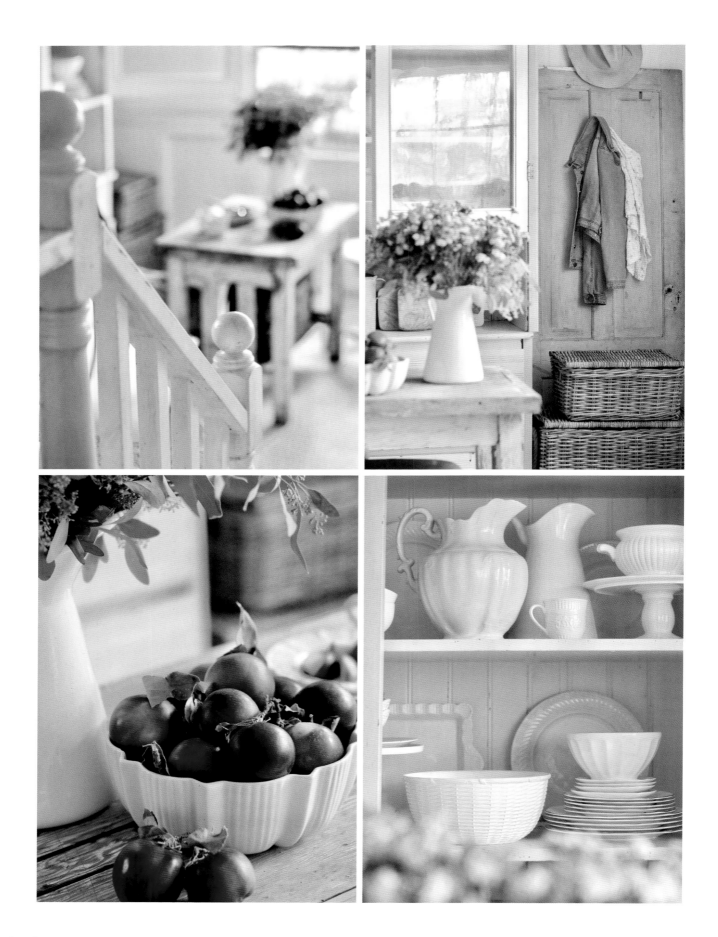

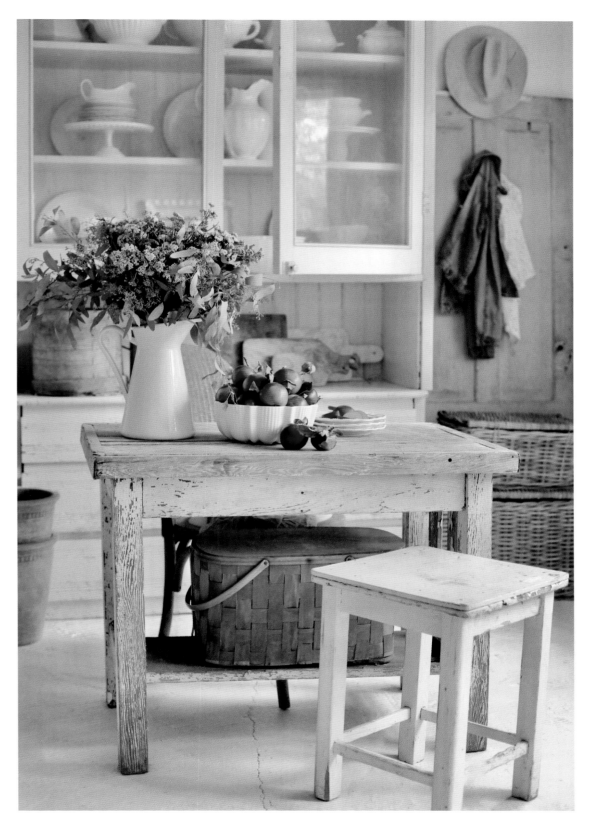

Simplicity is key in the cottage: an old pine board railing on the stairs, a vintage ironstone mold holding freshly picked apples, baskets and old chippy benches and tables. In the antique cupboard, stacks of collected plates, platters, and pitchers find a spot to land when not in use.

In the dining area, a small vintage table is a great spot for a cup of tea and a chat while gazing out the windows.

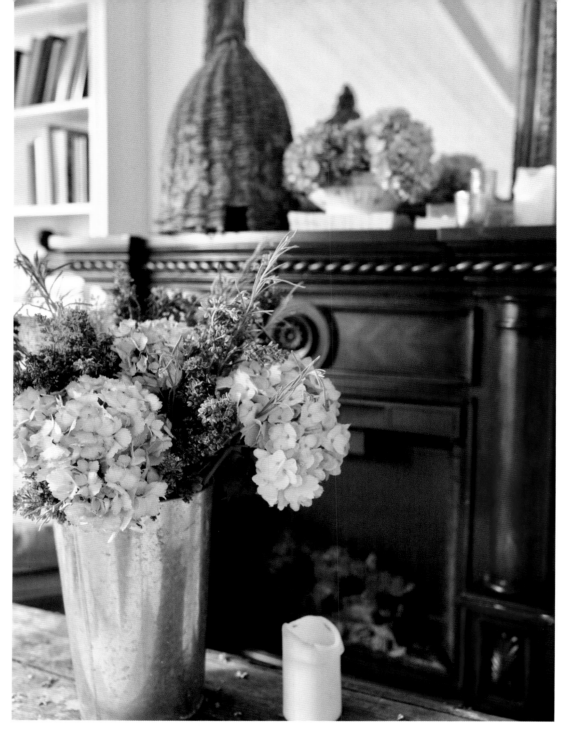

In between the bookshelves, a dark, carved-wood fireplace provides heat in winter and simple ambiance the rest of the year. In the living room, the decoration is somewhat garden inspired. The old, mud-covered, woven French bee skep, a galvanized flower bucket filled with mixed seasonal blooms, and a worn bench keep the look very casual, letting architectural details such as the bookcases take center stage. The slipcovered sofa mixes easily with always moving and changing chairs and tables, and the fireplace decor tends to stay simple, often just old bottles with a few clippings of favorite blooms and several books stacked up.

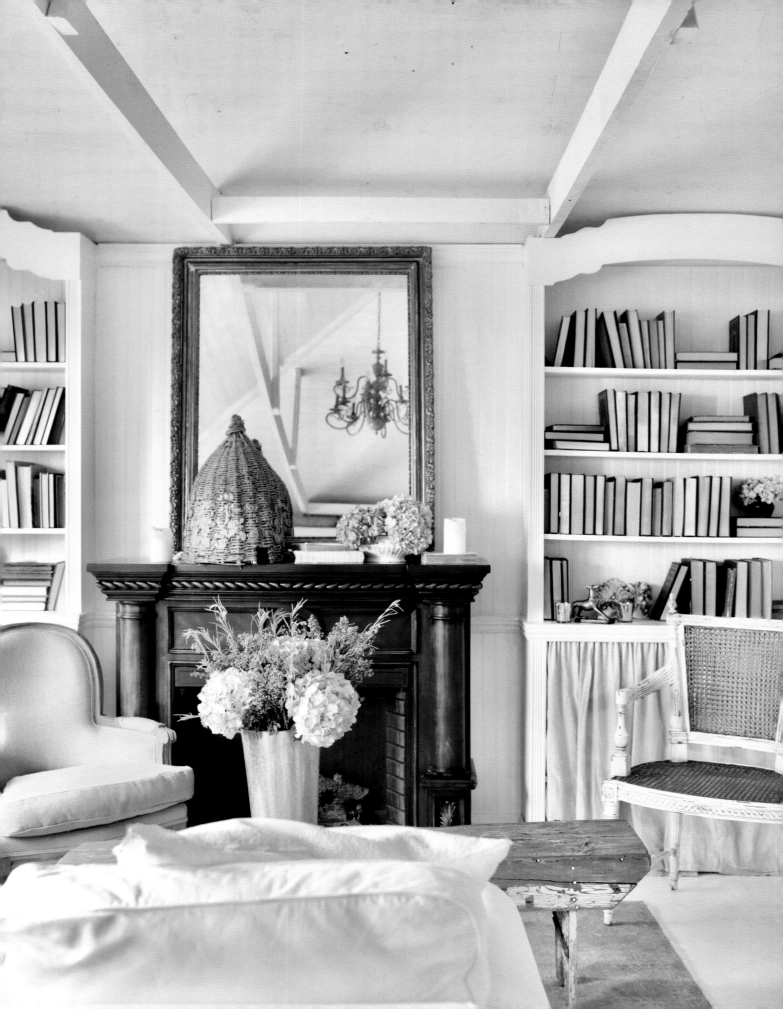

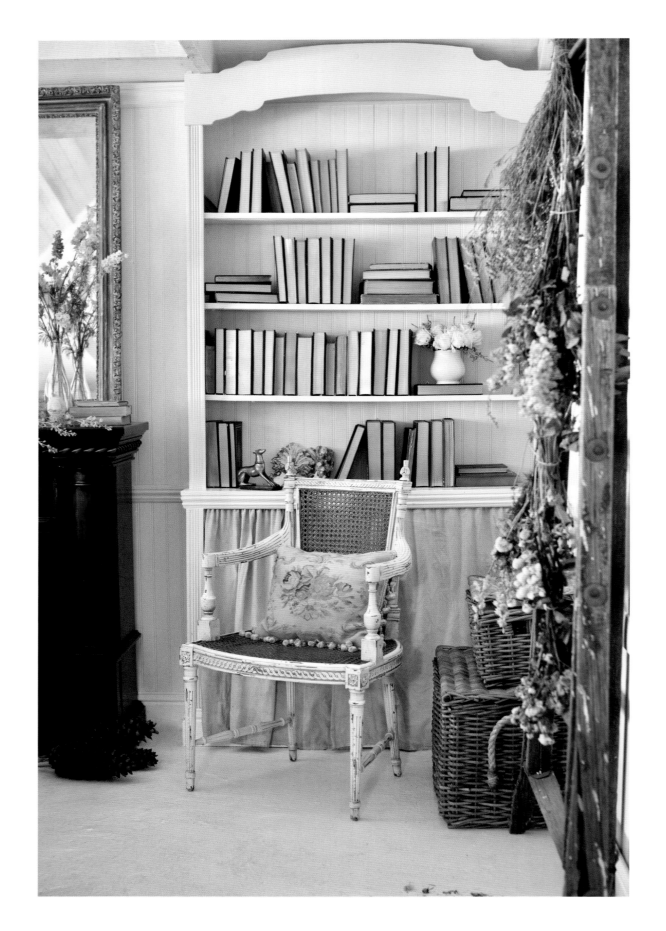

In the living room, with the tall open ceilings and expansive wall space, we built the pair of bookshelves right into the space along the back wall. A toss-away piece of wood that had been cut out with a soft curve for use in another spot fit the bookshelf tops perfectly when reversed, and became the crowning finish. My grandmother's old books, vintage bits, and various pieces that speak to me fill the upper shelves.

Drop cloth curtains on the lower book shelf conceal storage of old books, vases of flowers, misfit trinkets, and bits of salvage pieces until I find a spot for them.

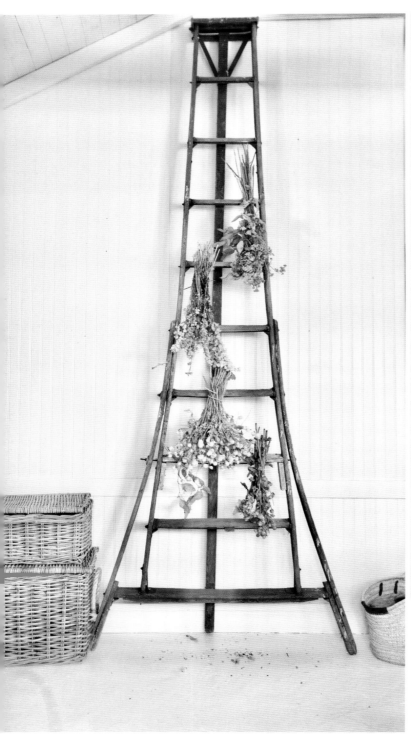

An antique wooden orchard ladder serves as a place to dry flowers or hold linens and grain sacks. I saw this ladder leaning against an old barn while out for a run and decided to stop and ask about it one day when I saw someone in the yard. There were several of these old apple-picking ladders stacked up on the property, but the one that spoke to me was the damaged one, and I was excited that the owners didn't mind if it was hauled away. The silvered wood and rungs that had been rubbed smooth by years of use, and even the splits in the sides near the brackets, are the things that make it so appealing to me.

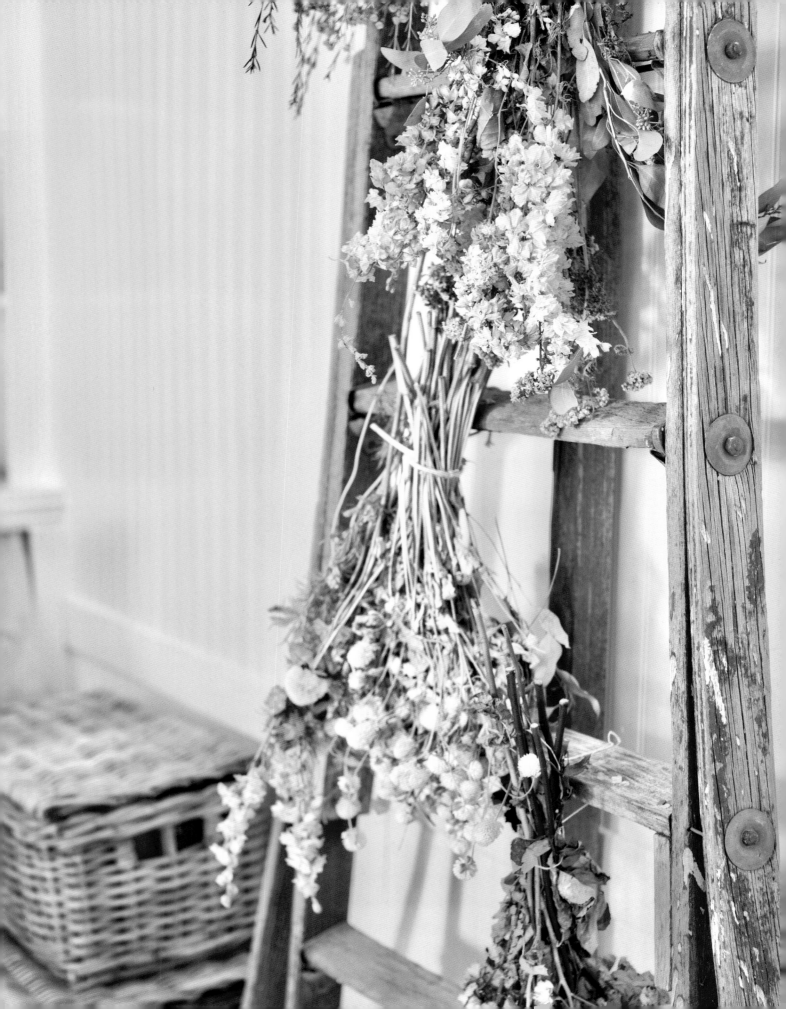

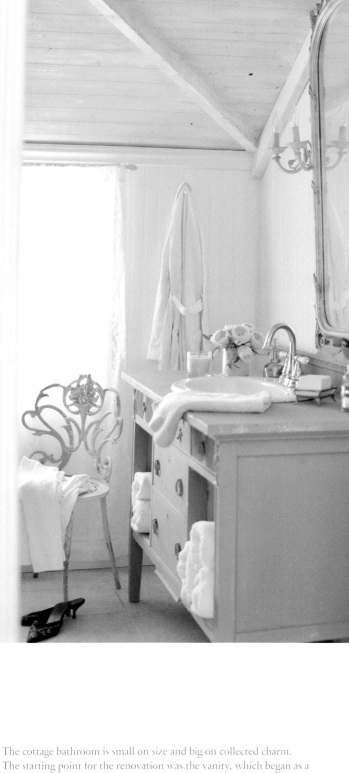

The cottage bathroom is small on size and big on collected charm. The starting point for the renovation was the vanity, which began as a sideboard found at a yard sale. The urns and bands of fluting and carved bits were enchanting, but there was a door missing from one side and the veneer was peeling, so it came at a bargain price. I spent hours chipping away at the top to remove the veneer and then took the door off the other side for symmetrical open areas, ideal for storing towels or other bathroom essentials. With the addition of a drop-in sink, a coat of chalky gray paint, and a good sealer, a very simple vanity was born.

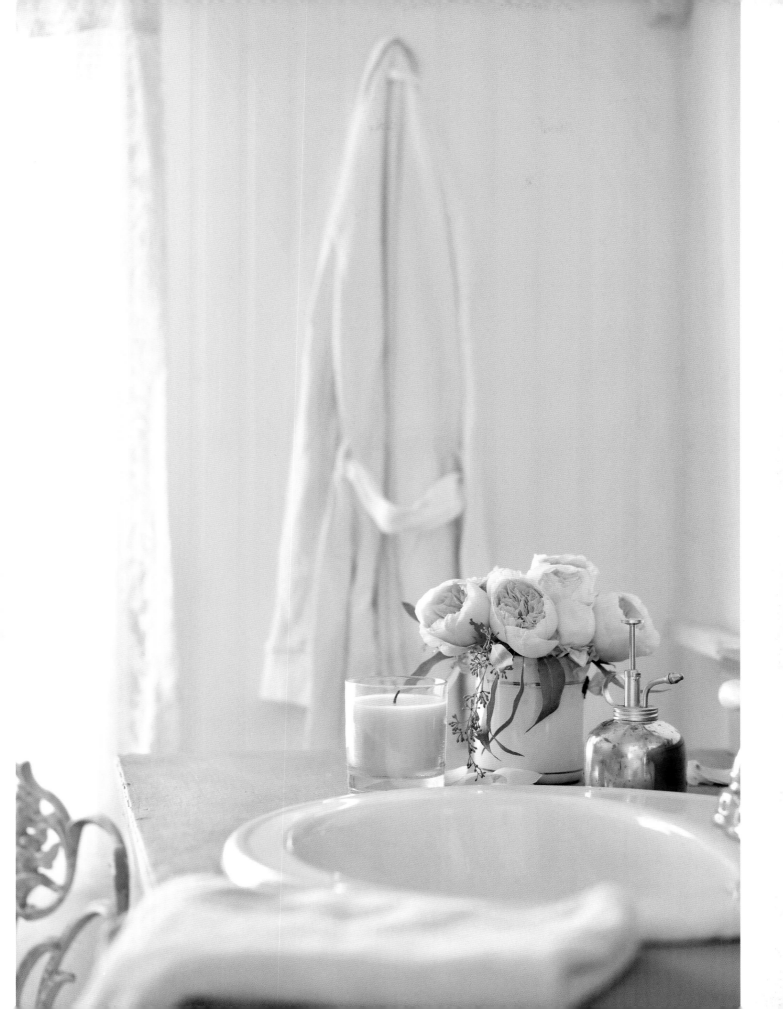

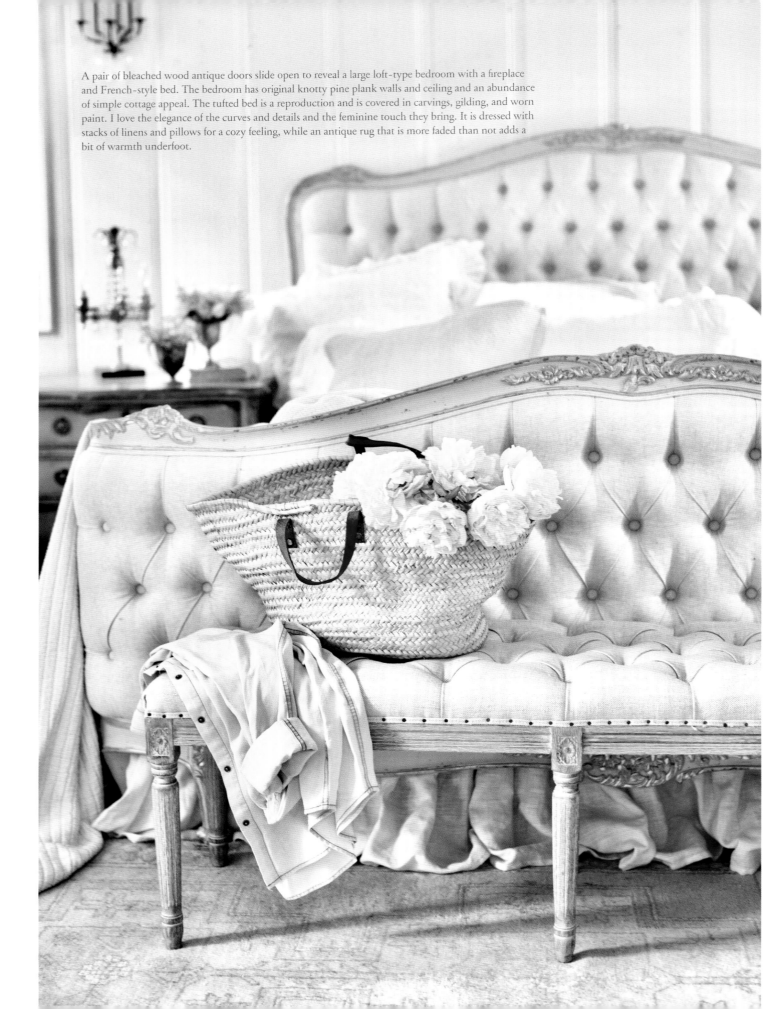

A pair of bleached wood antique doors slide open to reveal a large loft-type bedroom with a fireplace and French-style bed. The bedroom has original knotty pine plank walls and ceiling and an abundance of simple cottage appeal. The tufted bed is a reproduction and is covered in carvings, gilding, and worn paint. I love the elegance of the curves and details and the feminine touch they bring. It is dressed with stacks of linens and pillows for a cozy feeling, while an antique rug that is more faded than not adds a bit of warmth underfoot.

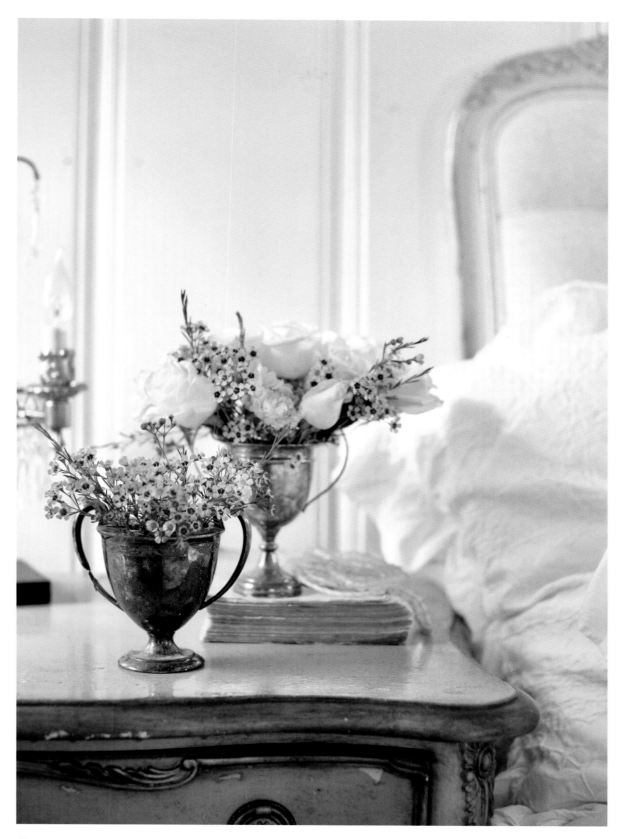

Old silver creamers are perfect vases for tiny bouquets of wax flower and roses. A simple yet sweet touch on the nightstand chest.

Being that the cottage is nestled into a grove of tall trees, sunshine streaming through the windows is at a premium; so the windows are often bare other than simple sheers. The fireplace got a recent antique makeover as a result of another meant-to-be find. The antique surround is made of horsehair plaster and came with chipping paint and damage after having been left exposed to the elements for four years. I looked past the many issues that came with it and we were delighted to find that it was almost the exact size the bedroom fireplace needed. We cleaned it up and gave it a light coat of fresh paint to bring out the molded details and enjoy all the quirks.

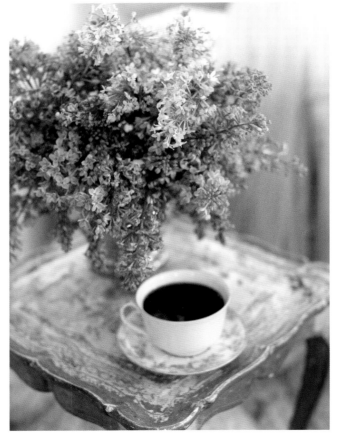

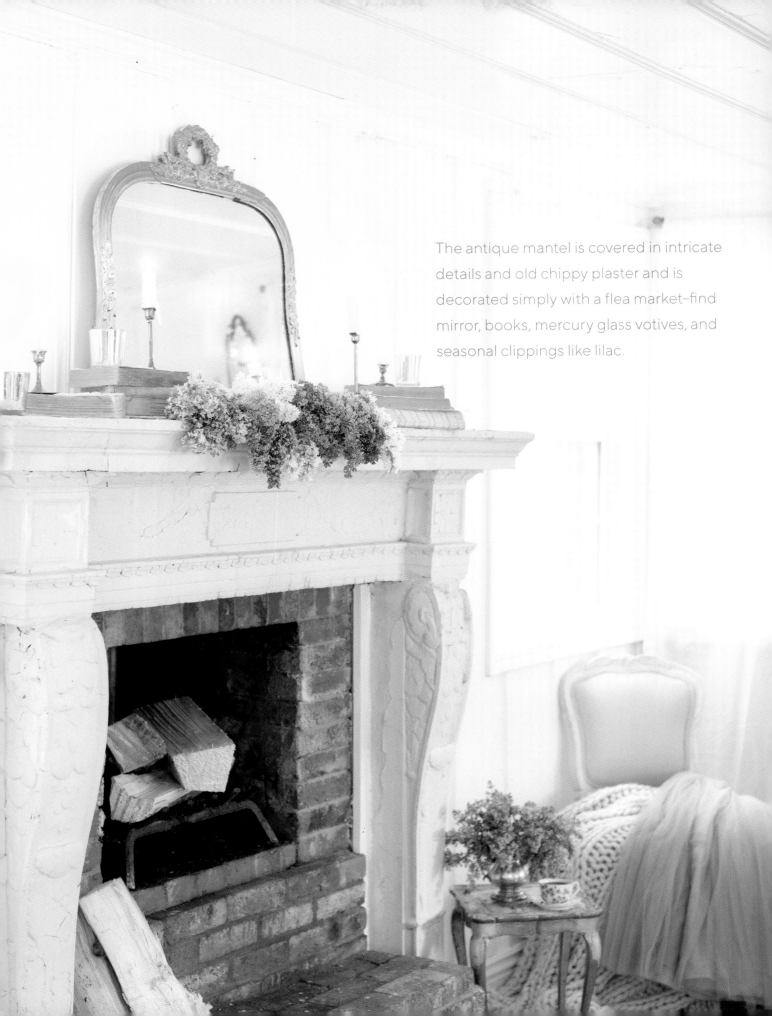

The antique mantel is covered in intricate details and old chippy plaster and is decorated simply with a flea market–find mirror, books, mercury glass votives, and seasonal clippings like lilac.

THE GREENHOUSE

When I was a little girl, my dad built a small playhouse in the backyard. It was on an upper level of our hilly backyard, and we had to climb steps overgrown with ivy to reach it. It was just a small one-room house tucked under the branches of several oak trees, with an open door, rustic peaked ceiling, windows with pretty curtains, and a plywood floor. For me, that house held the most wonderful invitation to imagine and dream.

Much about that little house inspired what I call my grown-up-girl playhouse—which is my greenhouse. It has unfinished walls, open-beam ceilings, and an abundance of little windows to let in the sunshine and breeze. Part potting shed and part getaway, it is set in a quiet spot in our yard, tucked under a large old-growth oak next to an always changing garden area. Deer walk through nibbling on a rose here and there, and birds flock to the apple tree that sits by the arbor and walkway. It is a somewhat enchanted spot.

We followed a simple European-style design with a pea gravel floor, which lends an old-world feeling and has a most delightful sound as it crunches underfoot. On the shelves, oodles of old rusty buckets and containers for flowers and collected watering cans—all weaknesses of mine. In spring and summer, those shelves become sort of a flower market style, with several buckets of fresh blooms waiting to be arranged. And for a quick change into a retreat area, the vintage daybed (which usually lives in the attic) provides a place for a lazy nap or makeshift guest bedroom whose abundant open windows let in warm summer evening air all night long.

Baskets of blooms and a favorite bicycle on the pea gravel path to the greenhouse. One of my favorite design details of the greenhouse is the Dutch door, which reminds me of one that might appear in a storybook house.

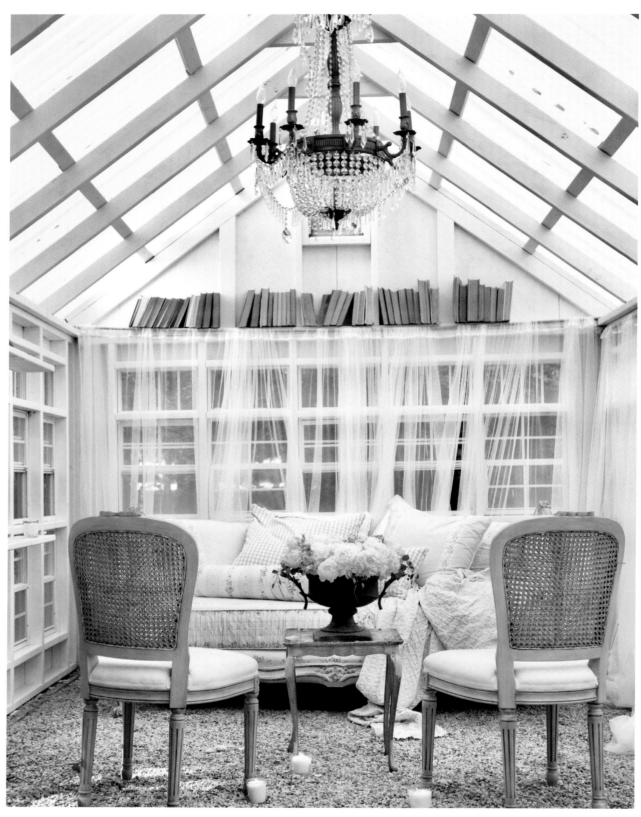

Flowers, French-inspired fabrics, and dainty tables create a cozy spot for retreating. A crystal-covered chandelier and candles tucked into the pea gravel create a cozy ambiance in the greenhouse for evening conversations.

The outside of the greenhouse looks much like a small cottage with crisp white paint. String lights illuminate the cottage-style garden, and vining wisteria on both sides of the greenhouse door climbs and covers the corners and helps provide shade from the hot summer sun.

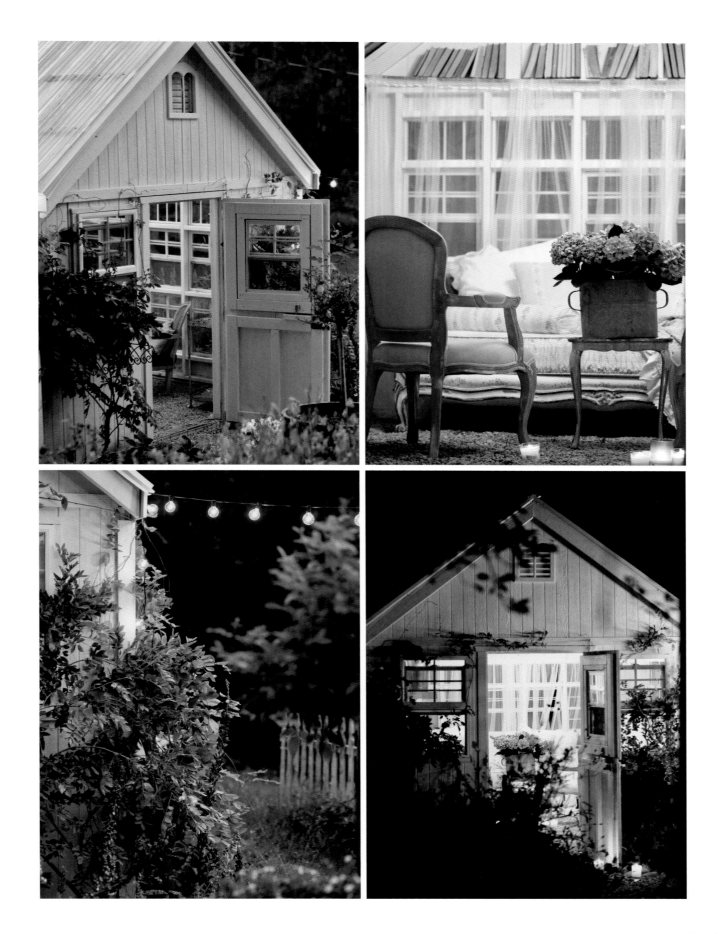

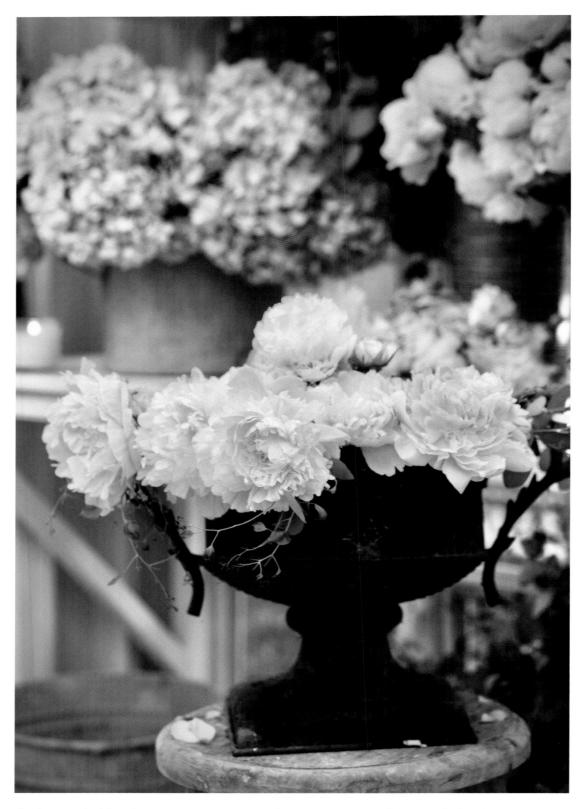

Old vessels, like this rusty urn, are perfectly charming filled with fresh-cut peonies.
Little Sweet Pea loves to follow us everywhere, to the greenhouse, where she
either naps or watches while creative work happens.

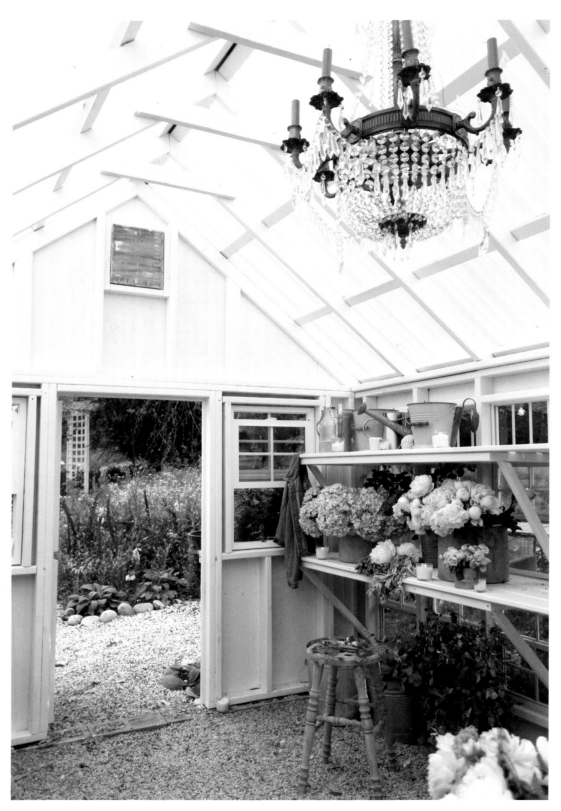

A signature decor element—a decadent chandelier dripping in crystals—makes this casual spot feel far more regal and enchanting than just a greenhouse made for gardening.

On the other side of the greenhouse, the shelves provide ample places for buckets and containers and for arranging flowers. I love that the pea gravel is forgiving of spilled potting soil and water, not to mention that it looks beautiful dotted with flower petals.

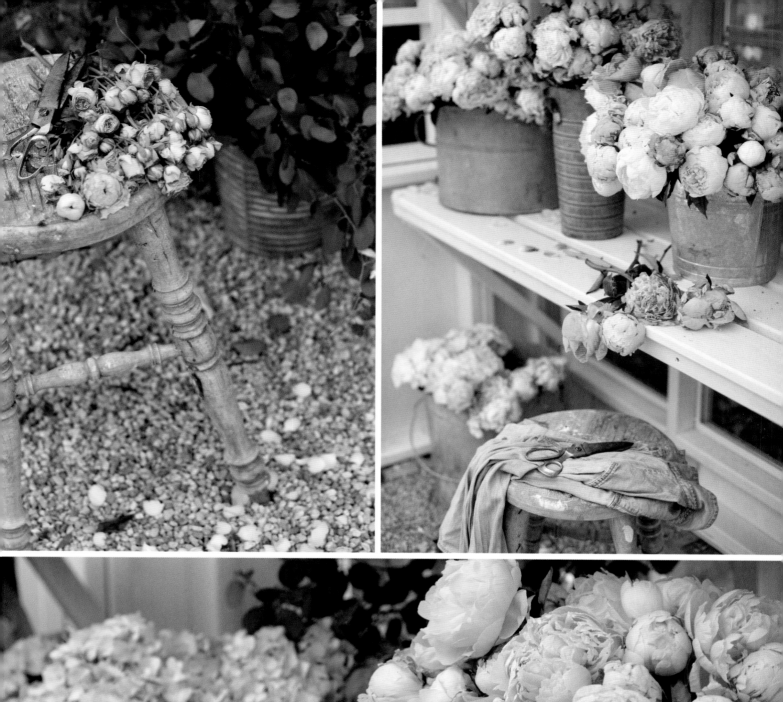
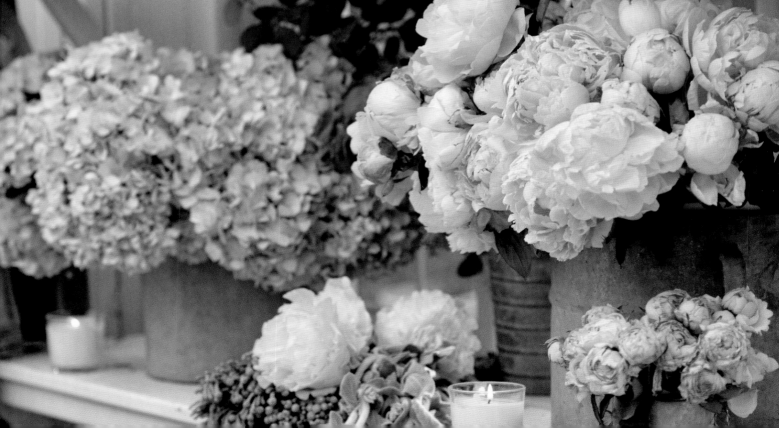

On one side of the greenhouse, a garden full of freshly planted roses is just starting to bloom, while wild growing sweet peas wind through the old picket fence. I have a thing for old garden and architectural elements—rusty gates, old wood covered in chipping paint, and cast-iron salvage speak strongly to me. I prefer to leave them as found and appreciate the old patina and the character they bring.

Just outside, a gravel path winds through a bank of scattered wildflowers that bloom in colorful abundance in summer. One of my favorite flowers to plant in containers and the garden is foxglove. The tall, stately blooms mingled with lavender, boxwood, salvia, and catmint create a cottage-style garden that blooms on repeat all season long. White rose trees are planted in whiskey barrels, and a softly rolling area is covered in wildflowers and wild sweet peas from spring through summer.

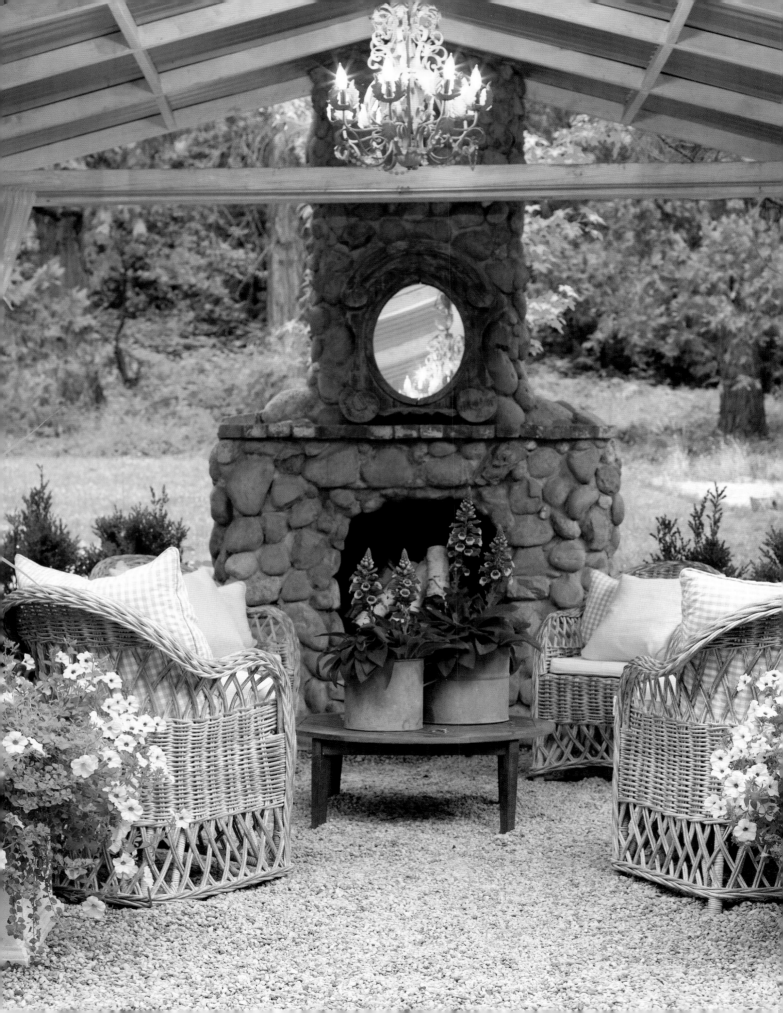

CHAPTER 5

OUTDOOR LIVING

One of the blessings of living in California is that abundant sunshine gives us the ability to mesh indoor and outdoor areas as part of our living space. The house doesn't stop at the door; it goes right on outdoors, where cozy chairs, a dining table, a rock fireplace, and music playing in the background beckon us. Living outdoors as much as possible is a huge part of our lifestyle, and we spend almost every month of the year outside enjoying the patio and lounging areas—so we have designed and decorated outdoor spaces much as we would indoors.

When we started there was no landscaping except for overgrown grass and a few old apple and pear trees. In the exuberance of the early years here, I wanted instant charm and would bring home every single pretty face that I saw at the market and plop it into a garden area by the cottage. There was no master plan to that garden; it was a little bit of this and that, and I didn't realize that the mishmash of those flowers mingling and reseeding each year was an English cottage-style garden in the making. Those mismatched, mingling plants taught me what I loved, what could be planted in abundance, what thrived in our space and soil. And they sparked my love affair with informal and overgrown flower gardens.

We also have areas that are more formal and curated in design, which is in contrast to the mostly natural landscaping on our acreage. Just beyond the French doors in the dining room/living room is a covered patio with a large story-book cottage-type rock fireplace. We have created quite a few "moments" on our property where people can retreat, but this patio area has become our everyday favorite. This is our place for relaxing when there is a chill in the air and when the summer breeze is warm in the evenings; and we also sit here to enjoy the sound of the rain on the metal roof in spring and autumn.

When we started building this fireplace, we had a loose idea of what it might look like, but the actual design was free-flowing. After building the foundation and frame out of concrete, we spent countless hours placing each rock onto the frame like a puzzle piece, finding the right size and shape to fit in each spot and then holding for about twenty minutes until it was set. It took perseverance and patience to wait for several rocks to set strong enough before stacking another. The result was an old-fashioned-style rock fireplace and a patio that adds so much charm to the backyard.

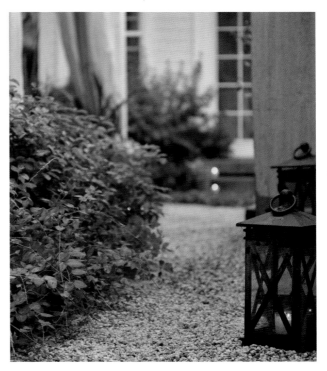

Four wicker chairs and a small table create a conversation spot by the fireplace. I prefer individual chairs over the more common sofa and settee set for outdoor living. Chairs allow people to sink into their own seat and relax. Just beyond the fireplace, the view looks to the back of the property and the line of old-growth trees that I love so much. Underfoot is a rolling area dotted with naturally growing sweet peas, vibrant ferns, and tall grasses. And just beyond, toward the back of the property, are a grouping of stately oaks in a meadow area and a small grove of apple trees.

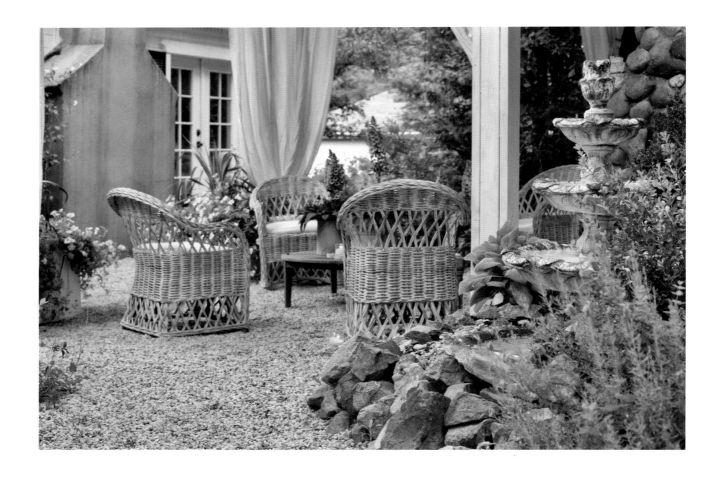

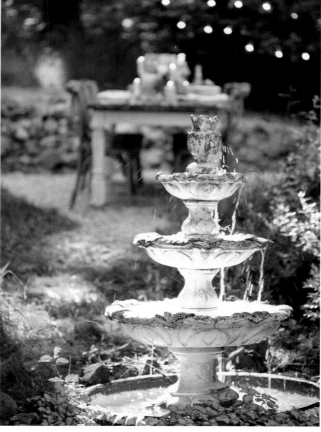

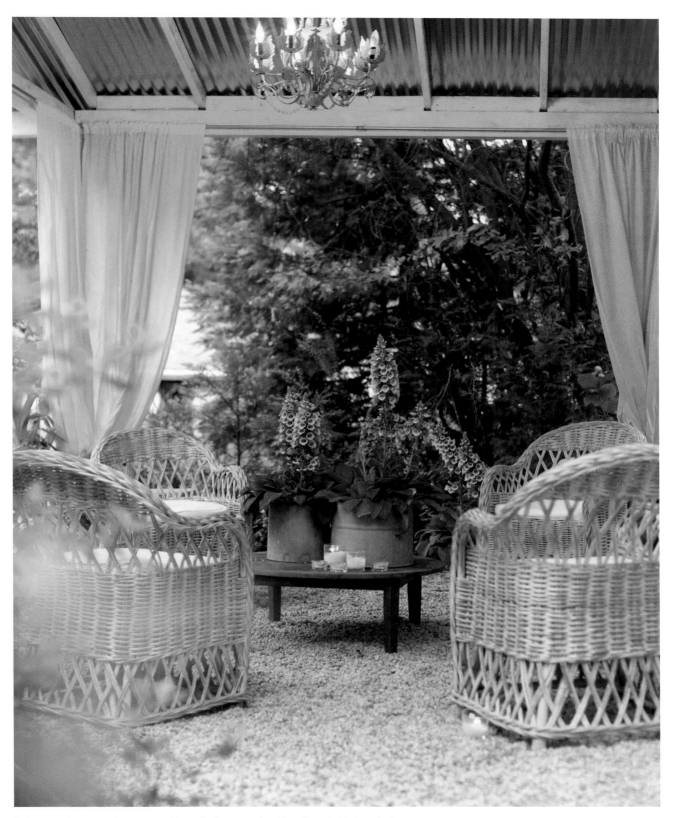

In between the two patios—one outside our bedroom on the side and one behind our bedroom—a tiered fountain bubbles away next to the fireplace, creating a serene music backdrop. The fountain is a favorite spot for feathered friends to bathe. On the table and in the garden, my beloved foxgloves are placed in old zinc buckets and are a perfect way to add a bit of color.

For an interesting collected feeling, a favorite old oak stump that I rescued from the firewood pile is repurposed as a table. Its weathered finish echoes my love of patina.

Just beyond the fireplace area is pergola-covered patio that sits behind our bedroom. This space feels more formal, with a bit of English garden allure. We originally created the patio with a trellis with vining rose and a base of boxwood to create a wall and a bit more of a private feeling. With the addition of climbing ivy, the over-twenty-foot-long wall provides a backdrop full of greenery year-round and is dotted with delicate blush rose blooms in the summer. The lion fountain tucked in the center of the wall provides a focal point, and the wood garden chairs supply extra seating and another spot to retreat to enjoy the outdoors. It is a perfect place for when the evenings are warm and a light breeze blows through.

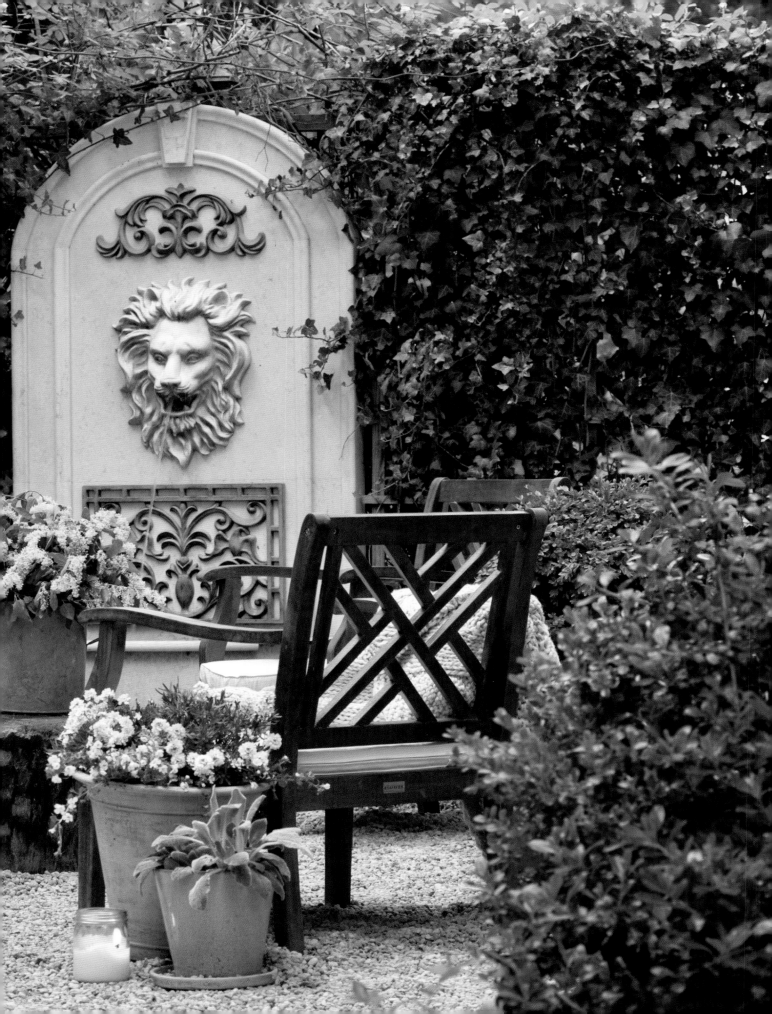

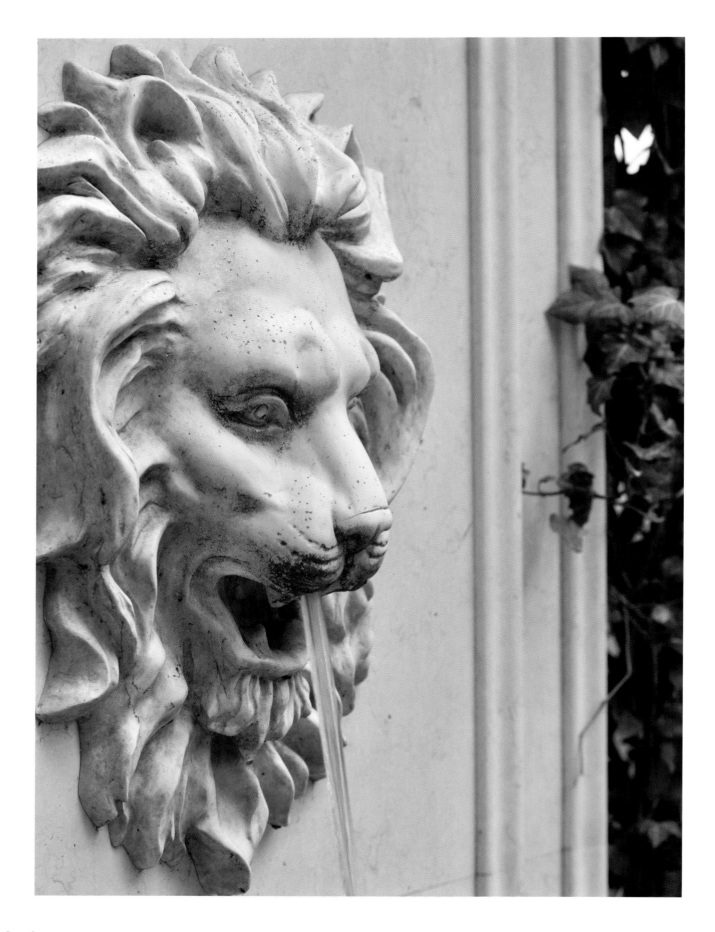

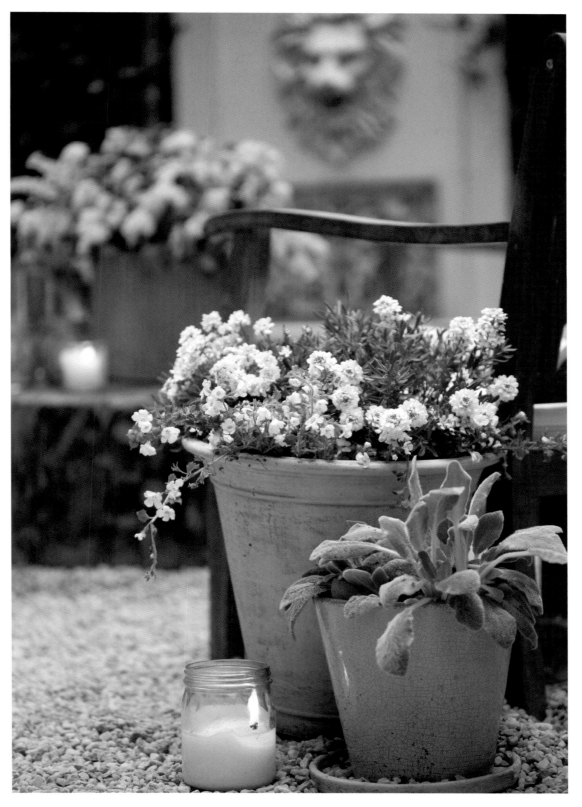

Pea gravel is my favorite choice for patios and walkways. It has an old-world European feel that brings to mind misty country mornings and beautiful gardens full of blooms.

Several large rock steps lead up to the pea gravel patio dining area. This is one of my favorite places to entertain and set a table out under the stars.

Our house sits in the center of a slightly sloped property, but the rolling land and amount of digging we had to do to create a level patio area allowed for carving out planter beds and creating a more formal border. Using wheelbarrows full of rocks that we found on the property, we built simple stacked-rock planter beds and filled them with favorites, such as boxwood, lavender, small roses, and a bed of thyme. Over the years, they have filled in and grown in abundance, spilling over the rocks and onto the paths and steps. And those little plants peeking out from between the rocks are happy accidents from reseeding and landing where they may over the years.

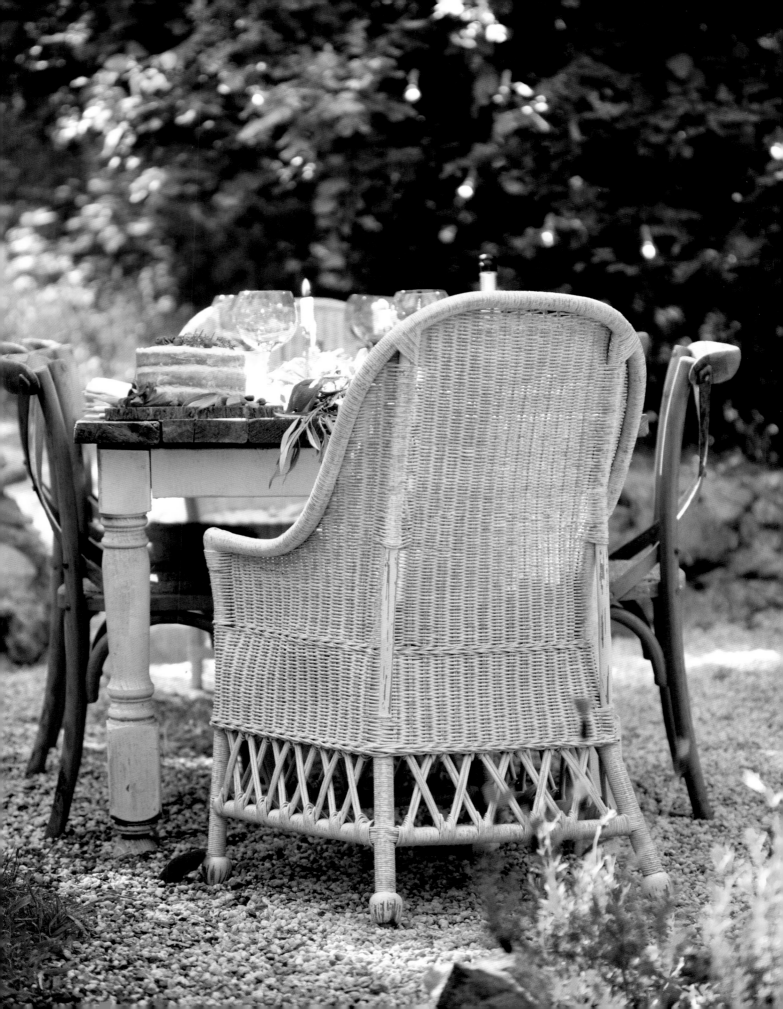

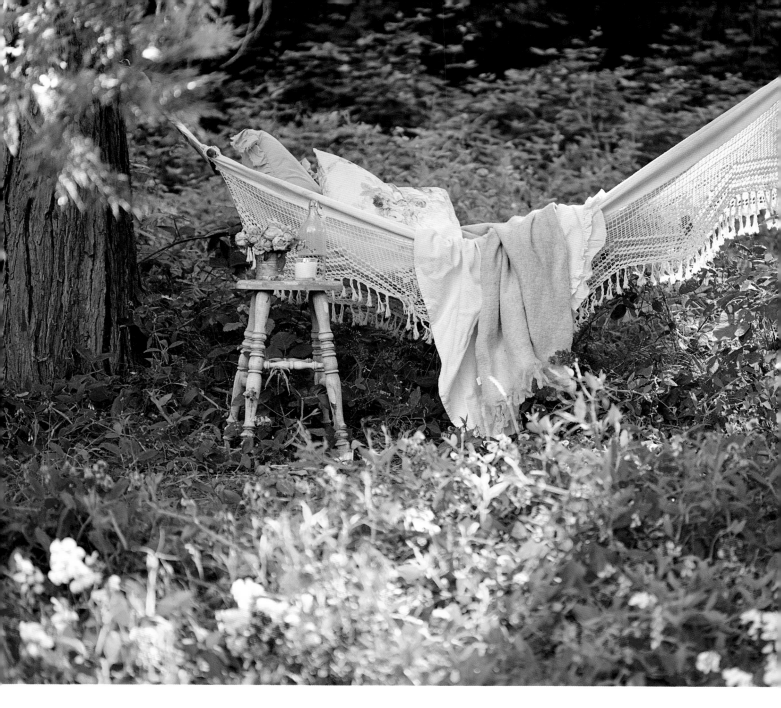

THE HAMMOCK

I love the idea of smaller vignettes in the yard- I tend to think of spots in the yard as little slices. For instance, the front has the fire pit and oak tree, along with the pear trees. Between the pear trees is a secluded spot for a dining table or bench. The patio with Adirondack chairs is another, and the softly rolling landscape and the apple orchard in the far back offers a secluded spot for a fire pit. These little areas create smaller "moments" in the larger view.

When we first looked at this property, I didn't see all of those "moments" on the acreage. We discovered them as we explored after moving here. But that very first time that I drove onto the property, I was drawn to a distinct line of towering old-growth cedar trees that divided the more formal backyard area from the free-flowing country areas. Those cedar trees were originally planted to be perfectly spaced to create an old-style country fence; you can see the old lines in the bark even now, where barbed wire once was. And though the trees are not used as a fence or property break today, in between any two of them is a perfect spot for a hammock.

The hammock is a quiet place to rest. A spot to pause for a moment while clipping sweet peas or hydrangeas or simply grab a book and settle in. I love to layer the hammock with fabrics, comfy blankets, and pillows to create a bit of a retreat feeling.

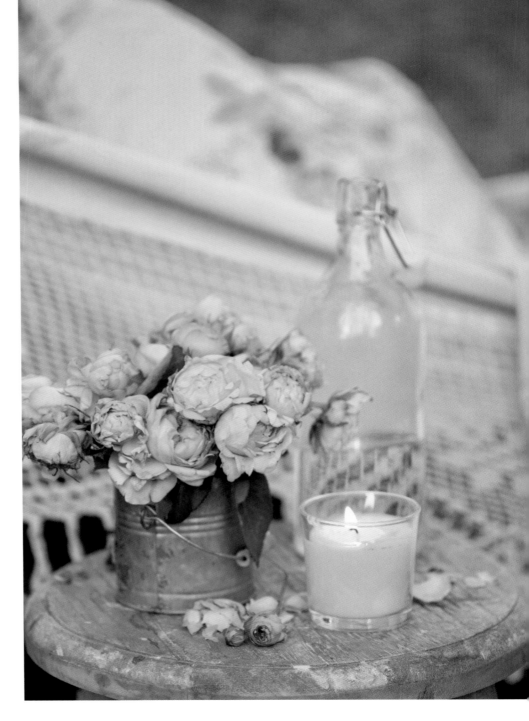

The hammock sits in between two cedar trees just a short walk up the hill from the dining area. If you follow the path from the table, it winds up through the bed of sweet peas, which grow naturally in abundance and carpet the ground underneath the hammock with purple, pink, and white blooms in the spring. The carpet of flowers creates a beautiful view and romantic mood, and beckons you to wander up and enjoy a few minutes swinging in the hammock in the breeze.

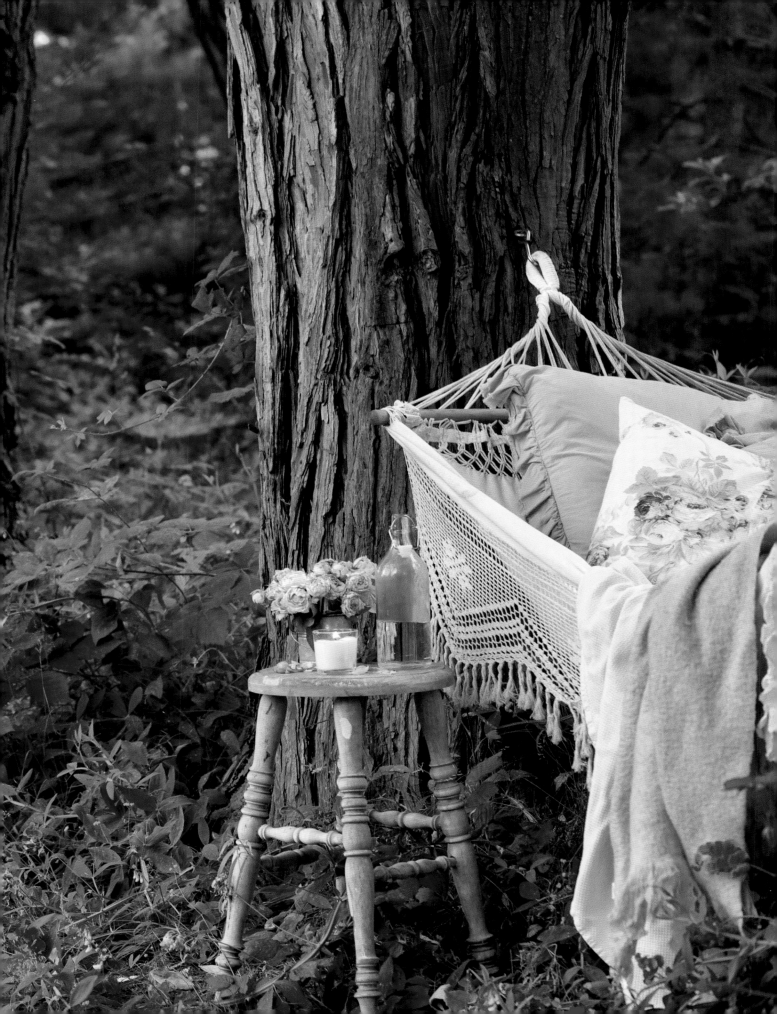

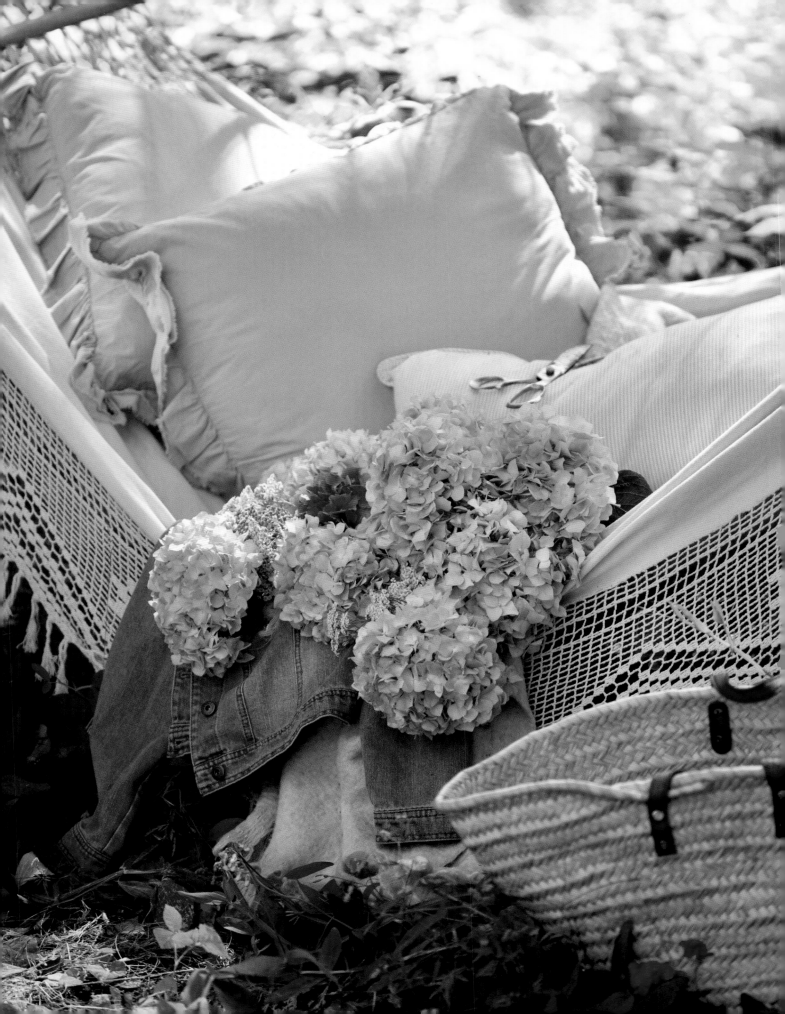

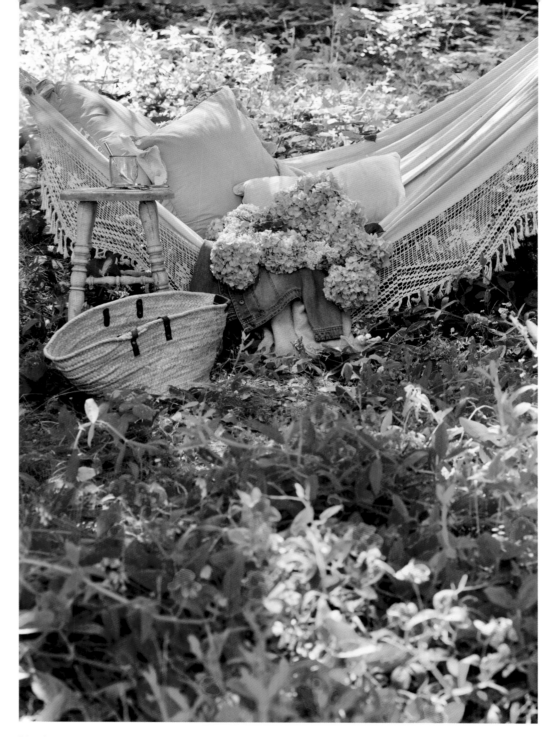

Hydrangeas bloom in abundance in the shady areas of the garden and are always favorites for clipping and taking indoors. We enjoy the free-flowing, rambling look of naturally growing plants like grasses and blooms on the property. Nature creates a beautiful composition, with romantic colors, vibrant greens, and soft yellows mingling. The naturally growing sweet peas are a feast for the eyes and a flower lover's treasure; they cover the hillside at the back of the property from spring to mid-summer, providing a beautiful spot to pause and soak up nature's beauty.

A Table Under the Sky

perfect evening get-together includes your favorites on the guest list, the prettiest of blooms marching down the table, and a dash of ambiance with flickering candles and twinkle lights in the trees. Which all together are like a sprinkle of magic.

I love to arrange a pretty table to set the stage for a beautiful get-together with friends and family. The ambiance and setting is most important to me—I tend to think of the food as the last item on the list when hosting a gathering. A bit backwards perhaps, but creating a place for conversation and treating my guests to a memorable evening that delights are most important.

Setting a table and planning a get-together is a little like writing poetry or composing music. I have been known to spend countless hours imagining and designing the table—from the all-important placement in the yard, to lighting the paths and steps, to placing the twinkle lights in the trees for a little bit of drama. And, of course, choosing the flowers to complement the occasion and arranging all the details at each place setting.

On the table, I like to think in layers—chargers, dishes, linens, flatware, compote dishes, etc. I don't always use the same elements, or the same elements at each place setting; sometimes it is a mix and mingle. And if not bringing in mismatched vintage china, my favorite lace-detailed plates are on repeat most often. I love to mix them with old collected silver or gold flatware and wine stems whose color and style may be exquisitely elegant and refined—or as simple as everyday clear glasses.

Crumpled linens and candles burned low at the end of a lingering evening—a beautiful mess of a table is a lovely sign of a *successful* get-together.

Favorite patterns of collected vintage china create a casual elegance on the table. Drippy candles provide the perfect amount of light for the evening gathering.

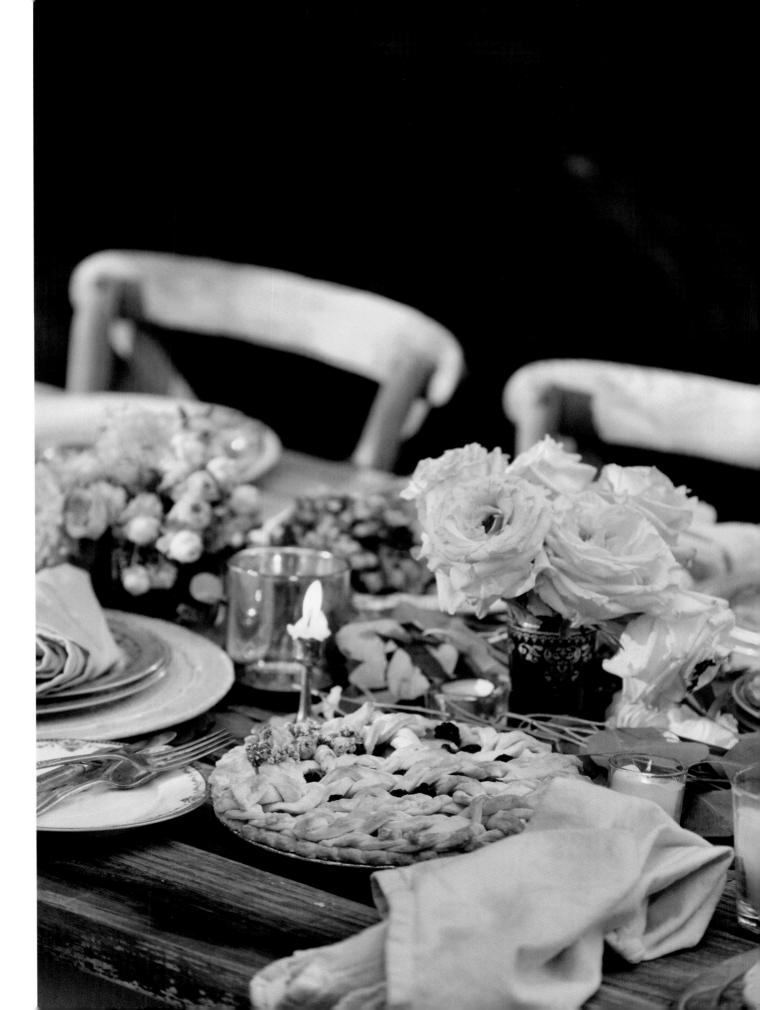

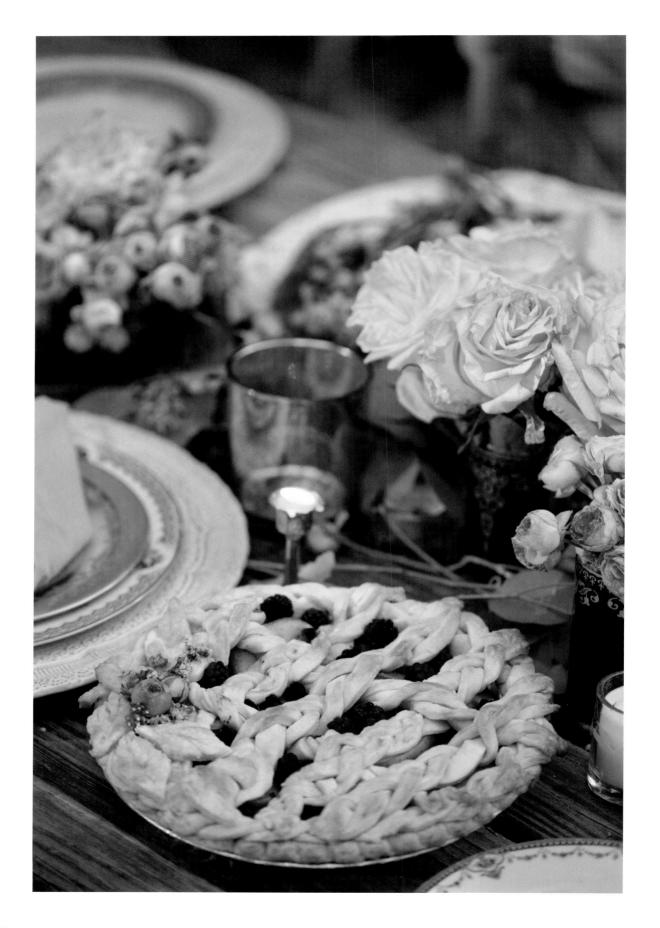

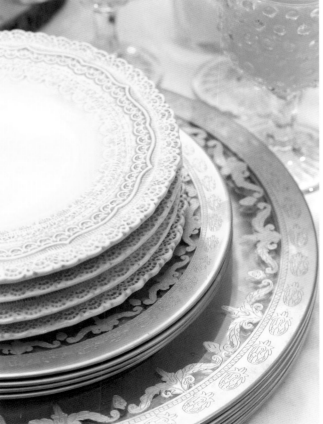

A delicate twisted and braided crust-topped pie is perfection for late summer or early autumn entertaining. Filled with a mix of apples and blackberries, it is a gathered-garden-goodness pie freshly picked from what was ripe. A few tiny spray roses and sprigs of yarrow create a simple romantic finishing touch on the lattice crust.

Not surprisingly, the flowers are the most essential table detail for me. They are my muse, and when creating a beautiful centerpiece for a table, I indulge in a bit of extra time to play with them. Depending on the time of year and occasion, I may use the simplest of bouquets in everyday glasses, a thick garland with seasonal blooms, or admittedly over-the-top full bouquets placed down the center of the table.

For most table settings, I start with the flowers, as their color palette and style dictate what direction the table will go. Ruffly peonies, delicate ranunculus, and delicious, heavy-scented, old-fashioned garden roses are my favorites. I almost always gravitate toward muted colors—blush, apri-

cot, lavender, and creamy whites. And when craving a bit more table-top drama, I will go with pops of deeper pinks and purples, bright coral, and even rich hues of greens and reds on occasion.

Several bouquets in varying sizes march down the center of the table or a lush bed of greenery in the form of clippings or a garland makes a lovely arrangement. A favorite garland embellishment is to tuck a few blooms amid greenery for a romantic touch.

For a less formal but no less enchanting table, gathered everyday glasses and vintage china containers filled with flowers create simple beauty.

I believe that over-the-top is always a good thing when it comes to flowers and table settings, and I freely indulge that belief.

For this table, a garland of lilac blooms and olive branches creates a lovely centerpiece. The wine stems echo the colors of the flowers, while blush linens and lace-detailed dishes mingle with regal gold flatware.

A blueberry-topped rustic cake, a cutting board of nuts and dried fruit, and a chunky loaf of bread are presented for nibbling.

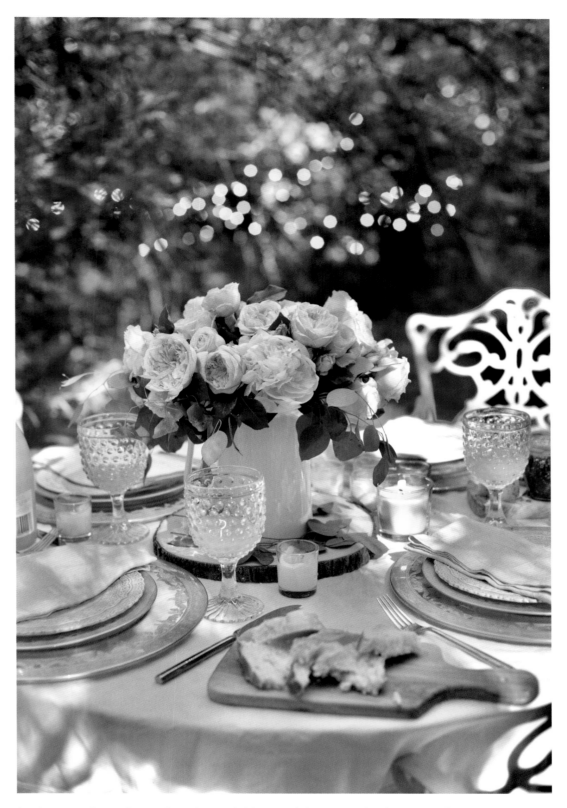

In the small apple orchard, an old iron table is an ideal setting for an intimate gathering. Gilded dishes, soft blooms, and a string of twinkle lights in the tree branches add charm to this little hideaway spot.

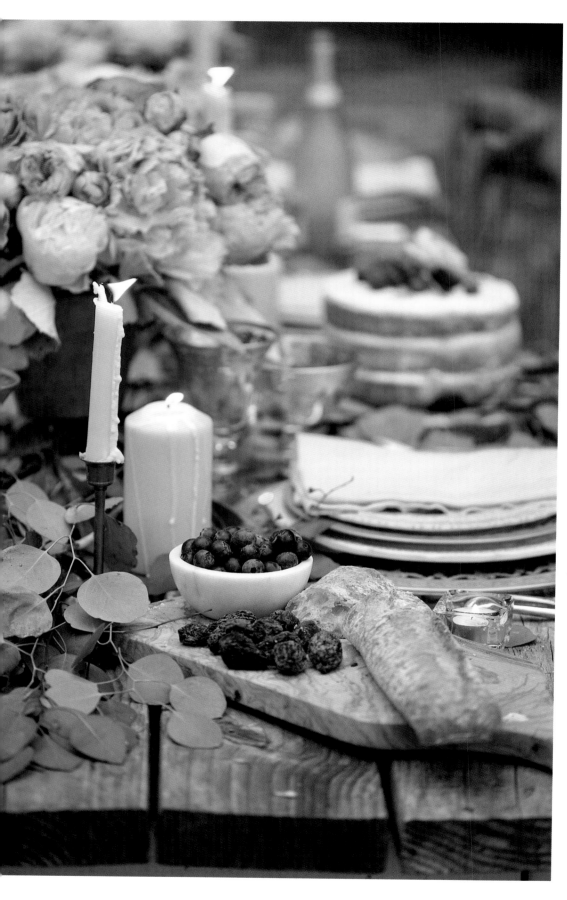

Blush candles and linens mingle with the gilded details on the dishes and stemware. Cottage-style arrangements of ruffly peonies and tiny spray garden roses embellish the center of the table.

Vintage brass candlesticks march down the center of the table to set the mood. Their less-than-perfectly-straight profile and a bit of a breeze bring the most delightful bits of wax dribbles and charm to the candles.

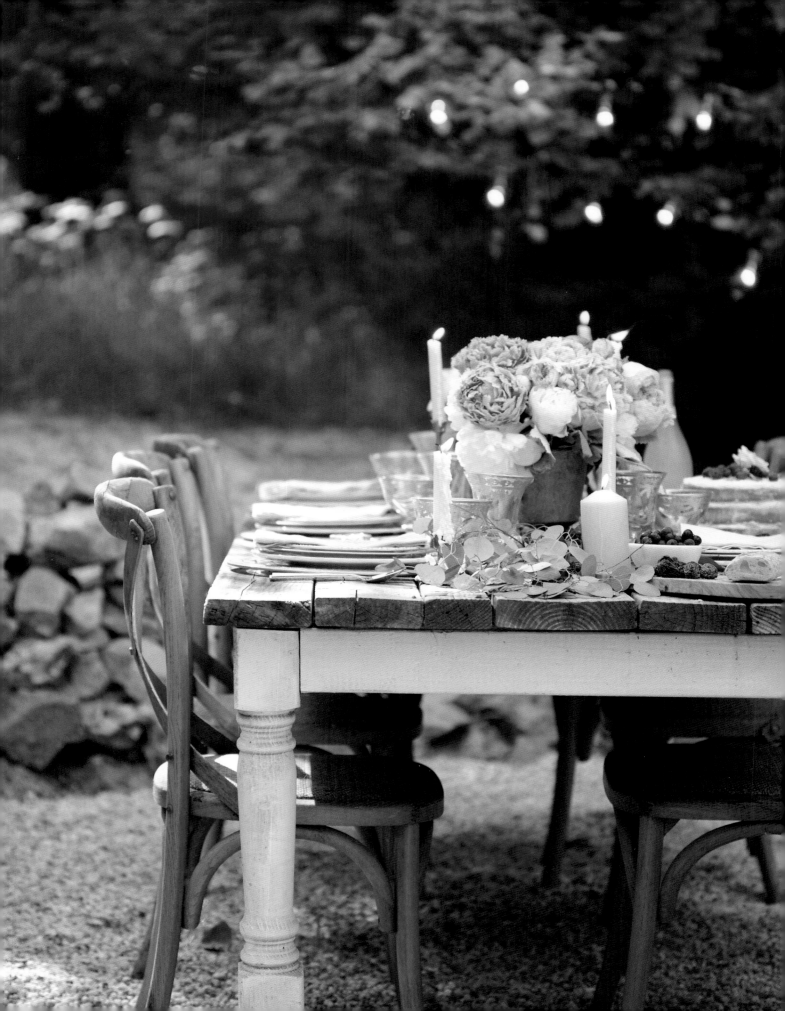

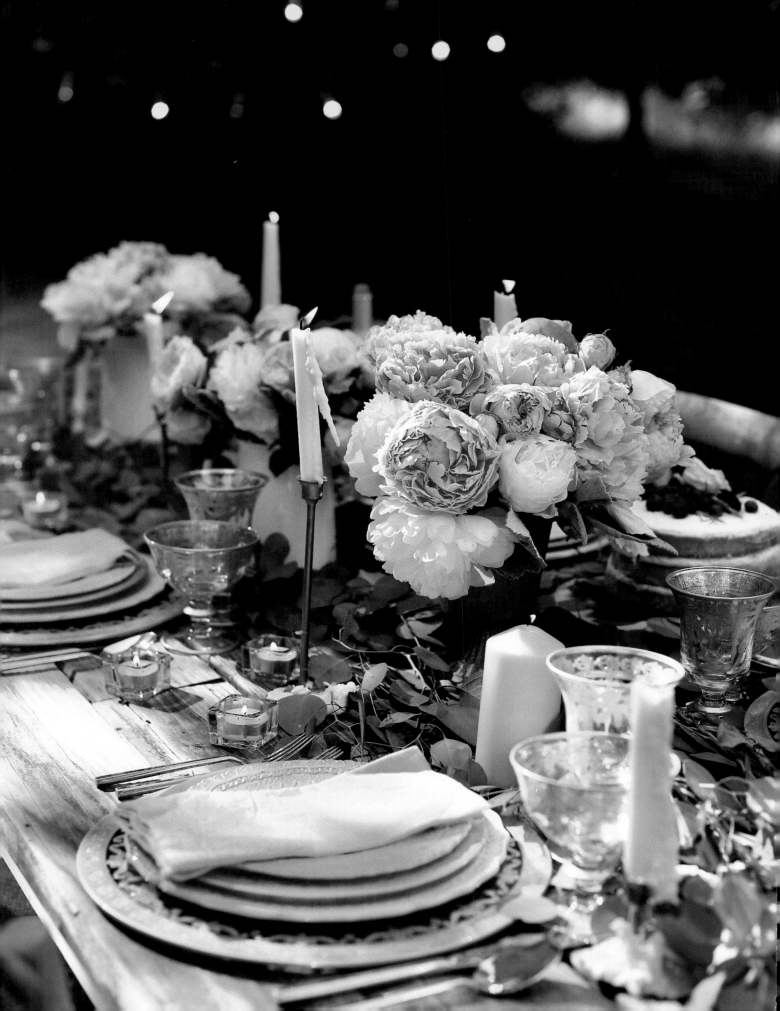

CELEBRATIONS

Even the most ordinary of days is a perfect day to celebrate. So often, we save our pretty table settings and decadent desserts for special events like birthdays or anniversaries. But it doesn't have to be a special occasion to bring home a pretty cake from the bakery, set a table with your grandmother's dishes and flowers, or even just light a few candles with dinner to make it feel more like an evening out—even if it is a Tuesday. Sometimes, those everyday elegant dinners are the most memorable since they are full of conversation in a relaxed setting that invites everyone to linger over dessert a bit longer.

However, when it comes to birthdays, graduations, and other events that we want to celebrate in a big way, these are occasions when we can indulge and bring a much more crafted event to the table, creating a party that guests will remember for years.

For a birthday party once, I set my beach bicycle in the front yard with a bouquet of balloons tied to the back. It was a festive prop that said "Welcome" to partygoers in a whimsical way and also created a fun spot for guests to take photos. I have dozens of pictures of the kids posing on the bicycle that day—wonderful photo booth memories.

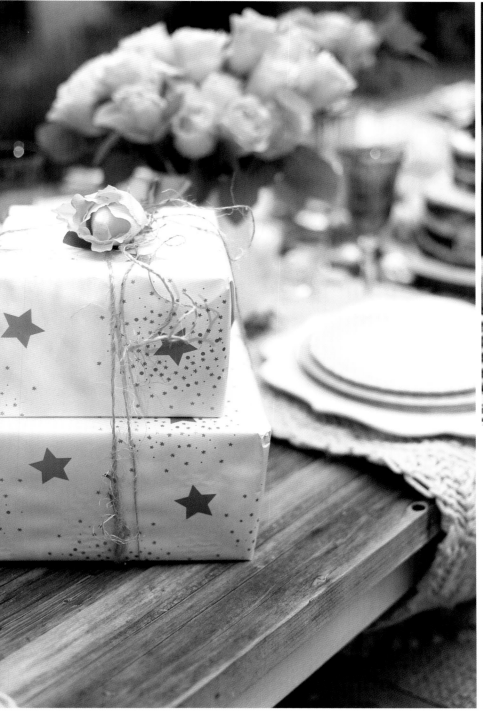

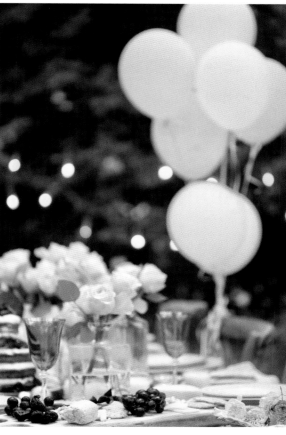

Layers of chocolate cake and frosting topped with fresh fruit and flowers create a dessert that looks pretty on the table while waiting to be enjoyed.

Blush-and-gold-wrapped presents tied with jute and topped with a bloom wait to be unwrapped, and balloons tied to a chair and twinkle lights in the trees set the ambiance for a charming outdoor party.

The first time I tried to make my grandmother's secret dark chocolate fudge recipe, it was not a success. It just didn't firm up like it was supposed to, and to be honest, though I have tried to make it several times, I don't think I have mastered Grammy's recipe yet.

But there is one thing that I love to bake and that has turned out perfectly: chocolate chip cookies. When I was first married and learning to bake, I had a special recipe I found and loved. Always one to add a little extra pinch of this or that when baking, I added just a bit of a different amount of something to the mix one day, and the result was the most delicious bites of buttery, ooey-gooey chocolate chip goodness. Our friends would request them when they were coming over, and my husband and kids would eat them as quickly as I could make them. After making them a half-dozen times—tinkering with and perfecting the recipe further—those favorite chocolate chip cookies inspired me to bake other decadent treats.

When we lived in the Midwest, I would bake to help warm chilly winter days and for after school treats, and now that my kids are grown up, I mostly bake cookies and sweets during the holidays or for special occasions. A couple of new favorites have moved into first place ahead of those famous cookies. If it isn't a delicious homemade cheesecake, I love creating a flower-topped treasure.

Always elegant and stunning on the table, flower-topped cakes are some of my favorite desserts to make. Whether frosted or more rustic, those layers of cake and frosting are delightful, with the flowers—much like the icing—on the cake to finish it. The main thing is to be sure the flowers are safe, meaning edible, organic, and washed—even if they aren't meant to be eaten and will simply be enjoyed visually—and use a barrier in between cake and flowers. If not using real flowers, you can use exquisite sugar creations in place of favorite blooms.

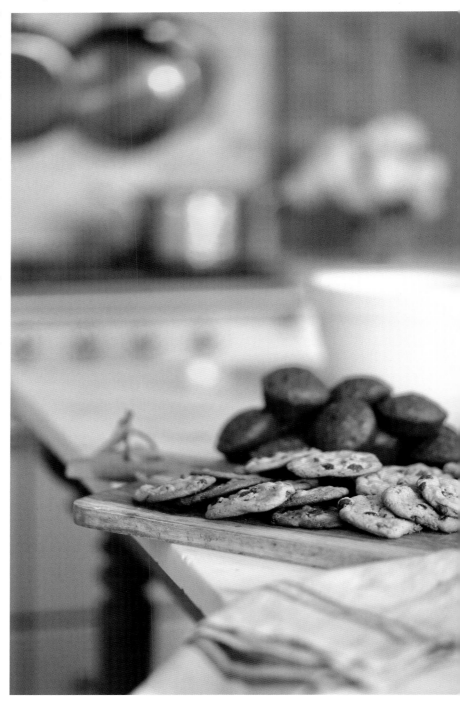

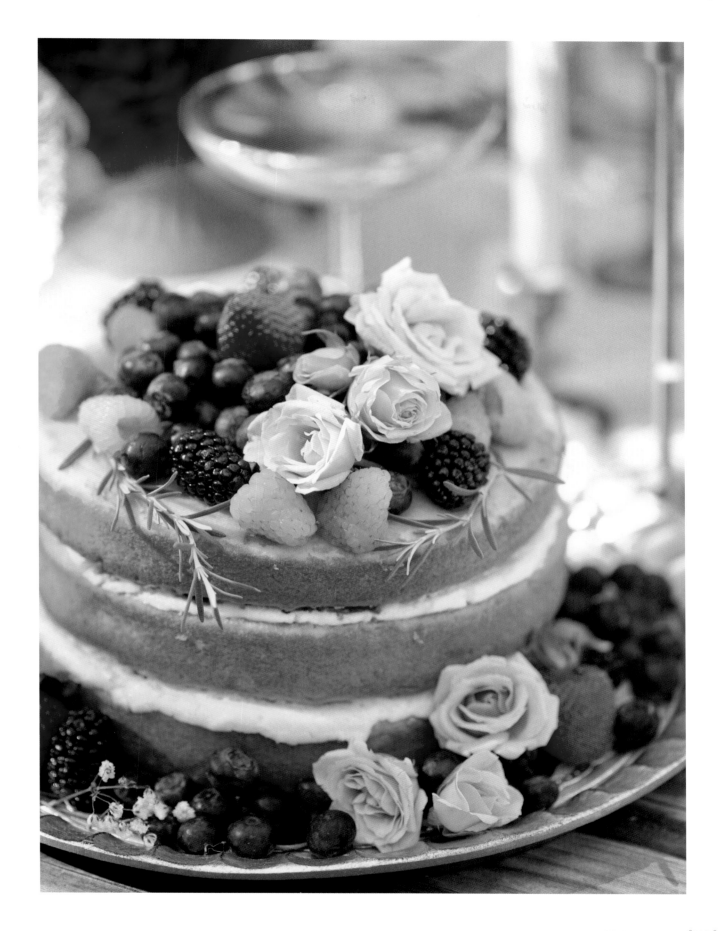

Autumn

"Over the river and through the woods / to Grandmother's house we go" wasn't just a verse in a favorite holiday song for me. Every year, we would travel to the mountains in California for Thanksgiving. And our drive along the small, barely two-lane road that led from a quaint old historic town up the mountain to my grandmother's house was one that was filled with anticipation.

Not being a traditional autumn-color-loving girl, indoors I embrace the softer side with muted fairytale pumpkins, baby boos, cabbages, and flowers mixed with natural elements such as wheat and eucalyptus. Outdoors, I find a mix of variegated squash and pumpkins along with some of those traditional rich colors for a bit of seasonal fun.

In autumn, I embrace the crisp air and leaf-covered lawn. Nature at this time of year just seems to invite a yearning for apple cider or hot cocoa by a bonfire out under the stars. And, of course, there are the pumpkins. From rich, saturated, traditional oranges to deliciously muted soft colors, pumpkins and squash come in a wide array of colors, shapes, and sizes. They bring an abundance of autumn charm when gathered on the front steps, lining garden paths, or mixed with flowers on the mantel.

Though I am far from traditional when it comes to incorporating those bold autumn colors in the house, I enjoy some of the natural elements that wear those shades and textures. Some of my favorite indoor autumn elements are things like wheat, wood bins full of dried hydrangeas and other flowers, bowls brimming with fresh seasonal fruit, and Cinderella-type pumpkins in subtle tones.

Pumpkins are kind of like the flowers of autumn, providing an *abundance* of beauty to the season. In a myriad of shapes, sizes, colors, and styles, they line the pea gravel path to the greenhouse, creating an autumn *festival* or pumpkin-patch feeling.

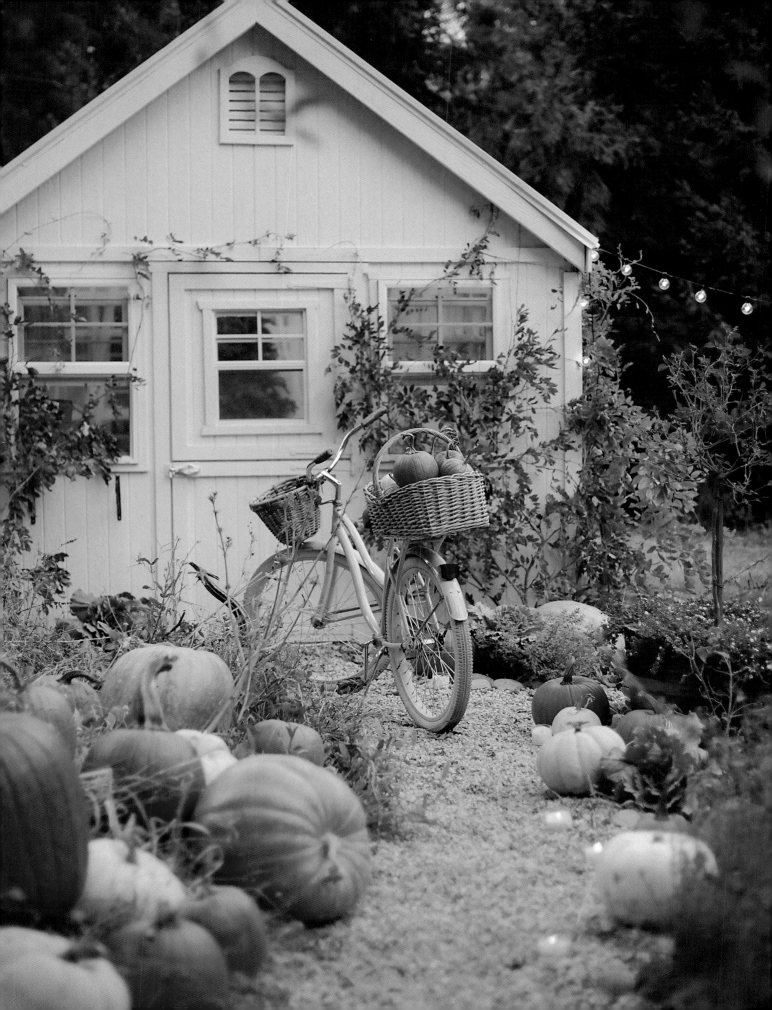

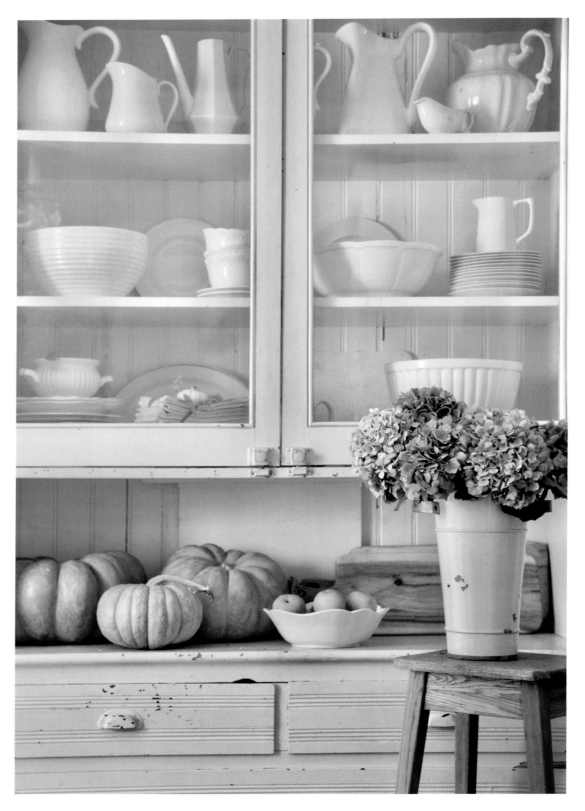

Heirloom pumpkins and a bowl of fruit decorate the china cabinet, and inside the doors, a sprig of eucalyptus and the tiniest of baby boo pumpkins perch on a stack of napkins.

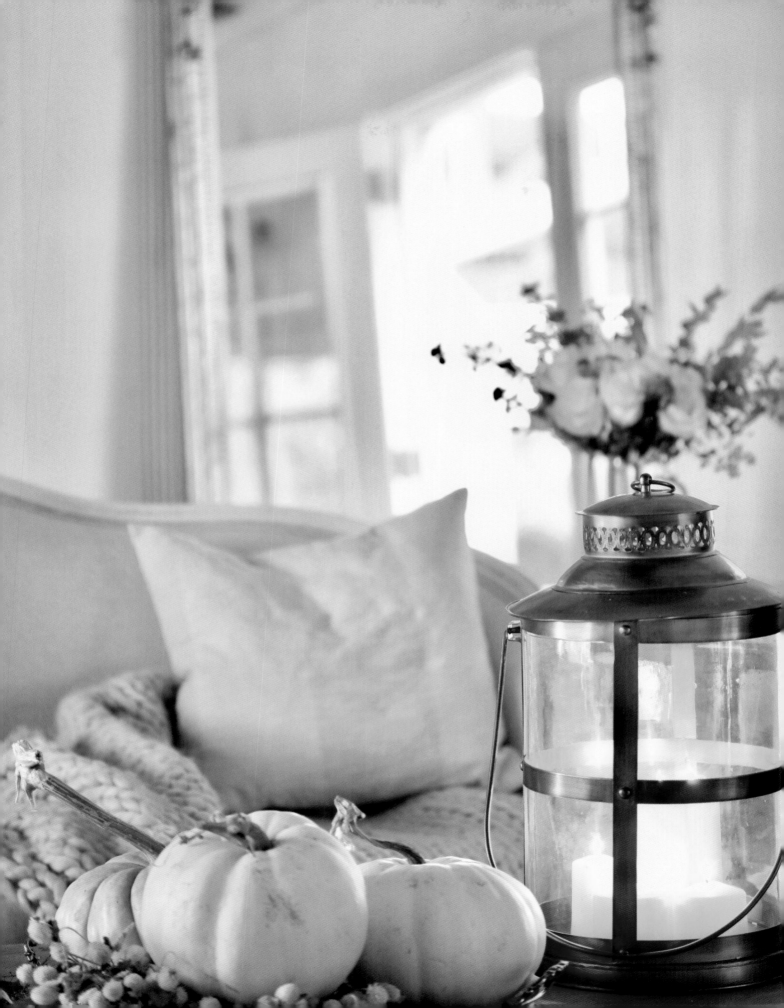

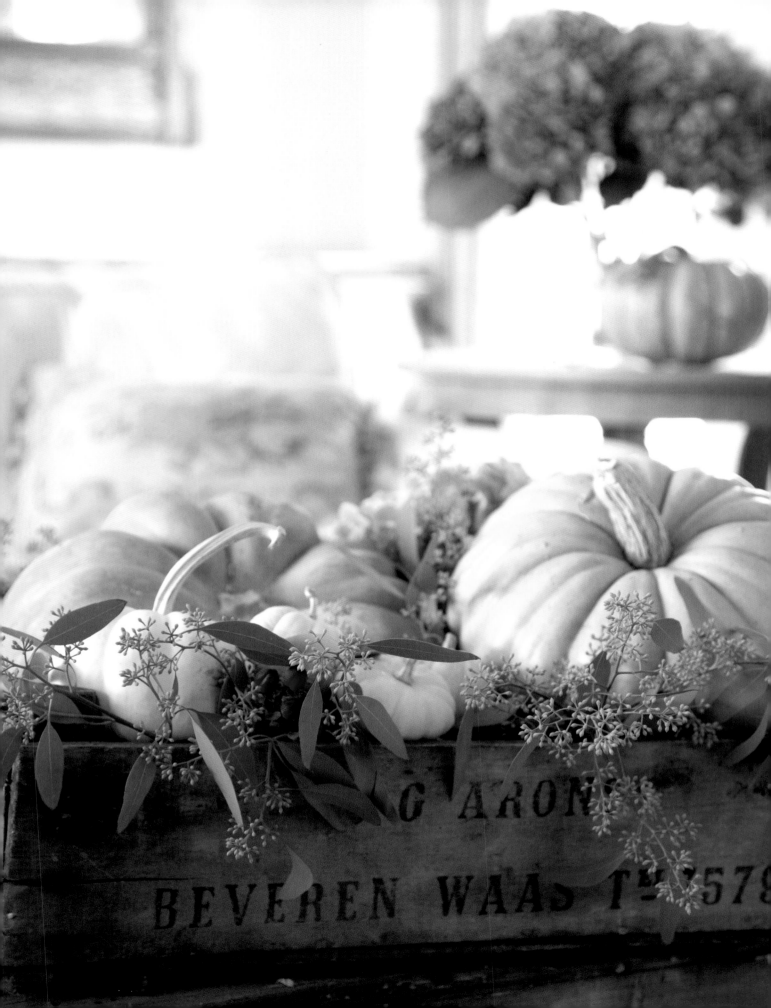

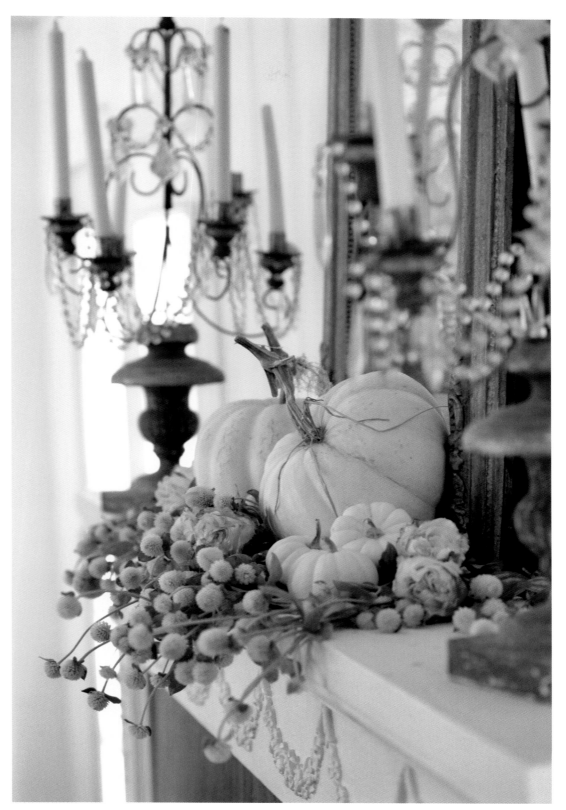

An old crate filled with dried flowers, greens, and a bevy of pumpkins creates a lovely vignette on the coffee table, and on the mantel, dried florals and white pumpkins are a simple natural decoration.

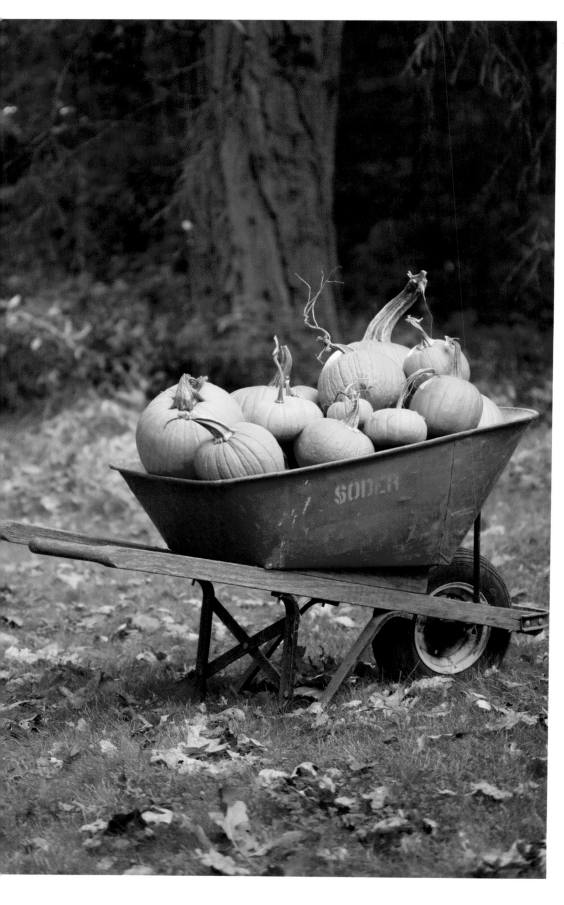

A weathered wheelbarrow filled with pumpkins galore is a simple, charming moment.

In the bedroom, a natural-leaf gar–land that dried to perfection provides a delightful, muted color for mixing with brassy golds, wood candlesticks, and little baby boo pumpkins for seasonal decor.

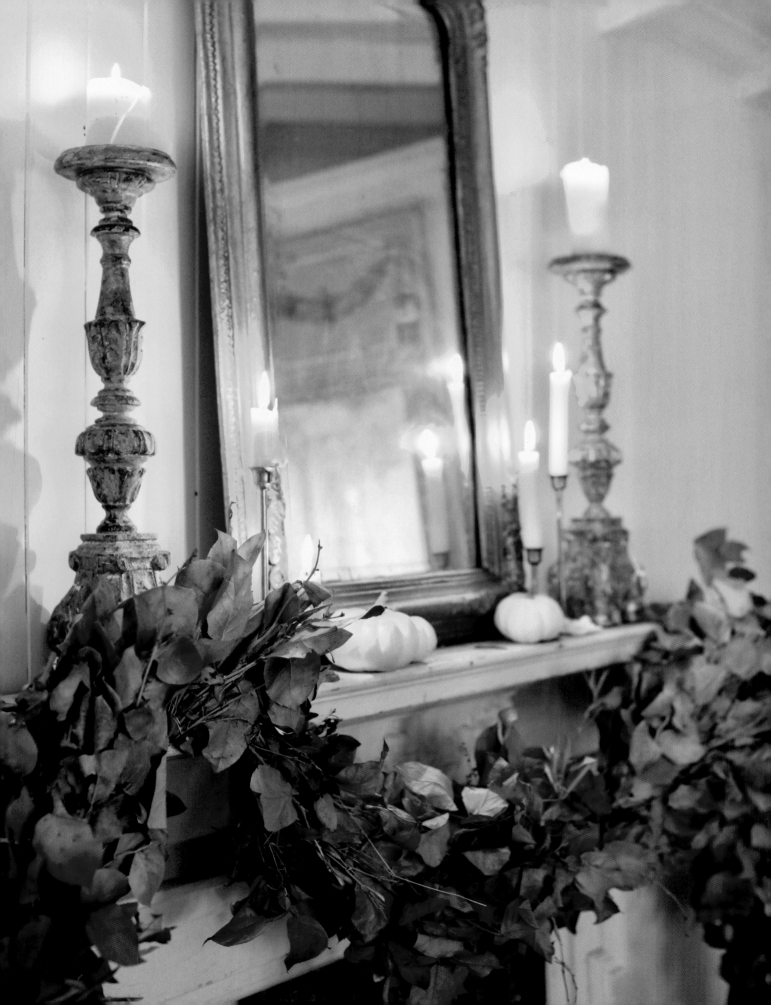

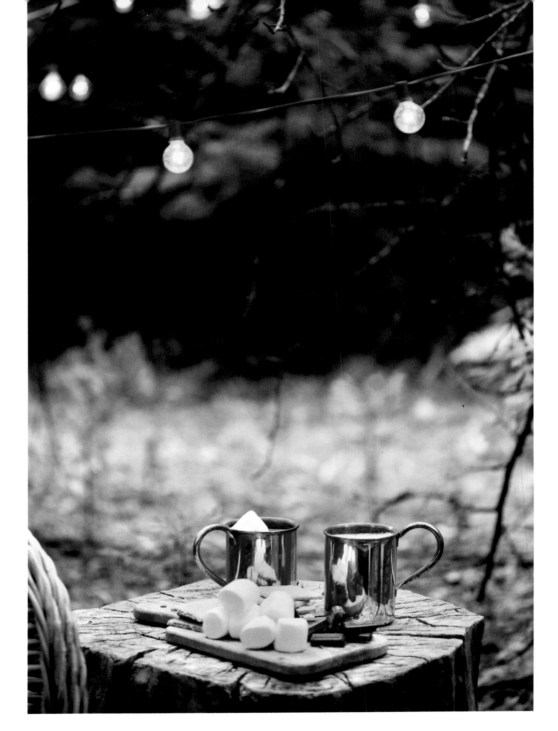

FIRE PIT

Set behind a line of trees and the hammock—if you follow the informal path—you will find the remnants of an old apple orchard tucked into the hillside. Though the apples that do grow are small and the trees no longer produce more than a few handfuls of fruit each year, I love the knotty trunks and bark they have and their wild, fairytale silhouettes.

This area wasn't a place where we landed much originally—since it is a bit more removed from the house—but one day while setting up a table, I was inspired by the old finger-like branches of the apple trees and the lush backdrop not far behind them and wanted to create a couple of quiet moment areas—one of them being a fire pit for campfires, roasting marshmallows, and sipping hot cocoa under the wonder of stars.

In the fall, the trees are covered in colorful leaves and the ground is dotted with them as they fall, which makes this a fun spot to place a few loads of chunky pumpkins around the fire pit and enjoy an autumn evening with a cup of spiced apple cider.

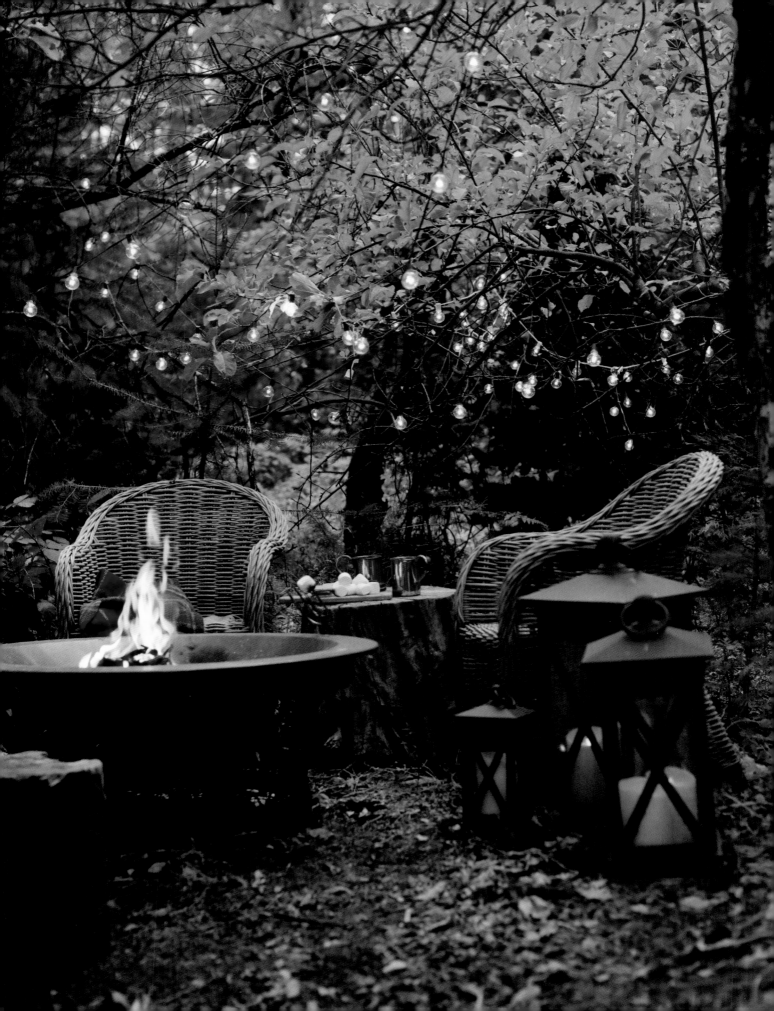

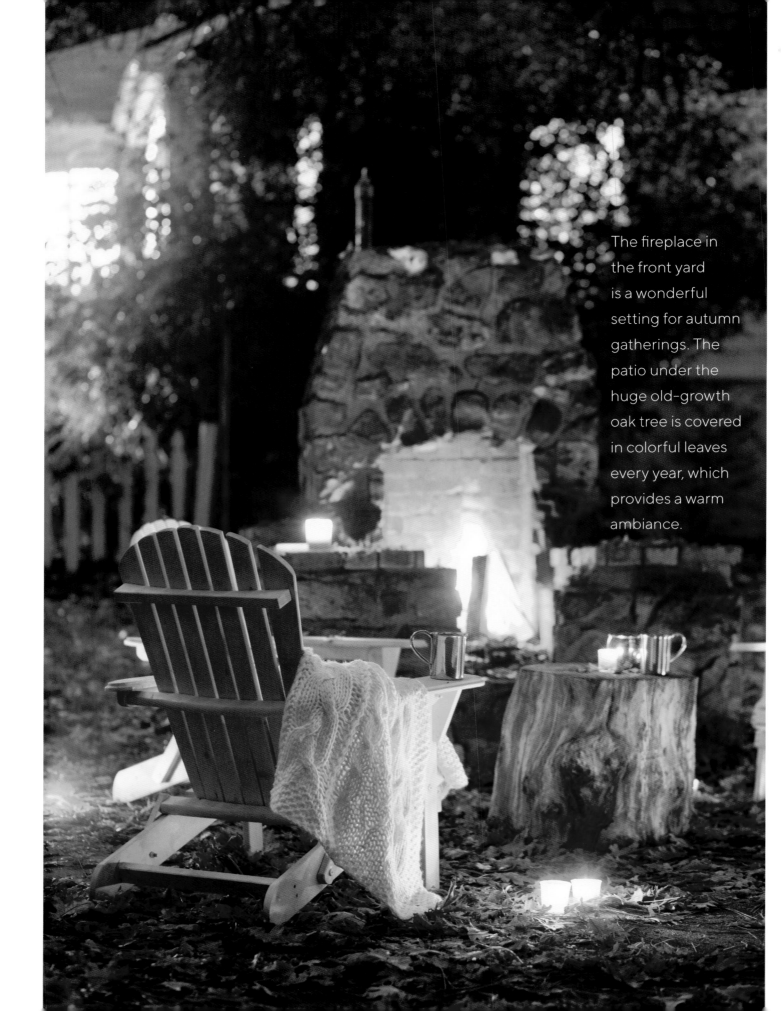

The fireplace in the front yard is a wonderful setting for autumn gatherings. The patio under the huge old-growth oak tree is covered in colorful leaves every year, which provides a warm ambiance.

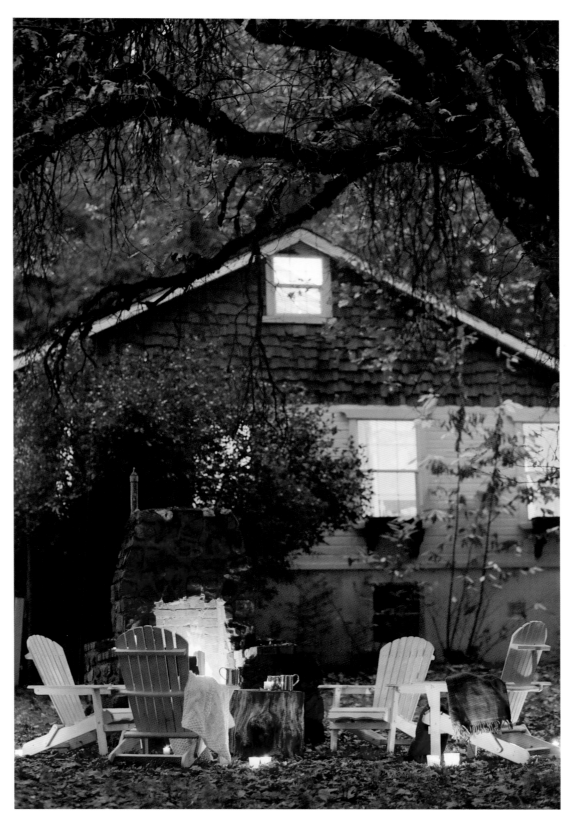

I remember the first time I saw the large rock fireplace under the oak tree in the front yard. The size of the tree by itself was enchanting but an old original rock fireplace underneath it created an even more enchanted spot. My favorite time of year to enjoy this area is the spring or the fall, when the trees are full of new bright green leaves or when the oak leaves surrounding the patio change colors.

Christmas

When I became a parent, I could see all the wonder, enchantment and beauty of Christmas through my children's eyes—and it was even more than I remembered feeling as a child. The magic that fills the Christmas season is something that I enjoy indulging in for much longer than the usual season. With fresh wreaths on the doors, eucalyptus and cedar garlands on the mantels, and twinkling trees in almost every room, my love of Christmas brings holiday cheer throughout my home much as my love of flowers and chandeliers does.

The first year that I decided to put up more than one full-size tree was when the kids were still little. I loved our family tree in the living room that twinkled from morning until bedtime—but the minute we left the family room, the rest of the house felt bare. So I started by adding a tree to our bedrooms—I wanted to enjoy those twinkling lights while relaxing or working from bed. And my daughter loved having one of her own. And then down the hall to add a bit of Christmas cheer in those in-between spaces. And I even set up trees outdoors, under the covered patio or by the orchard to add a bit of sparkle and magic.

In the little cottage, we have a large nine-foot tree in the living room and another in the bedroom to welcome the kids or guests who may come for a visit. The living room tree twinkles in the window at the top of a long driveway, which spreads a bit of cheer to passersby as well.

Though an abundance of Christmas is sprinkled throughout the house, I tend to like my trees decorated on the simple side and want them to fit in with my every-day color palette and look. My favorite trees are the ones that are frosted or sprinkled with a bit of faux snow. On the frosted trees, you will find muted colors and decorations that let the tree and twinkle lights do much of the talking. And to complement the faux trees and add a bit of fresh Christmas scent to the house, I bring in lots of fresh greens and garlands for mantels and stair railings as well.

Christmas was always my most favorite time of year while growing up. And I think that feeling and those memories are the reason I enjoy the *holiday* season so much as an adult.

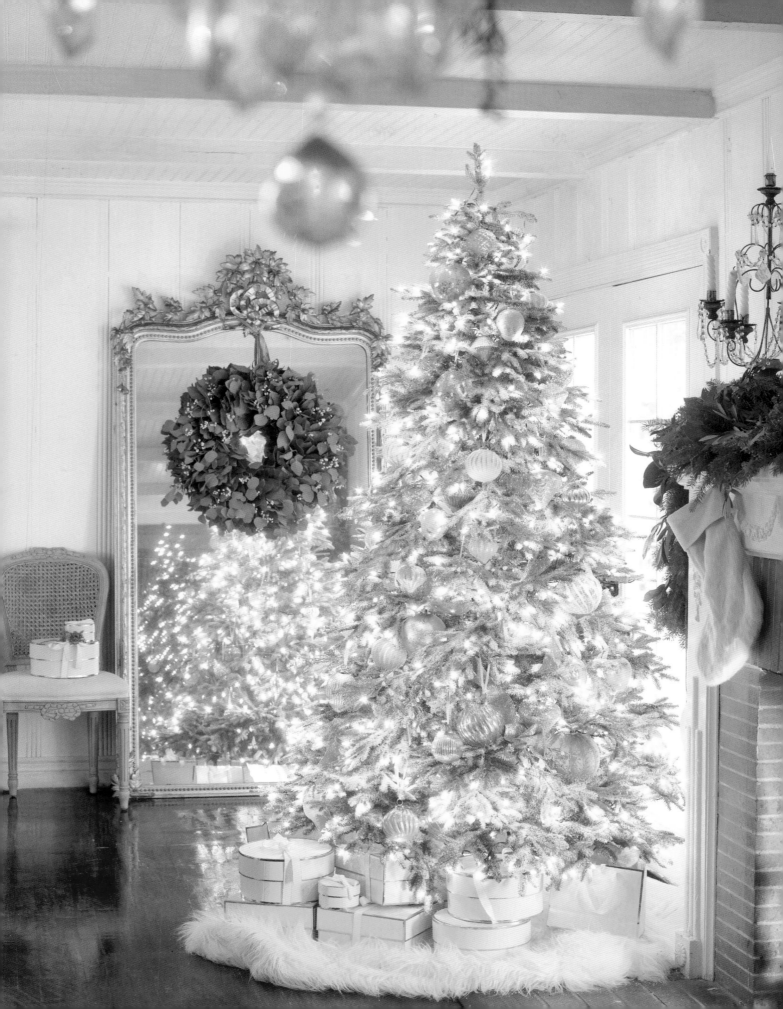

These deer were my grandmother's and are one of those things that bring a touch of sweetness along with memories. Chunky stockings get an extra-festive touch with a couple of small ornaments on the loops, which also provides a way to distinguish whose is whose when the stockings otherwise look all the same.

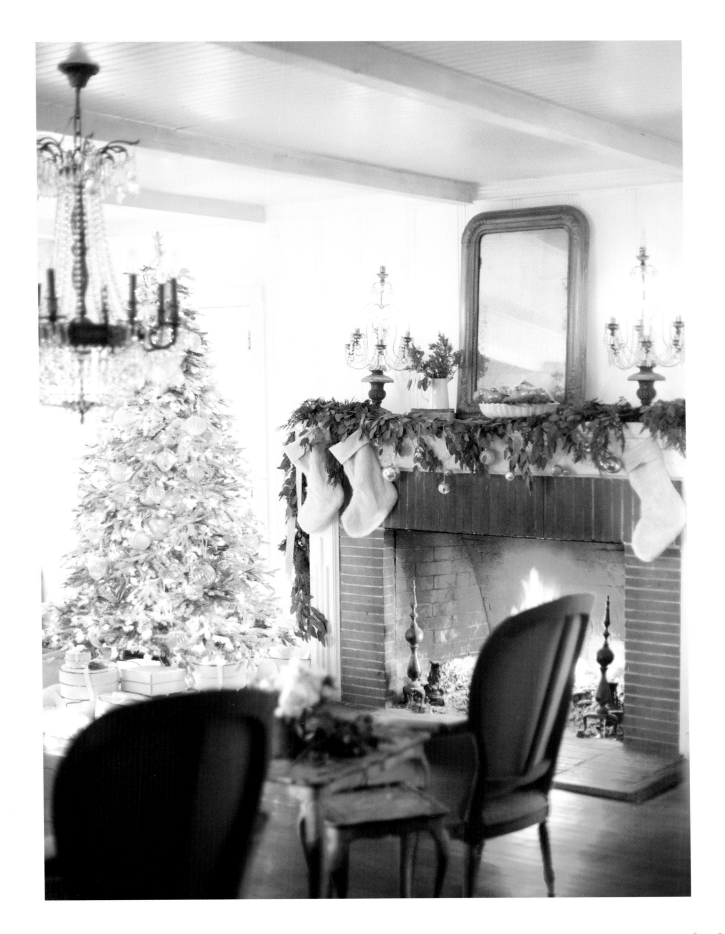

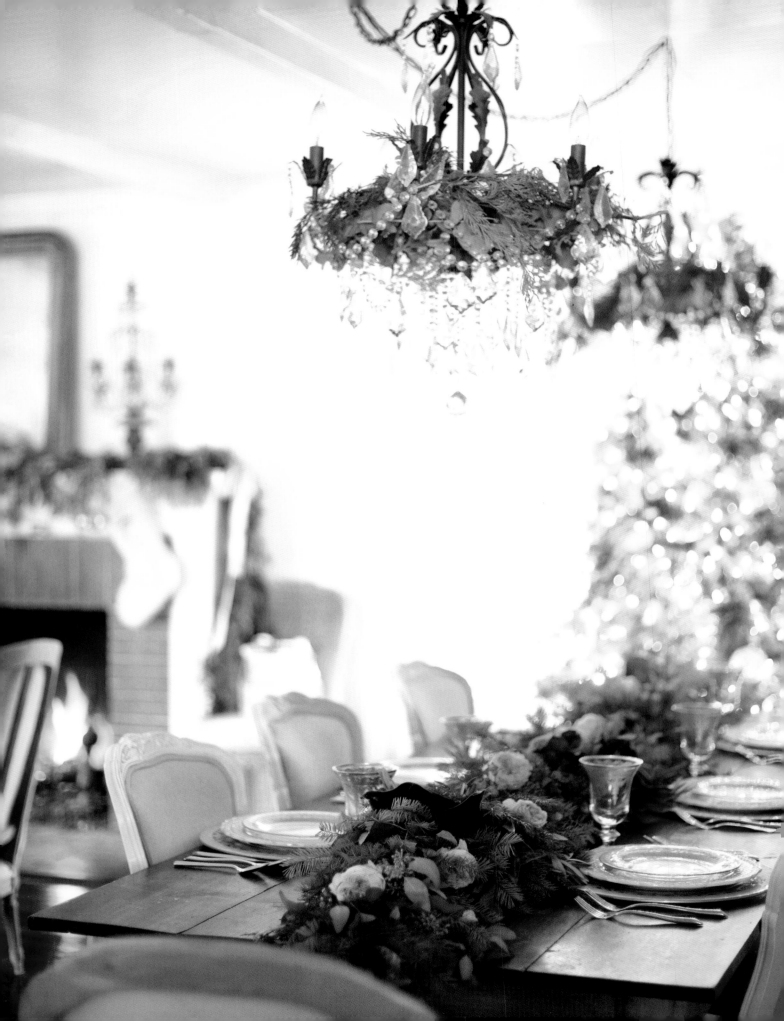

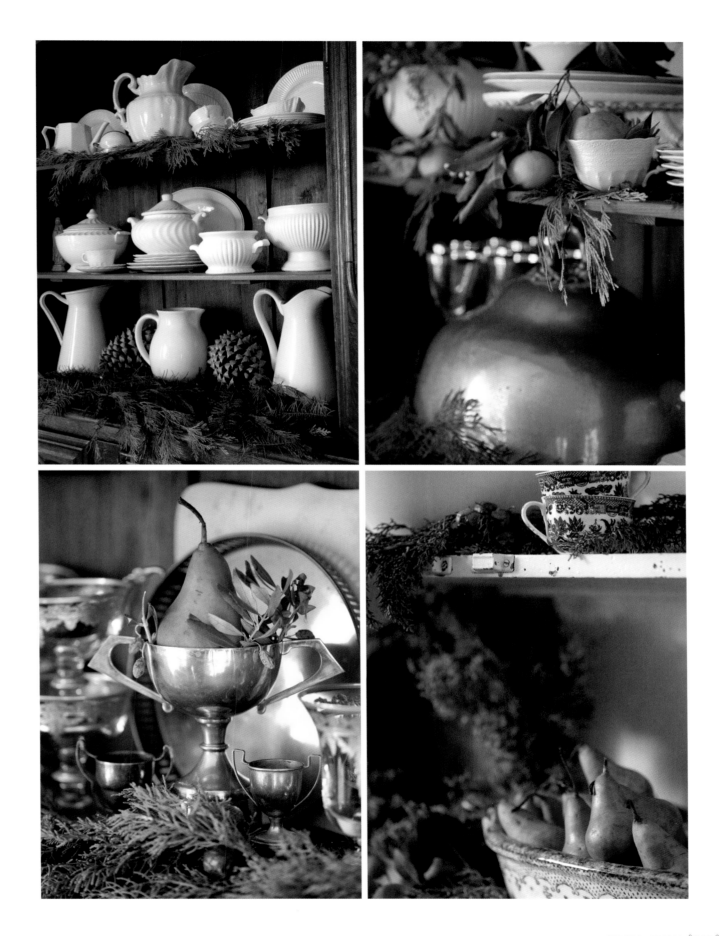

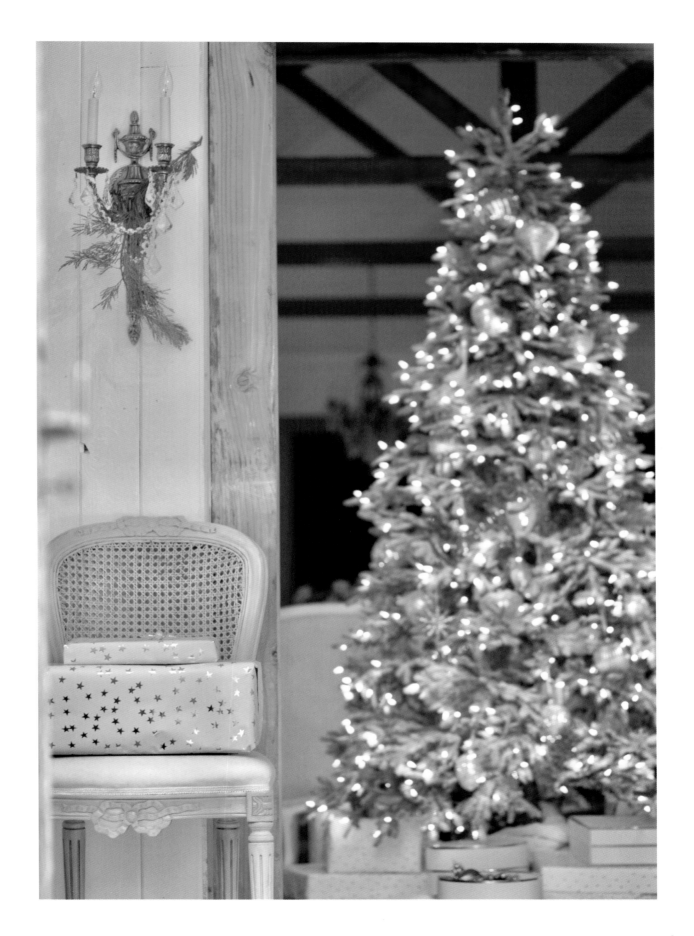

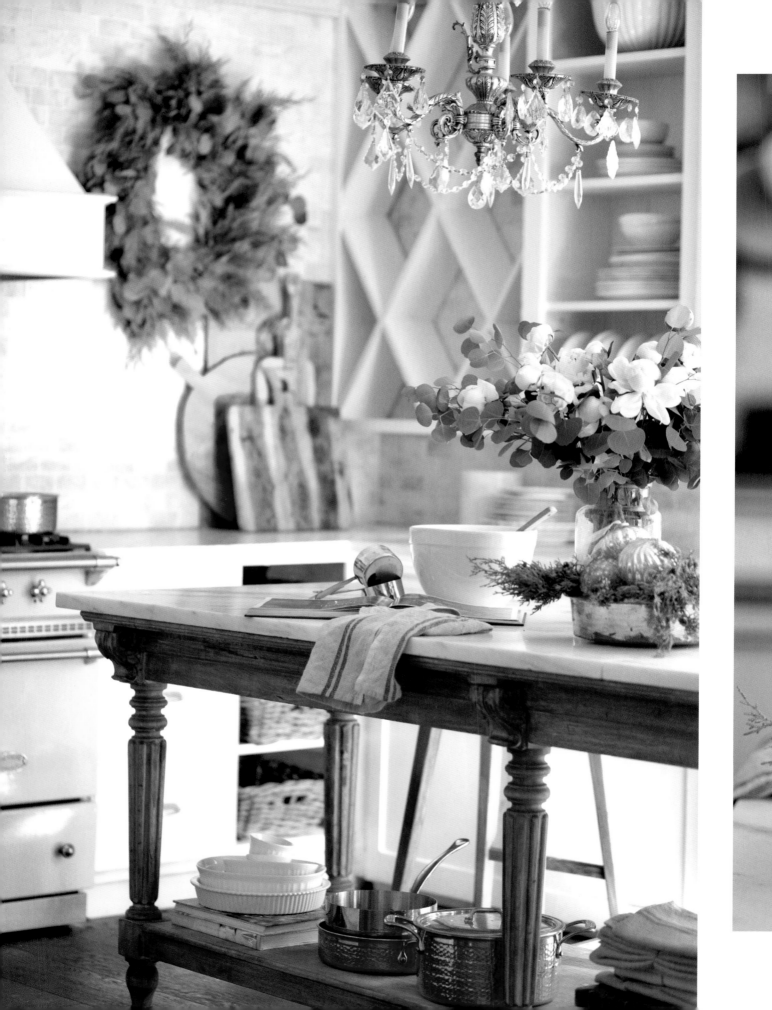

In the kitchen, containers of French country baubles, clippings, and a fresh wreath are all that is needed for a festive feeling.

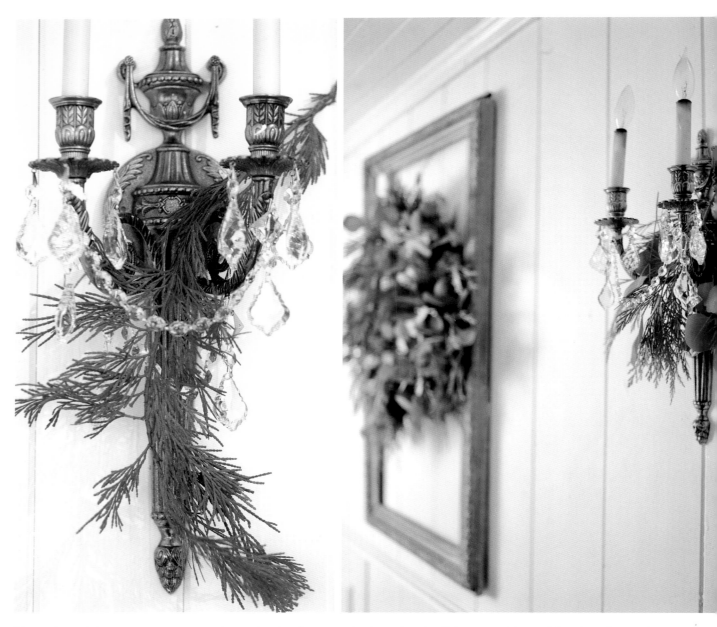

I love to add greenery everywhere in the house during the holidays—sprigs of fresh-clipped greens tucked into sconces in the hallways, a fresh garland draped on the stairs, and a green wreath inside an empty frame add a festive touch without overwhelming.

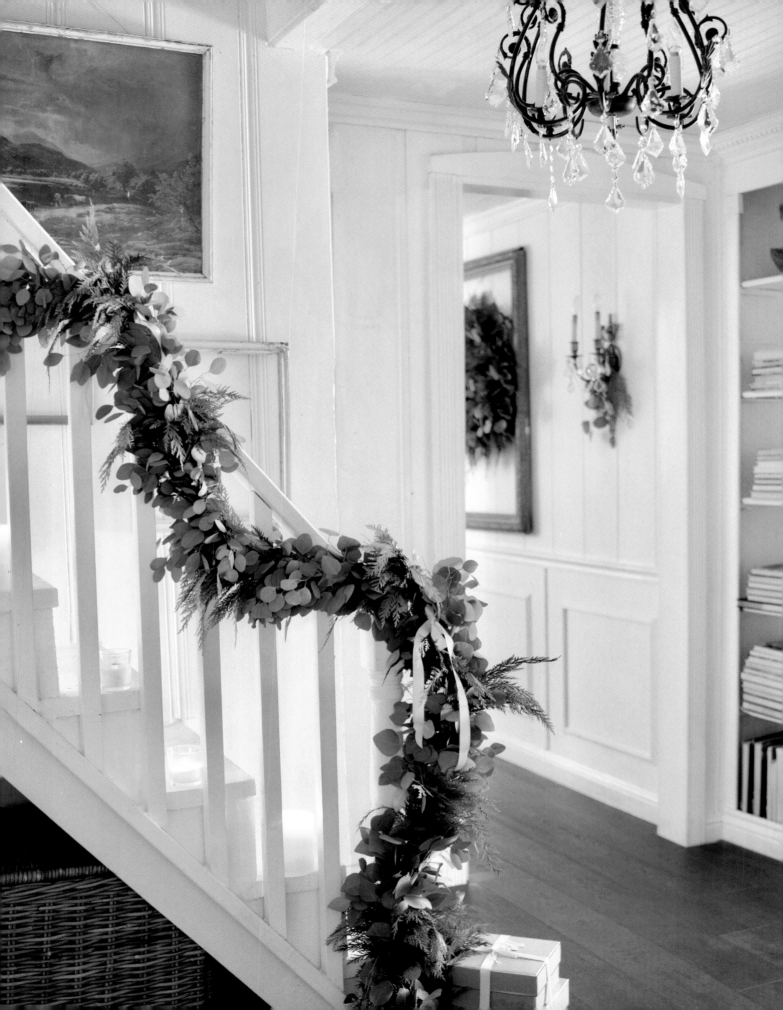

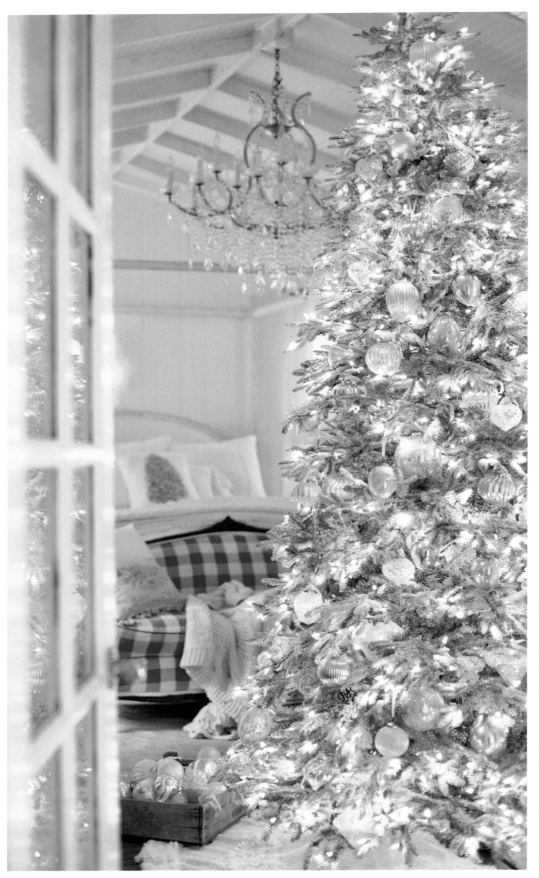

In the bedroom, a little bit of vintage and a little bit of new. I vary the look here each year, but there is always a tree; this one is an artificial Fraser fir from Balsam Hill. I often decorate the tree in my favorite blush, white, and mercury-glass colors. I keep the bed area festive with clippings of juniper and flowers on the nightstand and a few ornaments, and let the mantel and tree do most of the talking. In the guest bedroom and in the bathroom, fresh greens seasonal touches are perfect.

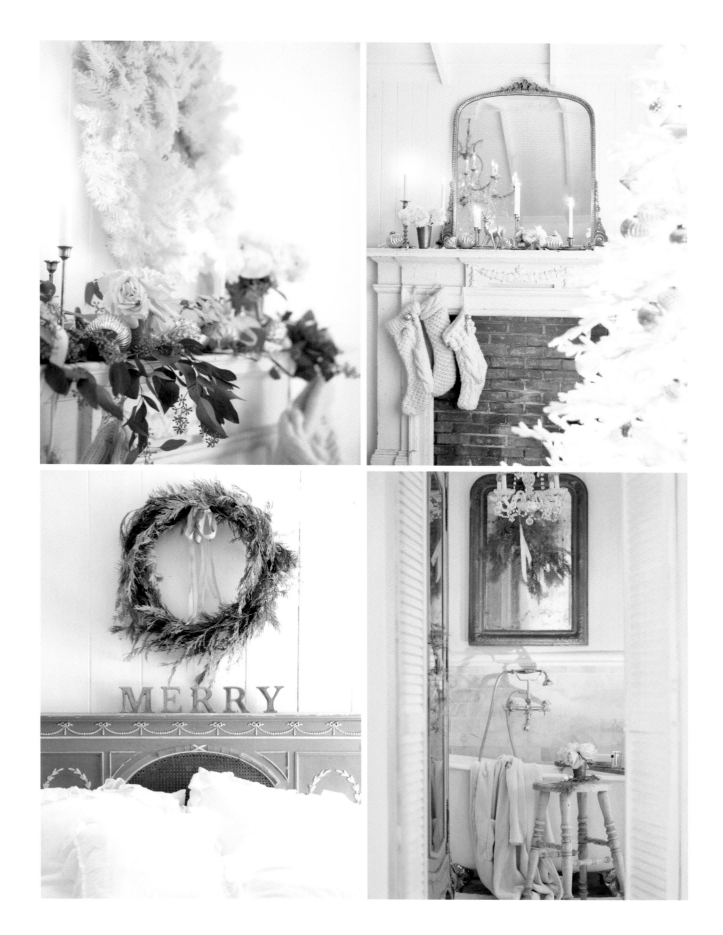

My office mantel is dressed with fresh eucalyptus and flowers that mingle perfectly with a crisp white Christmas tree covered in vintage-style blush baubles and a pearl garland.

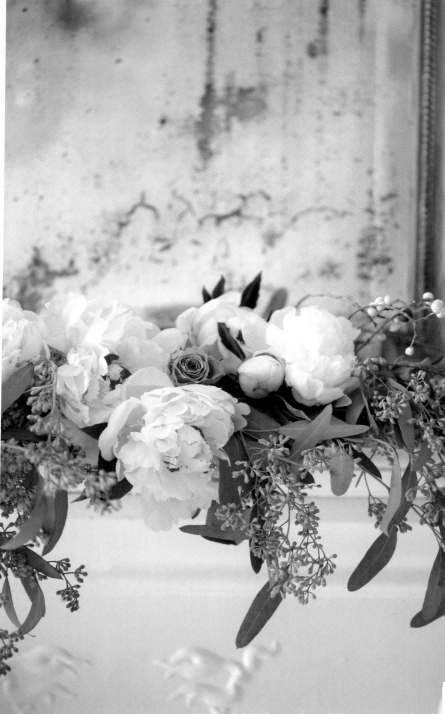

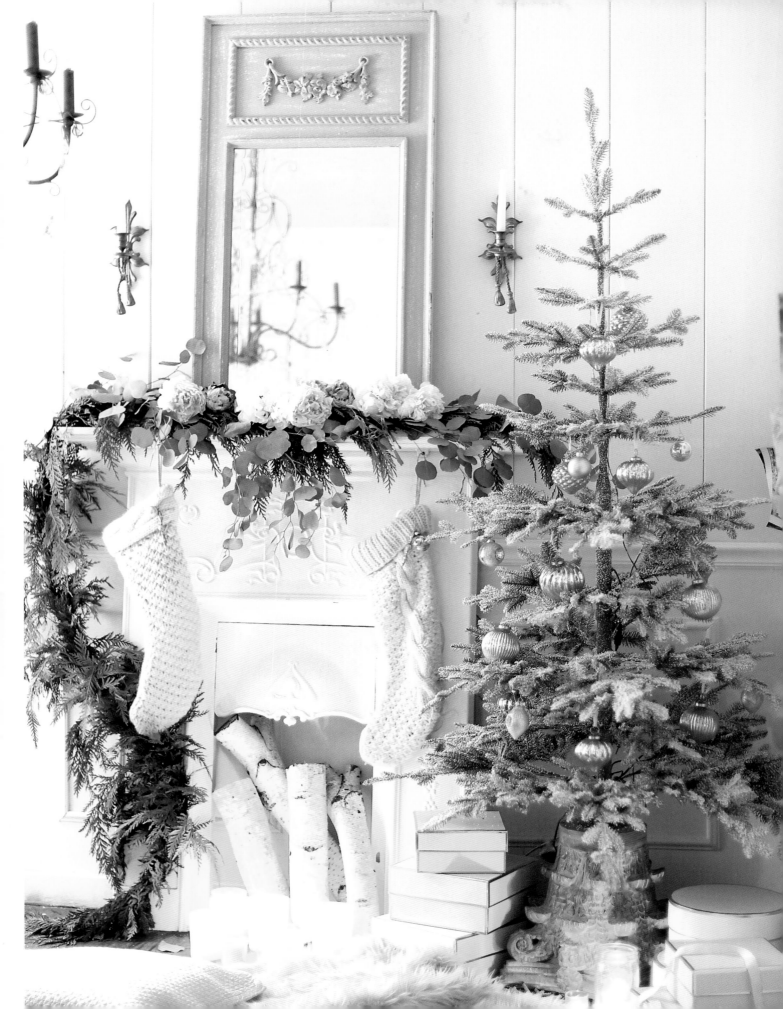

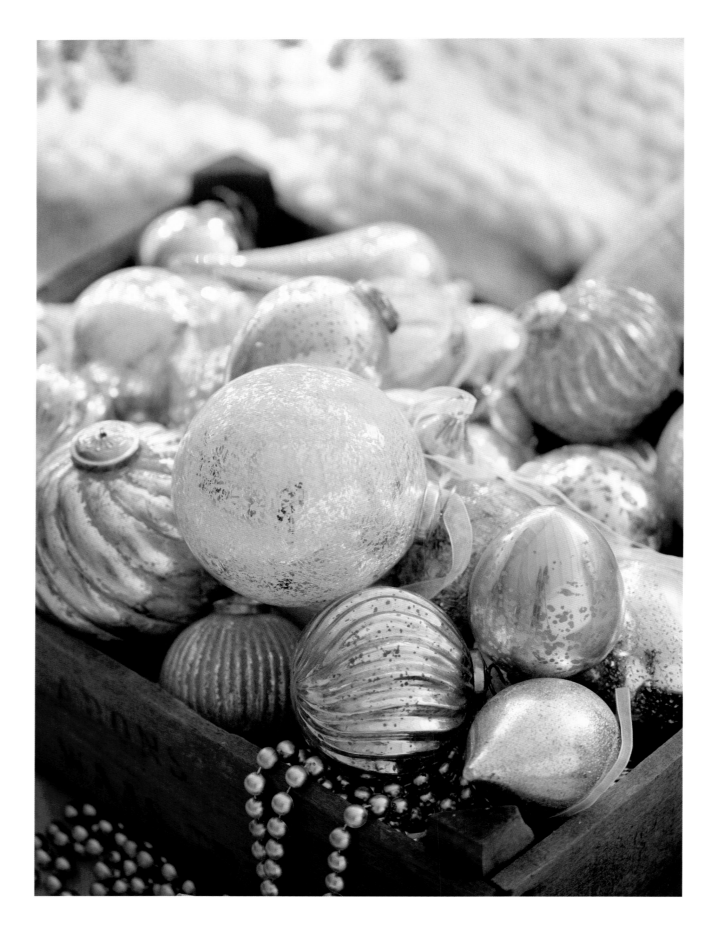

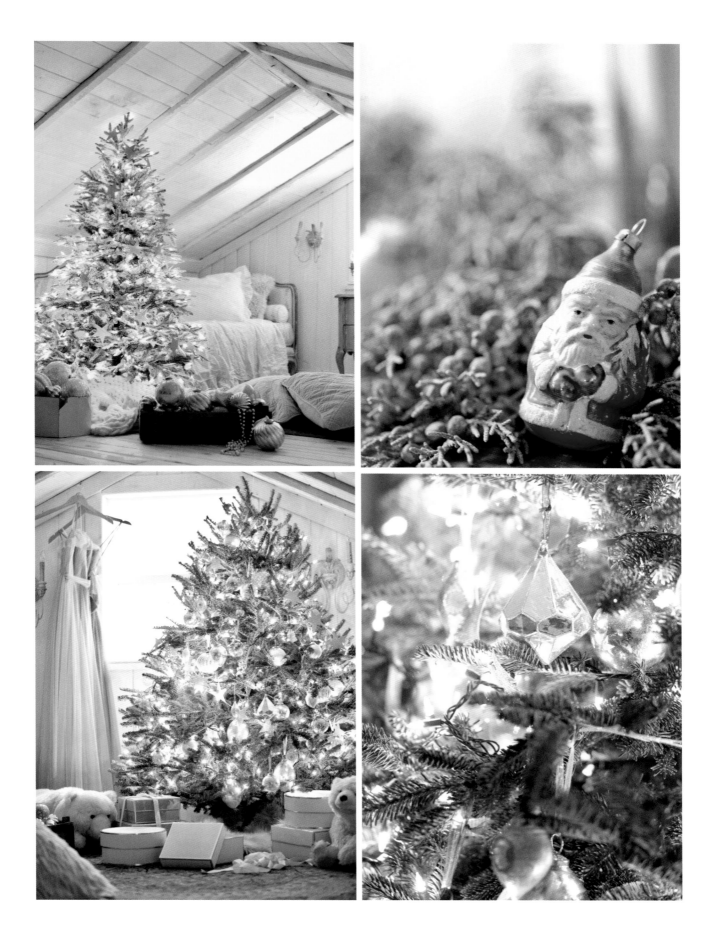

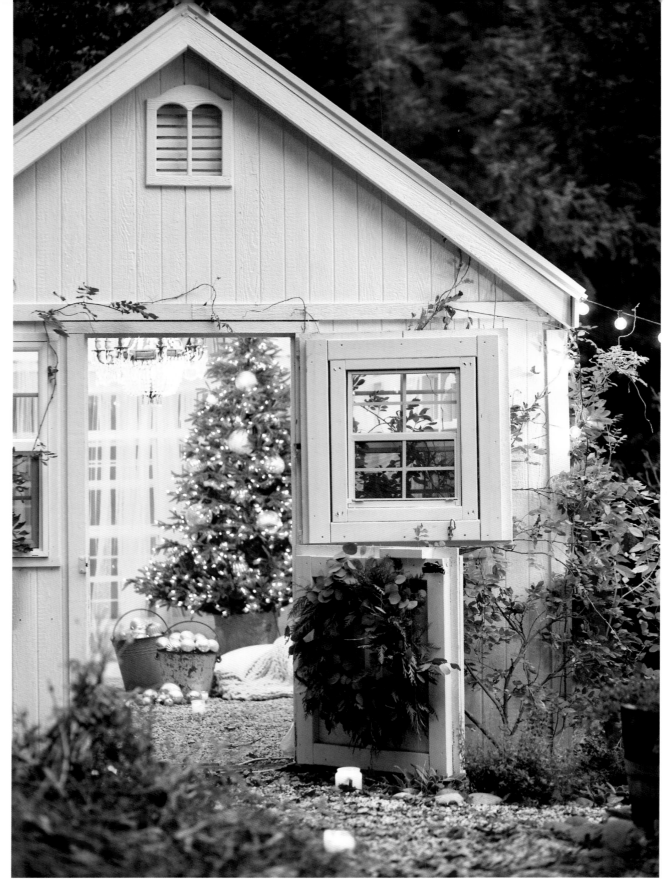

Outdoors, a couple of twinkling trees illuminate the patio area, inviting friends to wrap up in a blanket, step outside and warm their hands by the fire.

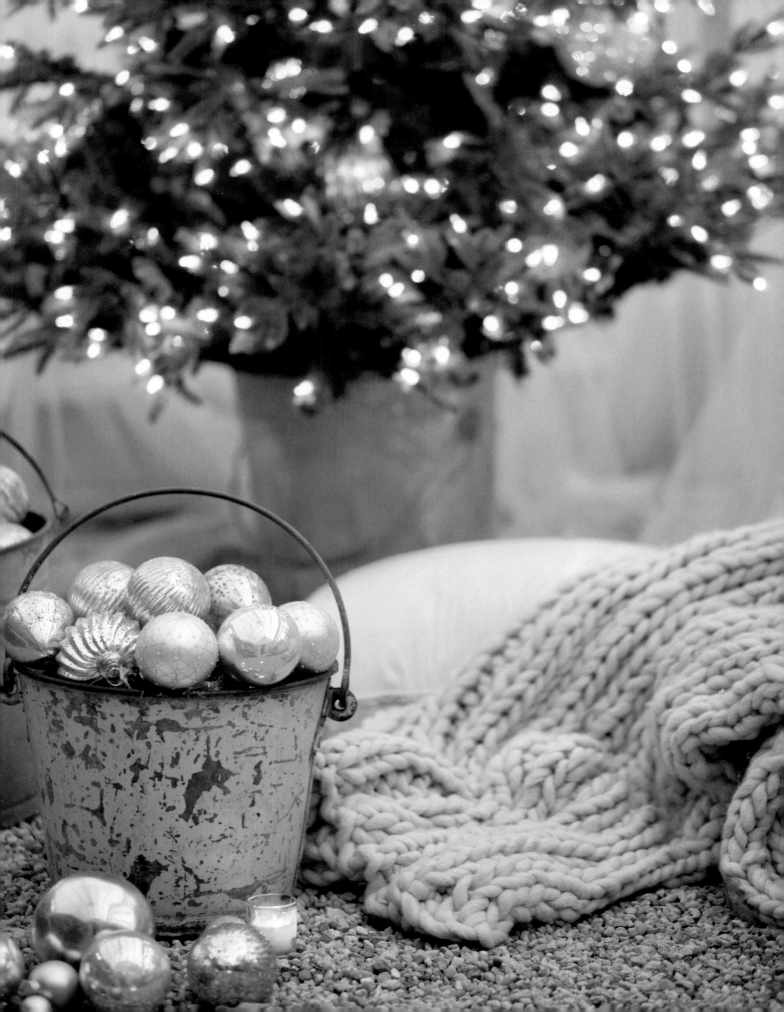

One of my favorite side projects: my beach bicycle and bloom photography series. It is a collection that captures my beach bike styled with flowers and nature in various settings— from the front-yard camellia tree covered in blooms in spring, to a sunset on the beach, to the wine country and anywhere that inspires.

And for Christmas, I wanted to capture that bike with a touch of holiday charm—and so my daughter and I loaded up my bike, a small battery-powered tree, and a bundle of pretty packages and drove to a few spots where the ground was covered in leaves on a quiet country lane.

We unloaded the bike and with packages and camera in hand, found a spot that inspired us and where there was just a bit of mist appearing in the air from the late-afternoon rain. We arranged the basket with presents and that tiny, twinkling tree and waited until dusk, when the light was just right. I set up and started snapping away, and while taking photos, I didn't realize that several neighbors had come out to watch, wondering what we were doing and to take a closer look at an unexpected holiday moment. And after watching for a bit, they asked where they could purchase a copy of the photo when it was ready.

It is moments like those that inspire me so much. I love the feeling of sharing my wonder and excitement with someone else who is inspired by it and sees the world as I do for that moment.

THE JOURNEY

When I think about this house and where we started that first day with nothing more than a few tools and a dream, I will admit that I get a bit emotional.

This isn't just a house with walls and floors and a roof and a yard outside. It is memories. It is hard work and passion and dreams coming true. Over the years and project, this house has become a home—the one I imagined that it could be that first time I stepped inside.

It is that simple 1940s cottage where there are projects yet to happen and door frames with pencil markings showing how tall the kids were each year that will never be painted over. Where the hallway turned into a bathroom and the bedroom became an office and the attic a place to retreat. It is where my children grew, where everyday life happened, where dreams started and became real, and where French Country Cottage began.

That song about a house that builds who you are, in some ways, is very kindred to me. Because, as we renovated and loved this house, as much as it changed and became somewhere that we would build our lives, it also built part of me. My blog was born here. This book was written here. These walls are filled with so many beautiful memories.

Looking back at the journey from where we started reminds me that sometimes I need to toss aside my practical side and lead with my heart, to let the discoveries along the way show the path rather than following some detailed, thought-out plan. It reminds me that the smallest of baby steps add up to big things, and that you should work towards and follow those big dreams even if you aren't yet sure how they may come true.

Because I had no idea that day when I pulled into the driveway of this old house in the California countryside that it would be the beginning of a wonderful journey and the start of so many things I never even imagined. It isn't simply a house that became a home. It is a place that nurtured our family and encouraged living a life fueled by passion, inspiration, love and simple beauty. Opening this cottage door that first time was just the beginning of so many wonderful adventures, beautiful moments and dreams—and the beginning of so many more yet to come.

SPECIAL THANKS

It may have started out as a whim one day—just a little blog about this old house. But *French Country Cottage* has turned into a little spot full of inspiration, where so many dreams first began and where many are being dreamed up right now. And it has opened the door to community and friendships that I could not have anticipated that first day.

My sincere thanks to:

My husband, for believing in me, for all of your help in making this book happen, and for loving me always. I am so grateful for you and all you do. You and our family are my biggest inspirations and loves.

My children: Ryan, for always motivating and encouraging me to reach a little farther. Cullan, for all of your help and working on those seemingly never-ending projects with us every day and for always bringing lots of laughs with you. Ansley, for your help with keeping things running smoothly behind the scenes and for being my assistant and mini me. Each of you inspire me in so many ways every day—I love you.

Dad, for seeing this cottage for what it could be from that first day, for your help and guidance along the way to make that vision come to life, and for all the fun memories that have come along with working with you.

Taylor, my sister, for encouraging me to step out of the forest, one baby step at a time, again and again.

Mom, for being my mom and my friend and encour-

aging me to always try something new and to do my best. And you and Scott for always being there for all of us.

My grandparents, whom I miss dearly and who had a big influence on who I am. And my brothers, our bigger family, and my friends, who have supported my pursuit of this dream. And Erin, Sandy, and KariAnne, for always encouraging, being you, and making me laugh.

Jill Cohen, for believing in *French Country Cottage.* And Madge Baird and Sky Hatter at Gibbs Smith, for your guidance in making this a dream come true.

The designers I have long admired and been inspired by: Rachel Ashwell, Carolyne Roehm, and Brooke Giannetti, for your friendship and support and for joining me on this book journey. And the late Charles Faudree, whose French country designs continue to inspire.

All of my fellow blogger friends, for being such amazing friends and for your support and encouragement. So grateful to know each of you and be a part of your world.

The companies I work with—Balsam Hill, Home-Goods, Lamps Plus, Eloquence, Bella Cottage, Soft Surroundings, Ave Home, Lowe's, Arte Italica, and Lacanche—for your constant support and friendship.

And my *French Country Cottage* friends and community, for taking time out of your day to read my ramblings and be a part of my romantic, inspired world. Without each of you, *French Country Cottage* would not be what it is.

RESOURCES

For vintage items, I look to tag sales, Craigslist, Alameda Antiques Faire, High Point Market, Las Vegas Market, and eBay. Here are my go-to sources when buying new for the home, along with examples of what I purchased:

ANTHROPOLOGIE
www.anthropologie.com
Mantel mirror in bedroom, blush wine stems, lace dishes.

ARTE ITALICA
www.arteitalica.com
Lace-patterned place settings, Finezza place settings, gold glass dishes and stemware, yellow stemware.

AVE HOME
www.avehome.com
French gilded trumeau mirror in bedroom.

BALSAM HILL
www.balsamhill.com
All of the Christmas trees shown, blush French Country ornaments, outdoor entertaining elements—fire pit, copper mugs, lanterns by doors and on patio areas.

BELLA COTTAGE
www.bellacottage.com
Source for ordering Eloquence. Bedding, cane side chair.

ELOQUENCE
www.eloquenceinc.com
French linen sofa in living room, canopy poster bed in master bedroom, tufted bed in cottage, wood island in kitchen, wood sink base in bathroom, seltzer bottles in cottage.

FRENCH HERITAGE
www.frenchheritage.com
Coffee table in living room, round entry table in living room.

HOMEGOODS
www.homegoods.com
Chunky gray willow baskets through-out, blush towels, linens, bathroom bottles and soaps, weathered stools in bathroom and greenhouse, dishes in open cupboard, French-style mirror on patio fireplace, mirror on mantel in office, mirror in dining room.

HOOKER FURNITURE COMPANY
www.hookerfurniture.com
French desk in office.

JOSS & MAIN / WAYFAIR / BIRCH LANE
www.wayfair.com
Whitewashed chairs and patio furniture in front, back, and outdoor dining. Caned chairs in living room and cottage, candle chandeliers on mantel.

LACANCHE RANGE
www.frenchranges.com

LAMPS PLUS
www.lampsplus.com
Lighting throughout house—chandelier and sconces in attic, sconces in hallway and bathroom, sconces and chandelier in entry, chandelier in office and hallway by stairs, and sconces in cottage bedroom; bench at foot of bed in cottage.

LITTLE COTTAGE COMPANY
www.littlecottageco.com
Greenhouse.

LOWE'S
lowes.com
Bleached oak hardwood floors, marble subway tile in kitchen and bathroom and renovated areas in the house.

RESTORATION HARDWARE
www.rh.com
Mirror on vanity in bathroom, wood stools in kitchen.

SAN FRANCISCO FLOW-ER MART
www.sfflowermart.com
Fresh flowers and greens.

SHABBY CHIC
www.shabbychic.com
Bedding, pillows in bedroom and living room, shabby chic dollhouse furniture, vintage fireplace mantel in bedroom.

SIGNATURE HARDWARE
signaturehardware.com
Gold faucets, tub faucet, and sinks in bathroom.

SOFT SURROUNDINGS
www.softsurroundings.com
Blue chippy cupboard in dining room, French-style bedding, weathered bleached chairs in cottage living room.

TARGET
www.target.com
Blush dishes on shelves, floral bedding, aqua and pink beach bikes.

WILLIAMS SONOMA
www.williams-sonoma.com
Blush table linens.

ABOUT THE AUTHOR

Courtney founded the lifestyle blog and brand *French Country Cottage*—a place inspired by inspiration, to share and to be inspired. She writes about entertaining, decor and design ideas, the ongoing renovations of her 1940s cottage, and about living a lifestyle that is fueled by inspiration and the romance that comes with it. She loves the quintessential mix of rustic and elegant elements such as an opulent chandelier against weathered wood, indulges a love of all things sprinkled with ambiance, and believes that a chandelier and bouquets of fresh flowers belong in every room.

In addition to working as a blogger, she works freelance as a photographer and stylist and as a floral designer. Her work has been featured in magazines and websites in the U.S. and in Europe. Her *Beach Bike and Blooms* series has become a licensed photography collection.

A mom of three grown children, Courtney lives in a little slice of the countryside in California with her husband and dog, Sweet Pea. She loves to travel and discover new inspirations, and you can often find her, camera in hand, playing with flowers. Connect with Courtney on her blog, frenchcountrycottage.net, and on Facebook and Instagram at FrenchCountryCottage.

First Edition
18 19 20 21 22 5 4 3 2 1

Published by
Gibbs Smith
P.O. Box 667
Layton, Utah 84041

1.800.835.4993 orders
www.gibbs-smith.com

Designed by Sheryl Dickert
Printed and bound in China

Gibbs Smith books are printed on either recycled, 100% post-consumer waste, FSC-certified papers or on paper produced from sustainable PEFC-certified forest/controlled wood source. Learn more at www.pefc.org.

Library of Congress Control Number: 2018930263
ISBN: 978-1-4236-4892-5